Nathan
Christm
from
Gran

C000225745

RUGBY
WORLD CUP
MOMENTS

Published by Times Books
An imprint of HarperCollins Publishers
Westerhill Road, Bishopbriggs, Glasgow G64 2QT
www.harpercollins.co.uk

HarperCollins Publishers
Macken House, 39/40 Mayor Street Upper, Dublin 1, D01 C9W8, Ireland

First edition 2023

© Times Media Ltd 2023

The Times® is a registered trademark of Times Media Ltd

A catalogue record for this book is available from the British Library

Thanks and acknowledgements go to Robin Ashton and
Joanne Lovey at News Syndication and, in particular,
at The Times, Ian Brunskill and, at HarperCollins,
Rachel Allegro, Harley Griffiths, Rob Thompson, Kevin Robbins,
Rachel Weaver and Amy Townsend-Kennedy.

ISBN 978-0-00-858786-4

10 9 8 7 6 5 4 3 2 1

Printed in India

If you would like to comment on any aspect of this book,
please contact us at the above address or online.
e-mail: times.books@harpercollins.co.uk

www.timesbooks.co.uk

MIX
Paper | Supporting
responsible forestry
FSC™ C007454

This book is produced from independently certified FSC™ paper
to ensure responsible forest management.

For more information visit: www.harpercollins.co.uk/green

THE TIMES

RUGBY WORLD CUP

MOMENTS

David Hands

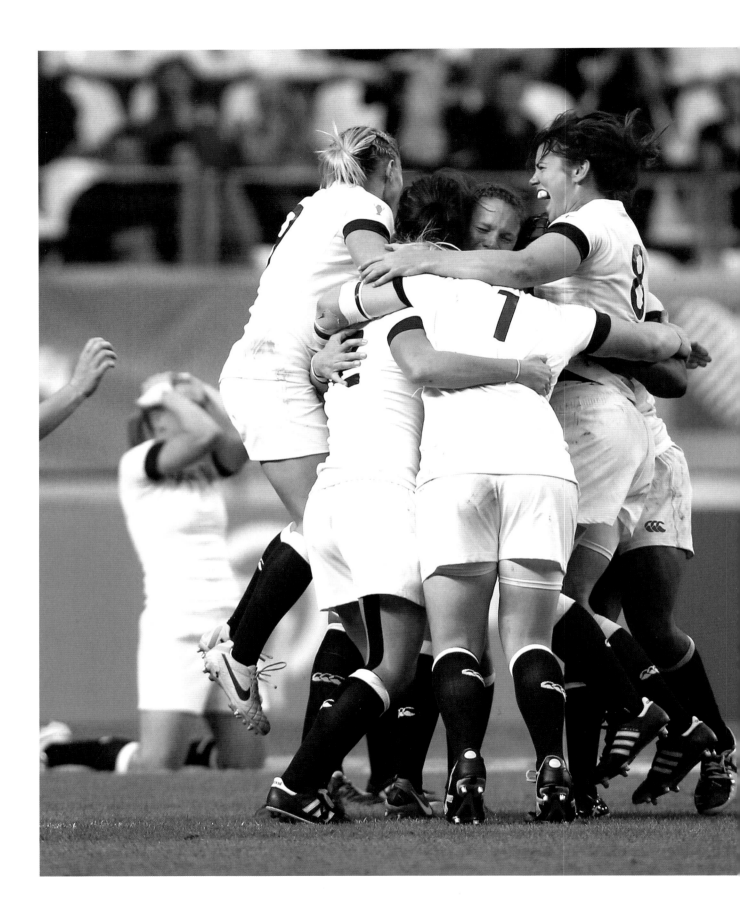

Contents

6 Foreword

8 Introduction

10 The winners

46 The tries

116 The drop goals

140 Down side

156 The upsets

192 Off the ball

210 Out of the blue

230 Legends

254 Index

255 Acknowledgements

256 Photo & writer credits

Foreword

By Stephen Jones

Rugby correspondent,
The Sunday Times, 1983-present

A World Cup in any sport is a heroic concept; by definition it represents the high point of the sport. But when rugby union introduced its own World Cup with an almost apologetic announcement back in 1987, there was no immediate outbreak of joy. Rugby was always so cautious, and has retained elements of that caution to this day.

The overriding emotion in the eyes of many rugby officials back in 1987 was that the World Cup, while welcome, might actually spill the game over into professionalism. It is somewhat hard, in these galloping finance-based days of mega-sporting occasions, to get across just how avidly the concept of amateurism was held by the game's grandees, and very many of its followers.

I got the impression at the time that the hierarchy appointed to run the first tournament was equally concerned that it upheld all of rugby's old principles and behaviours as much as it struck out for new worlds. As with the arrival of professionalism itself in 1995, once the World Cup found its stride there was nothing to stop it. There have been good ones, great ones, small ones and disappointing ones but the World Cup is here to stay and the figures are astronomical. It is expected that the box office for sponsorship and television rights will be booming.

The tournament continues to have its teething problems as well as its successes. In 1987, everyone was feeling their way; in 1991 and 1999, the men's tournament was spread-eagled out across the home unions and France, making it fiendishly difficult to organise from the commercial point of view and leaving it unfocused. This was because in those heady early tournaments, everyone wanted a slice of the action. So

when the organisers went into a room of peer unions in Europe, they found that the tournament had become even more scattered as the unions bartered for chunks of the event.

But by 1999, of course, we had already seen some of the outrageous power of the Big One to influence. In 1995, less than three years after apartheid had ended in South Africa, and the nation's exile from international rugby along with it, South Africa was still in turmoil as it tried desperately to adjust while the African National Congress swept into power. Even now the sight of President Nelson Mandela dancing on the podium alongside Francois Pienaar is remarkable: the long-incarcerated black president and the blond Afrikaner celebrating together in a spirit of mutual achievement and hope. It is probably too facile to attribute over-significance to the influence of sport on politics. But those of us present in 1995 in those glorious months will never deny what rugby did for the country.

As yet the sport was still amateur or, at least, the professional segments of the sport were still reasonably well hidden. But in a staggering semi-final between England and New Zealand in Cape Town, Jonah Lomu, the gigantic wing, demolished England with four sensational tries. At the time, many of the southern-hemisphere nations were actively expecting the game to go professional soon, and the mania which surrounded Lomu during that tournament, and for a long time afterwards, was shared by television companies and their executives. Suddenly they all wanted rugby, they wanted Lomu, and there was now no way whatsoever the game would stay amateur in the face of the volleys of income that were aimed at it.

The power of the tournament was seen again in 2003 in Australia. It was a blissful tournament, much of it played in wet weather and won, of course, by England. Jonny Wilkinson, who dropped the goal to win it for a magnificent England team, was to become as famous as Lomu and, since he was illuminated by northern-hemisphere media, possibly even bigger. England's

rugby became much bigger. Sir Clive Woodward advanced the cause of coaching by as much as a decade, although he was not there himself, notoriously, to accept the fruits of his inventiveness.

Since then, bigger and bigger. There was an interruption when New Zealand staged the 2011 World Cup. They did so not because they had any great commercial clout but because they deserved it for their previous influence on the sport (although by the time 2011 came round, they had not won the tournament for a cavernous 24 years). It was a homely affair, by no means disagreeable, but then it had to be backed up by a money-making colossus to keep in the black the funds that drive global rugby. So 2015 was staged in England, and only in England. The drawback there was the abject performance of the home team, just when a second world title would have sent the game in England into orbit.

And then, at long last, expansion. The men's tournament had always tootled around the foundation nations of the game, but the tournament of 2019 was awarded to Japan. The whole experience was quite magnificent, the massive Springboks came home in style against England and yet Japan beat Ireland and – playing quite stunning rugby – also beat Scotland.

The World Cup cycles seem ever-present. The women's World Cup began in 1991 as an ad-hoc, pick-up affair organised by four heroic ex-players on a shoestring. Although the tournament did not get the official stamp from the International Rugby Board, for everyone else it was a valid event, and the USA, who beat England on a thrilling Sunday at Cardiff Arms Park, were valid winners.

Since the pathfinding days in Cardiff, the women's tournaments have been held in Edinburgh, The Netherlands, Spain, Canada, England, France, Ireland and New Zealand. The visibility of the 2021 event in New Zealand was not high above the equator due to distance and time difference, but a remarkable final was in doubt until the last minute, when the Black

Ferns took an England throw at the lineout, just when England were about to mount one of their trademark driving mauls.

Which has been the best women's tournament to date? It is a matter of personal preference but for those of us who were honoured to be present for the 2014 event in France, we will never forget it. The crowds were excellent, the standards high, and two amazing displays of rugby in the semi-finals did more for the women's game than any amount of advertising could.

The next women's event takes place in England in 2025, and already it is shaping up as a behemoth. The organiser reckons to sell out Twickenham, capacity 825,000. What a sight that will be, and what a tribute to all the pathfinders.

But rugby has a World Cup forever. It deserves one and it is capable of running an even bigger event with way more contenders. Some of the old caution and reticence is still out there. The next Rugby World Cup must be blast off.

Introduction

By David Hands

Rugby correspondent,
The Times, 1982-2010

The production of this book has been similar to visiting old friends, with whom you can cheerfully catch up even after a ten-, twenty- or thirty-year absence. It is unusual to have lived and worked through the entire period of a tournament which has become part of the sporting fabric – my former colleague, Richard Whitehead, who was consultant for the companion volume on football's World Cup and to whom I owe much for his guidance in computerland, did not enjoy that luxury – so it has been possible to dip into my own archives, as well as those of *The Times* and *The Sunday Times*.

The whole exercise has revived many memories, not only of countries visited and games played, but those met along the way and the colleagues with whom one operated. Yes, many were rivals but also friends with whom one socialised when work was done. When the tournament began, of course, the nature of reporting was entirely different and, by and large, down time could be factored in so that the rugby did not become all-encompassing.

Now the job has become 24/7 for the daily paper journalist. Not only must they file instantly for the website, those reports must be constantly updated and then the paper itself serviced, all with a point of difference. In 1987, *The Times* covered the inaugural World Cup with a reporter in the camp of each home union and that was it; now a clutch of additional reporters and colour writers, as well as the specialist rugby writers, will trail England, diverting now and then for a look at the upcoming opposition or to feature a country which might be new to the competition.

The depth of television coverage is also a factor in what may appear in the paper. A match played on a Saturday evening in Australia is, allowing for the time difference, 48 hours old by Monday morning in Britain and therefore stale news. It is assumed that the rugby-loving public will have watched it live or on record that day, and read about it online or in a Sunday newspaper, so that by the time Monday comes around, a different angle is required. Hence, over the last eight years, if you seek a blow-by-blow account of what happened in the match, you will not find it in a Monday paper.

The growth of the public-relations industry is also a factor in the relationship between a sport and the media. On the one hand, columns written by, or ghosted for, leading players are part and parcel of the game's coverage; on the other, the ability to go behind the scenes is restricted, sometimes at the behest of the head coach, sometimes the decision of the communications team, and talking to a player happens in a strictly controlled environment. The amateur male players of 1987, 1991 and 1995 could be approached on an individual basis; professionalism has brought about a system of checks and balances, perhaps more of the former than the latter.

Then there are the changes to the game itself. The value of a try at the first two men's World Cups, and the first women's, was four points, increasing to five in 1992. Professionalism arrived in 1995, dramatically increasing the need for rugby to be both sport and entertainment so as to guarantee television coverage and ensure adequate funding. This is not the place to go into the various law changes that have taken place since 1987, many of them affecting ruck and maul and, more recently, the tackle, but they too have had a considerable impact on how the game is played.

Alongside all this has come the Television Match Official (TMO), the use of whom has insured that many games now last up to two hours, rather than two halves of forty minutes each plus a five-minute pause

at half-time. The way the game is now played demands, moreover, the incessant use of the Television Match Official: if teams always poke a penalty into the corner and then try to maul their way over for a try, or play pick-and-go whenever they come within five metres of the try line, then it is inevitable that often the referee will be unable to see whether there has been a score without consulting numerous camera angles.

So match tactics have changed, not always for the better. The kicking game has been explored and, in some instances, too slavishly employed. In that respect, the women's game offers on many occasions a better spectacle involving a greater number of players; kicking has improved vastly in the 32 years of the women's World Cup but it is not the first port of call. If you can find a women's match in which the drop goal has played a significant role, congratulations, whereas the men's game fully justifies the chapter devoted to it here.

The aim of the book has been to match significant moments during the World Cup in pictures and words recorded at the time. You will find, combing through the pages, that not all the words are drawn from the archives of *The Times* or, on occasions, *The Sunday Times*. This is because some of the best-remembered moments did not earn the verbal treatment they deserved: take, for example, the wonderful try scored by Takudzwa Ngwenya, the American wing, against South Africa in a 2007 pool match, woefully overlooked in most newspaper columns but replayed many times on screen.

So words that accompany some pictures have been written during the book's production, with the author's name at the end. You may find some stylistic anomalies (though consistency has been sought where possible) which reflect the paper's own changing style. Another example: in 1987 it was customary in match reports to refer only to a player's surname, unless one individual so dominated proceedings that they became the introductory paragraph.

When a writer was working abroad, their report would be by-lined 'from' as opposed to 'by' when working within Britain. Many of these apparent quirks have been retained for greater authenticity. Various archive reports contain ellipses, indicating where some paragraphs have been omitted so that the best description of the moment in question can be reached. The Women's World Cup of 2021 was held a year later because of the Covid-19 pandemic but its official year remains 2021.

Inevitably there is a degree of subjectivity in selecting the best moments and it would be amazing if some readers did not leap from their seats uttering the words "but what about…?" That, though, is what the best bar-room debates are all about. All I can say is that, for the most part, I was lucky enough to be there.

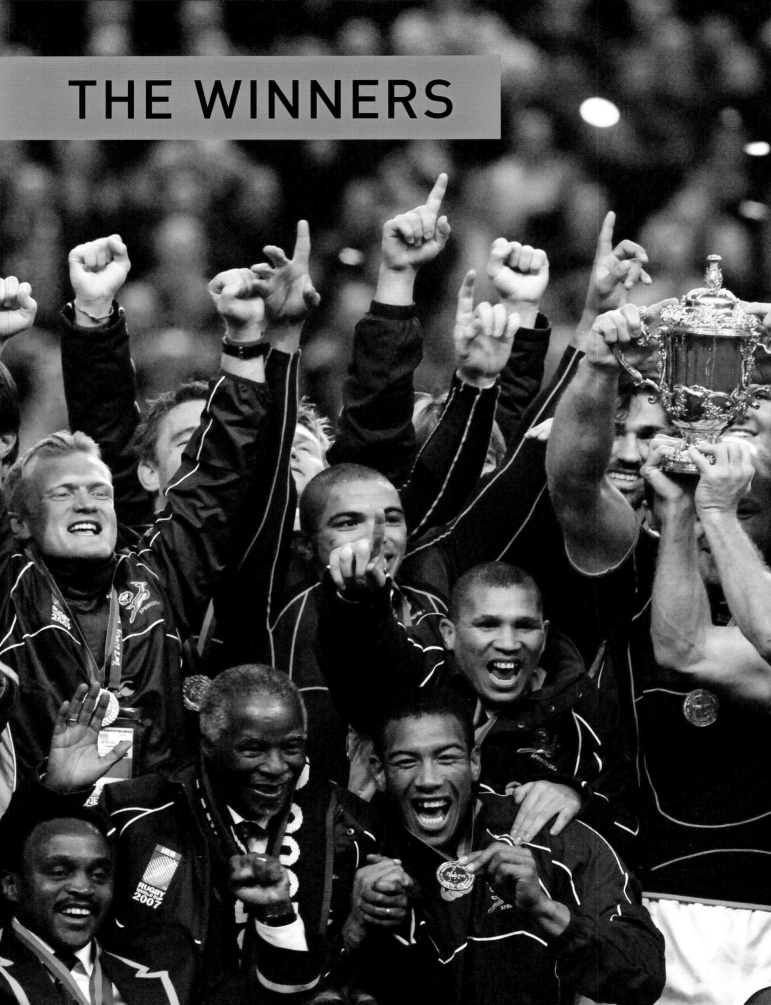

THE WINNERS

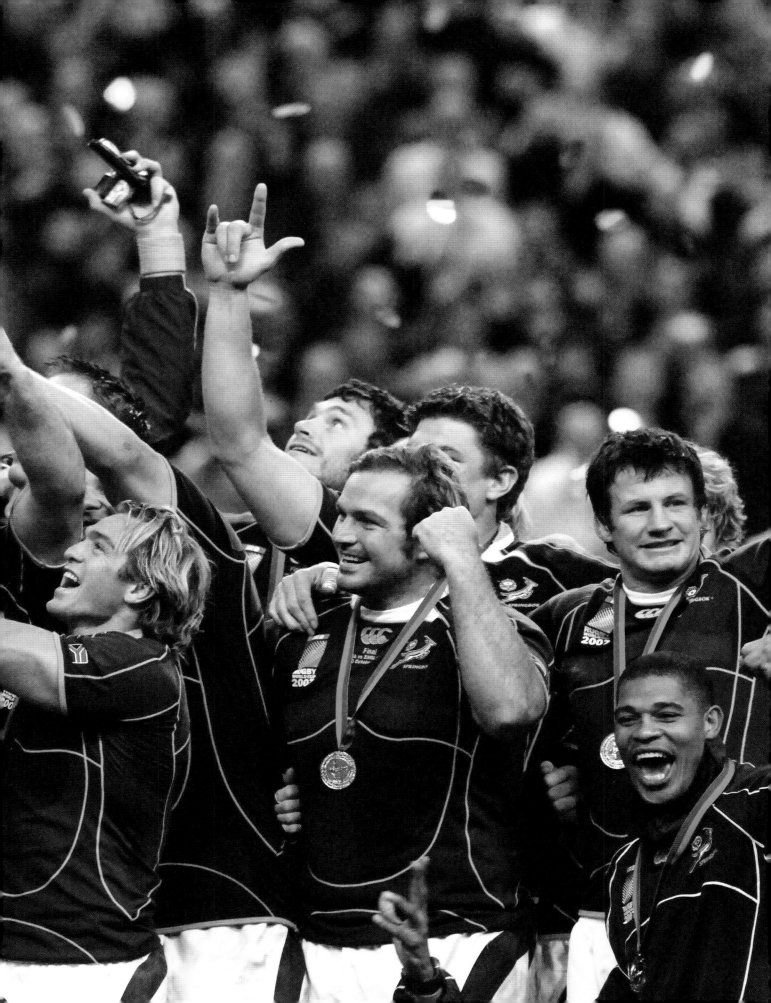

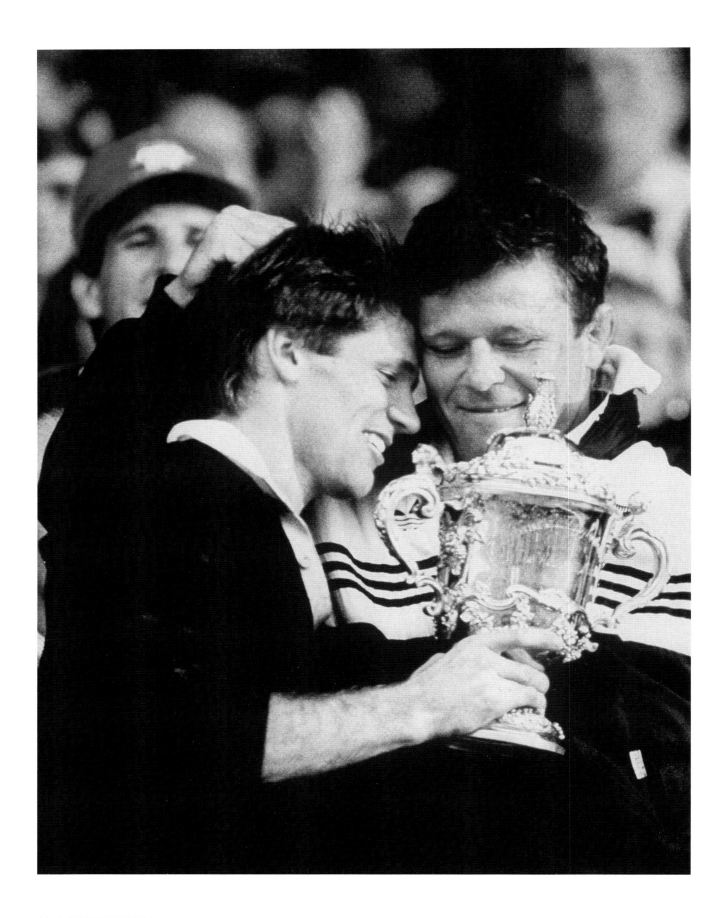

Captain Kirk boldly goes

New Zealand and Australia 1987
New Zealand 29 France 9
20 June 1987
Eden Park, Auckland | Final

Every picture tells a story, they say, and this one is particularly poignant. New Zealand, captained by the scrum half, David Kirk, have just become the first holders of the William Webb Ellis Cup. But Kirk shares the moment with Andy Dalton, the hooker appointed to lead the All Blacks in the inaugural World Cup but who did not play a single second in the tournament.

Dalton, who won 15 of his 17 games as captain between 1982-5, made waves when northern-hemisphere countries arrived in New Zealand and their players saw him advertising farming equipment on television. No mention of rugby, of course, this being a strictly amateur era but the game being followed so avidly in the Land of the Long White Cloud, nearly every viewer knew who Dalton was.

Visitors may reasonably have wondered whether Dalton was advertising for fun but the authorities had given their consent. However Dalton never added to his 35 caps: a hamstring damaged in training before the tournament began prevented him from playing and though he remained part of the squad, he could only watch as the young Sean Fitzpatrick cemented his place in the All Blacks front row.

DAVID HANDS

David Kirk (left) receives the congratulations of Andy Dalton who, in other circumstances, would have been lifting the trophy himself.

Americans state their case

Wales 1991
England 6 USA 19
14 April 1991
Cardiff Arms Park, Cardiff
Final

The inaugural Women's World Cup was held on a shoestring in Wales thanks to the efforts of four members of the Richmond club from London – Deborah Griffin, Sue Dorrington, Alice D Cooper and Mary Forsyth – all of whom were inducted into World Rugby's hall of fame in 2022. They received virtually no support from the authorities in the men's game, who were more concerned with running the second edition of their own World Cup later in the year.

Twelve countries took part, of whom England, France and the USA were the most experienced though internationals for women had begun only nine years earlier (between the Netherlands and France). Played largely on club grounds in and around Cardiff, the final brought together England, winners over France in the semi-finals, and the USA, who beat New Zealand in the penultimate round.

In the final, the Americans elected to demote Barbara Bond, their captain, to the replacements and gave the leadership to Mary Sullivan, the full back. Though England led with a penalty try converted by Gill Burns, in the second half the USA romped away, scoring tries through the flanker, Claire Godwin (two), and the scrum half, Patty Connell.

DAVID HANDS

Tam Breckenridge, the US lock, gets the ball back against England.

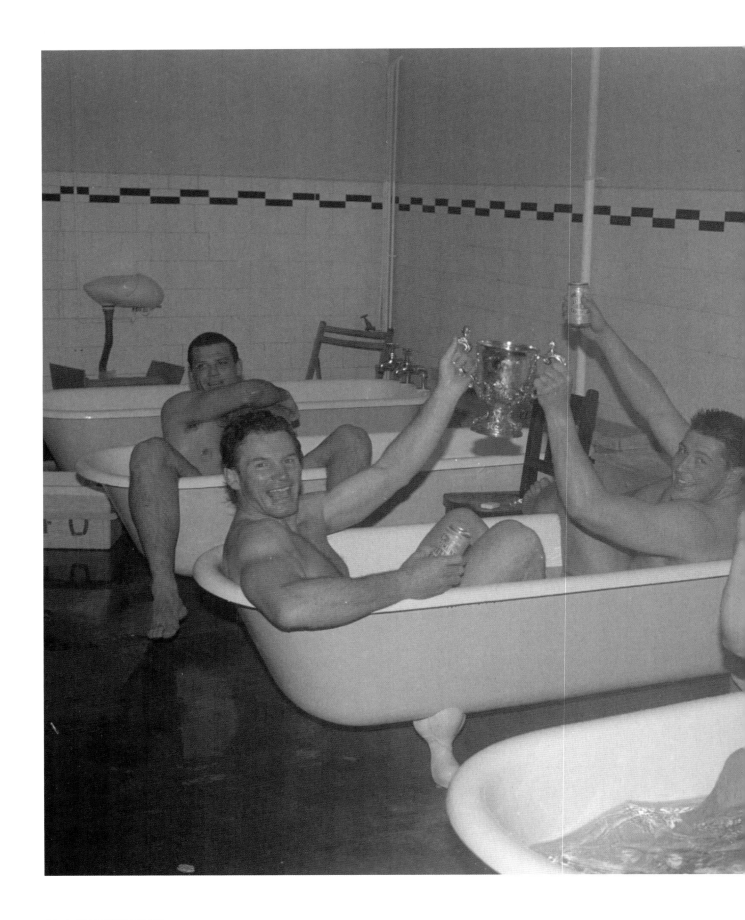

Bath time for 'Bill'

Britain, Ireland and France 1991
England 6
Australia 12
2 November 1991
Twickenham, London | Final

Once you get your hands on the William Webb Ellis Cup – or 'Bill' as the Australians affectionately christened the trophy – you don't want to let it go. So once it had been handed by Queen Elizabeth II to Nick Farr-Jones, Australia's captain, the cup joined the Wallabies in the bath.

England's bathing arrangements were their pride and joy for many years and, despite modernisation, two remained in situ at the time of writing, one is in the RFU museum and four were said to be "on site". But in 1991, two of Australia's successful forwards, the flanker, Simon Poidevin, and the hooker, Phil Kearns, shared their bath with 'Bill', watched gleefully from another bath by Michael Lynagh, the fly half who kicked two penalties and the conversion of Tony Daly's try.

Anthony Herbert is remembered as one of the Australia players who popularised the trophy's nickname and 'Bill' received a victory parade through Sydney when the Wallabies returned home.

DAVID HANDS

Simon Poidevin (left) and Phil Kearns share trophy and 'tinnies', while Troy Coker (back) and Michael Lynagh (front) celebrate too.

England's revenge

Scotland 1994
England 38 USA 23
24 April 1994
Raeburn Place, Edinburgh
Final

BY DAVID HANDS

Where England's men failed in the final of their world rugby union tournament, England women (admittedly at the second time of asking) succeeded yesterday. Nourishing the bitter experience of failure against the United States – the only team ever to have beaten them – in Cardiff three years ago in the inaugural tournament, they squeezed the life out of the Eagles, whose fluent back play has so dominated this tournament.

Playing on the Edinburgh Academicals ground at Raeburn Place, where the first international rugby match was played between Scotland and England in 1871, England defied the pre-match oracles to win by five goals and a penalty goal to four tries and a penalty goal. That their winning margin included two penalty tries and a pushover disturbed them not a jot – such is the desire for victory which infects even the youngest of sports.

But the tactical sense was sound enough. The Americans entered the final having scored 364 points in four games, their speedy backs having ridden roughshod over every opponent. England knew they could not counter the threat posed by Jen Crawford and Patty Jervey so, like England's men, they played a set-piece game and denied the Americans space, clipping the Eagles' wings.

Gill Burns, England's captain, dominates a lineout.

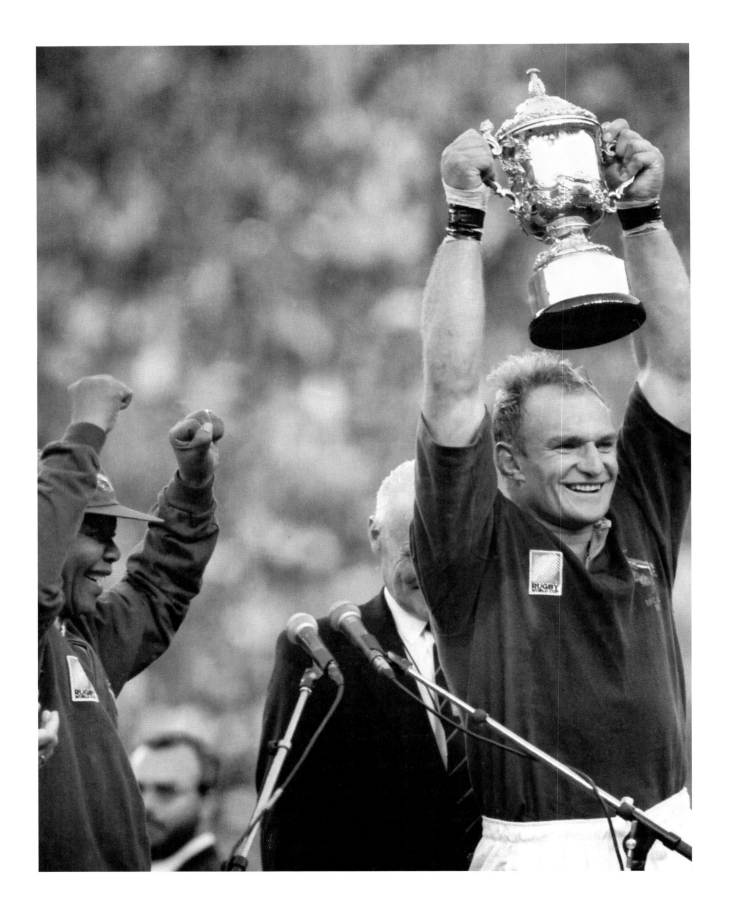

The rainbow nation rises

South Africa 1995

South Africa 15
New Zealand 12
(after extra time)

24 June 1995
Ellis Park, Johannesburg | Final

FROM DAVID MILLER

For any other head of state, from Africa or wherever, to have appeared at a Rugby World Cup final wearing a player's No 6 shirt and symbolic cap would have been at best inelegant, at worst histrionic and opportunist. For Nelson Mandela, it was a touch of genius.

To take hold of the very colours of your historic enemy, of your cultural, social and political oppressor, and to raise them aloft as a symbol of brotherhood, was more powerful than a million words. With a mere green-and-yellow cloth on his back, instead of resorting to guns and bombs, this unique statesman's gesture had overturned a former hated bastion of racist privilege and created, instead, a talismanic club of equality.

That this statesman should, coincidentally, be granted the euphoric climax of the narrowest South Africa victory, in extra time, was beyond expectation and served to intensify the impact. What might be achieved elsewhere in the world's most troubled regions by such magnanimity, by such demonstrative respect towards a political rival's most cherished and precious institution?

While sport was officially the name of the game, and the game itself produced one of the most intense afternoons of physical endeavour and emotion that any of those present are ever likely to witness, the wider watching world is entitled to be open-mouthed in admiration for Mandela's spontaneous stage management of this unique moment in his nation's evolutionary crisis.

The man is truly blessed with that simultaneous gift of humility and innate leadership. At this finale of five weeks' sporting festivities, blacks and bokke saluted him with equal fervour.

Francois Pienaar, South Africa's captain, lifts the cup and Nelson Mandela cheers with delight.

Black Ferns cast 16-year shadow

World Cups: Holland 1998
Spain 2002
Canada 2006
England 2010

Anna Richards played for New Zealand in five World Cups, those of 1991, 1998, 2002, 2006 and 2010 – of which, the Black Ferns won the last four. Here she recalls her experience.

I liked playing with my mates, I liked working hard, I liked winning. It's addictive. We lost in the semi-finals of the first tournament in which I played, in 1991, and New Zealand didn't send in 1994 because of uncertainty whether the tournament in Scotland was properly sanctioned. That's what kept me going so long, the fact that we had lost and then the disappointment of not being able to go to the second – I felt there was something to make up for.

When the possibility of a Women's World Cup arose, our coach, Laurie O'Reilly, contacted fifty or sixty girls to ask if they could afford about NZ$5,000 to be able to travel to the UK. The side was picked from those who could raise the money. We begged, borrowed or stole to be able to go and I think Laurie paid for the jerseys.

He organised it all and it was a great trip. We knew the English and the Americans were good, we didn't go expecting to win, we just felt so intrepid to be taking part. The New Zealand union sanctioned our going but offered no support and the media tried to find the 'wow' factor – they tended to sensationalise it a bit. But we were really serious about what we were doing, we wanted to be very competitive.

I was playing half back in that tournament and we lost 7-0 to the USA in the semi-finals. By the time the 1998 tournament came along, we had another really good scrum half in Monique Hirovana'a and I was

asked if I wanted to switch to fly half. I jumped at the chance and loved it. We went into the World Cup in Amsterdam on a wave, we'd beaten the touring England side 67-0 the year before and we were playing really exciting rugby.

We found ourselves staying in the same accommodation as the Welsh team and had a great time with them. Everyone played at the same stadium, the Dutch National Stadium, and it was awesome. We even had some supporters turn up, which was really cool. I think we won our first match 134-6 [against Germany] and I got to play alongside my sister, Fiona [who played lock]. And, of course, we won which made it such a memorable time.

I didn't enjoy the 2002 tournament so much, even though we won, because I didn't like the way we were playing the game. But 2006 in Edmonton really stands out because of the final. It was an incredibly exciting game to be part of, a real challenge. Our semi-final against France was played in about 35 degrees but by the time the final against England came round, we were playing in three degrees. England had struggled against Canada in their semi-final but they brought their A game to the final.

The trouble is, you get so caught up in the moment trying to win that you don't allow yourself time to enjoy it. But I knew that 2010 would be my last. I'd been called up late and I just wanted to enjoy myself – and I did. The final with England was a really close game, I was one of three New Zealand players to get a yellow card and I'd never had one in my life, but even though there were just three points in it at the end, I never felt we were going to lose.

During that whole period, it was the support around the game that really changed. As in the men's game, players became fitter, faster and stronger but in 1991, we'd never heard of fitness tests, there was very little analysis. When I spent a season with Richmond in 1994, I found English forwards far more technically advanced than New Zealanders and we've always struggled to match them at the set pieces.

The kicking game has evolved and that's a massive difference down the years. I never did too much kicking, our backs were so good I didn't need to. And I really loved playing, the adrenalin rush of it all.

ANNA RICHARDS

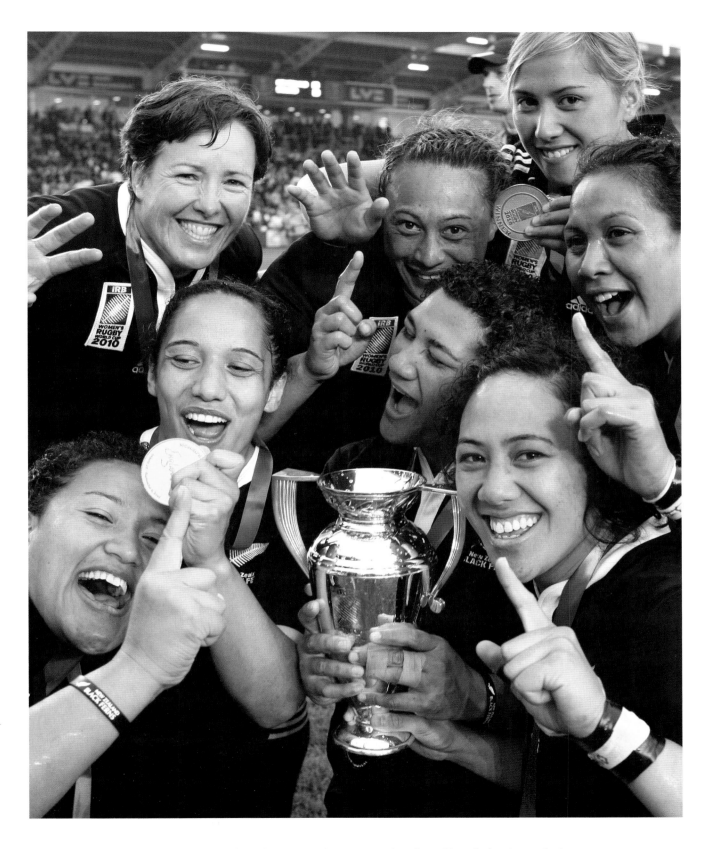

Anna Richards (back left) and the Black Ferns celebrate their victory in the 2010 Women's Rugby World Cup final against England.

Amiria Marsh, New Zealand's full back and scorer of the try that kept England out of reach in the 2006 final.

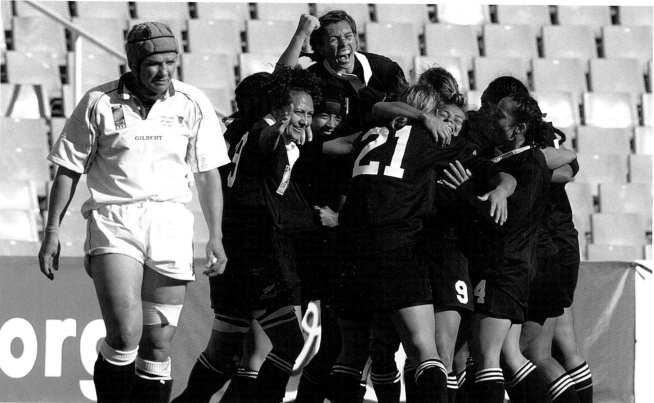

(t) Anna Richards tackles England's Shelley Rae during the 2002 Women's World Cup final in Spain.
(b) New Zealand's players gleeful after retaining the cup in 2002.

New Zealand's Vanessa Cootes avoids being tackled by the USA's Kim Cyganik in the 1998 Women's World Cup final in Holland.

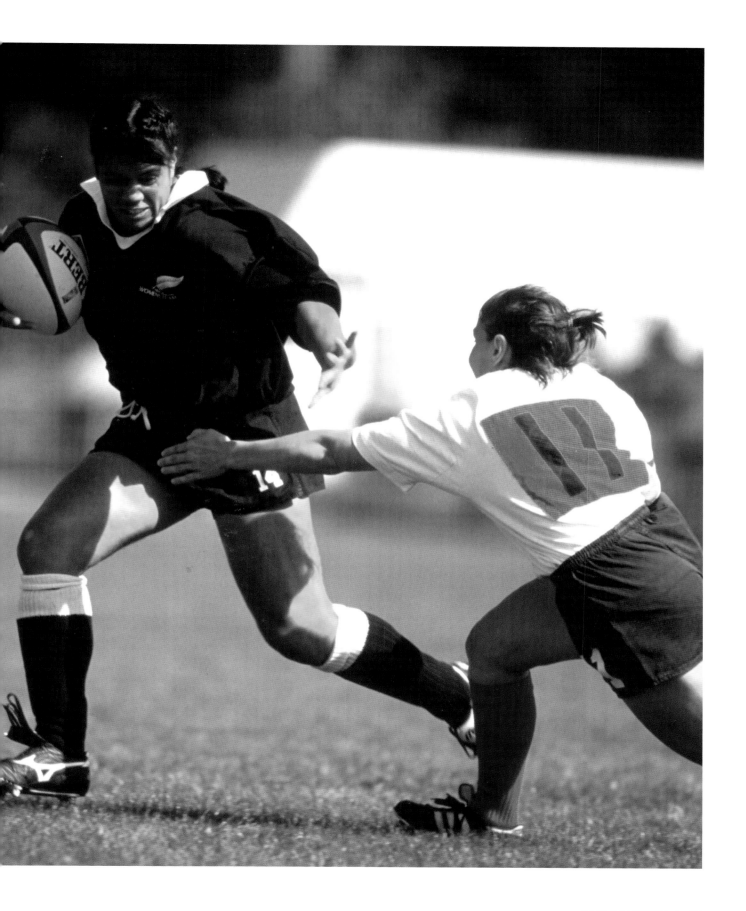

Vive la différence

Australia 35 France 12

6 November 1999
Millennium Stadium, Cardiff
Final

The 1999 final matched the tournament as a whole, in that there were too many flaws. The difference between the winners and the losers was greater than in any previous (or subsequent) final and was, in addition, marred by accusations against the French of foul play.

It took place on the same day that, back home, Australians were voting for or against republican status. The referendum resulted in a 54 per cent preference for the status quo and word of this filtered back to the Wallaby camp and John Eales, their captain and a confirmed republican, before the final was played.

Thus it was that Eales accepted the William Webb Ellis Cup from Queen Elizabeth II, the head of the Commonwealth, who smiled as she shook hands and said: "Congratulations. We have both beaten a republic on the same day."

DAVID HANDS

The 6ft 6in John Eales looms over Queen Elizabeth II (5ft 4in) at the presentation ceremony.

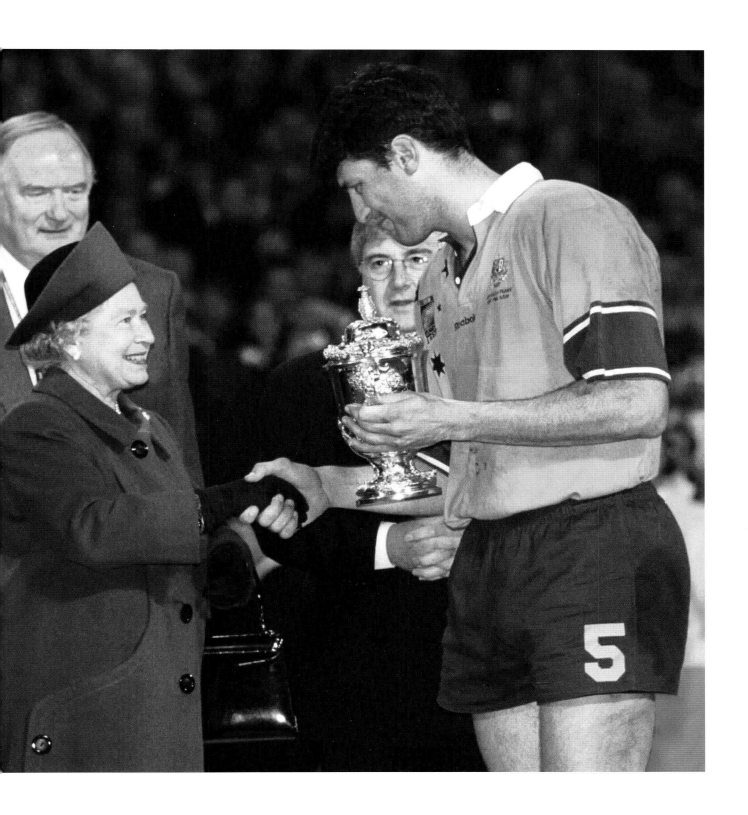

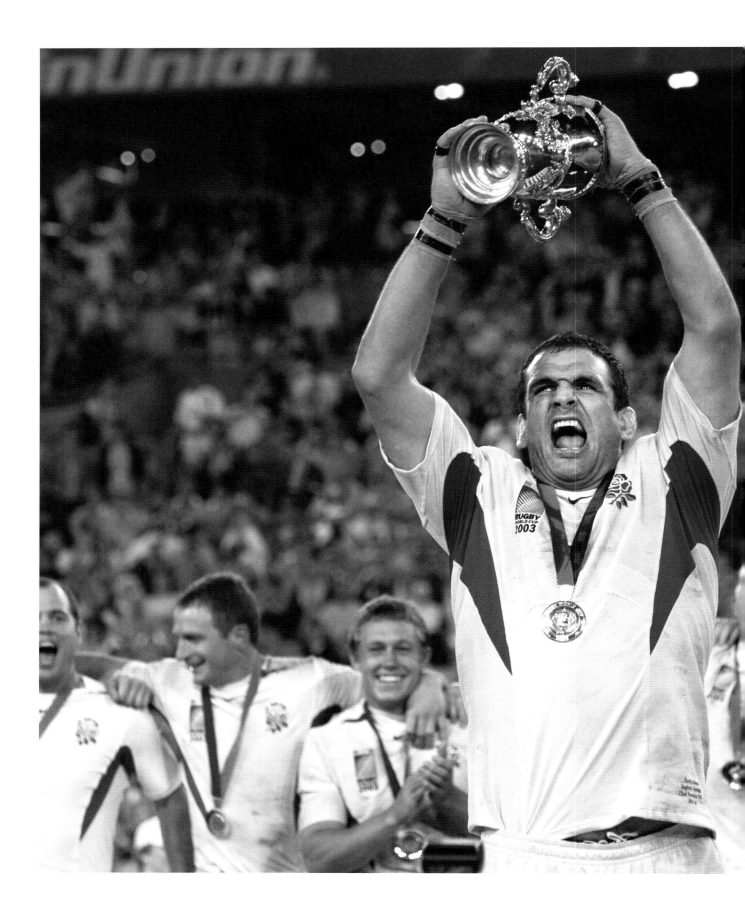

King of the world

Australia 2003
Australia 17 England 20 (after extra time)
22 November 2003
Telstra Stadium, Sydney | Final

FROM GABBY LOGAN

Martin Johnson stands on the podium and holds aloft the Webb Ellis Cup. The biggest prize in rugby looks tiny and vulnerable in his huge, gifted hands. In that one moment a lifetime's work was complete. This man has orchestrated British Isles victories, a European Cup win and five domestic titles and now at last he is king of the world.

To be just a few feet from Johnson is to feel you are in the presence of greatness. Until you see him in the flesh you can't begin to imagine how awesome he is. He was born to lead; he was born to live this dream.

I am in a privileged position, waiting to conduct post-match interviews. I'm on the pitch and I couldn't be closer to where Australia or South Africa, or in football it would be Brazil or Germany, are lifting the trophy and you wonder what it feels like? Now we know. It feels like an out-of-body experience. This doesn't happen to us, we usually come second.

Martin Johnson brandishes the trophy while behind him (l to r) Kyran Bracken, Mike Catt, Jonny Wilkinson, Matt Dawson and Ben Kay exult.

Springboks hold firm

France 2007
South Africa 15 England 6
20 October 2007
Stade de France, Paris | Final

FROM MARK SOUSTER

As South Africa's players lifted Thabo Mbeki, their country's President, on to their shoulders at the Stade de France on Saturday evening, and as he shared in the nation's delight at a second World Cup victory, it was obvious that the Springboks had been playing more than just a game.

They wanted personal and collective sporting glory, of course, but in a way they had been playing, too, for the future of South African rugby, one that they hope will be based on ability rather than colour and quotas. They hope what they achieved over 80 minutes makes a statement that will reverberate at home for years to come.

The momentum generated in the republic from their success and the manner in which it has again galvanised a nation may have bought the white-dominated sport time but the reality is, change is inevitable. What will be critical is the pace at which that is introduced and managed. "To see the President of our country holding the World Cup is something to be proud of," Jake White, the coach, said. "It doesn't get bigger than that in the context of where we have come from. He said how proud he was to be a South African and how proud he was of the players."

South Africa's president, Thabo Mbeki, is lifted on to players' shoulders as the Springboks celebrate their victory in the 2007 World Cup final against England.

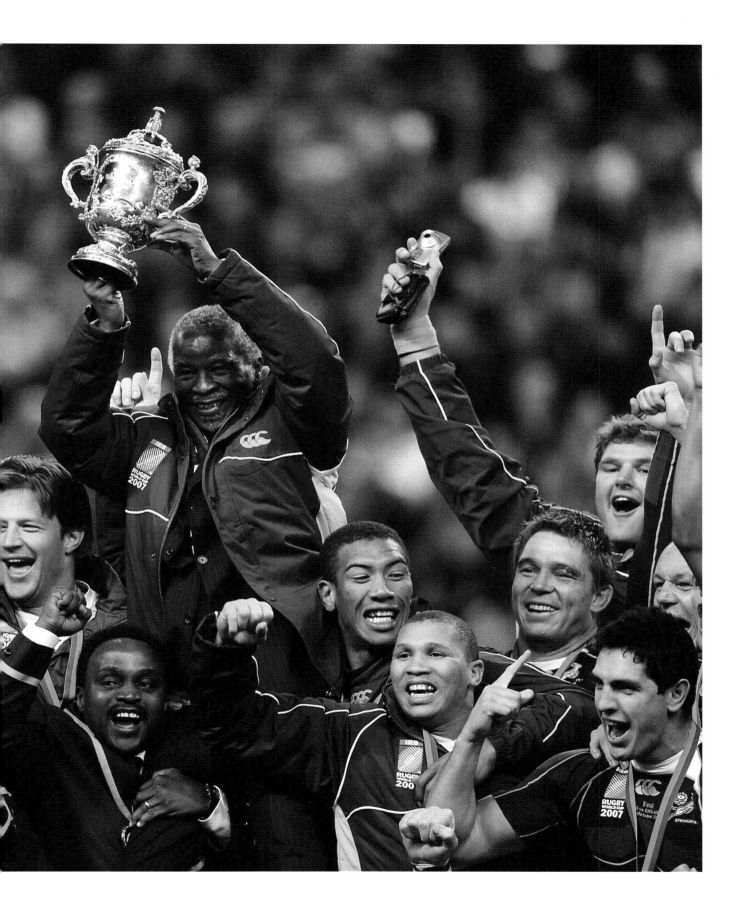

All Blacks shift the monkey

New Zealand 2011
New Zealand 8 France 7
23 October 2011
Eden Park, Auckland | Final

FROM MARK SOUSTER, RUGBY CORRESPONDENT

By any measure, the 2011 Rugby World Cup was a huge success, even if it cost the country many millions of dollars to stage. Its down-to-earth approach was summed up by the players being driven around not in a fancy open-top bus, but on the back of a fleet of what were little more than market farm trucks.

The seventh edition of the tournament was the largest sporting event New Zealand has hosted. Through it, the country would appear to have grown in confidence. It has shown that, given the opportunity, it can organise and deliver an event of such scale.

It helped that the country was steeped in rugby. However, the manner in which the tournament connected with every remote village or homestead was inspiring; so, too, the manner in which New Zealand opened its arms to the world. Twenty teams and about 100,000 visitors were invited in and few could have been disappointed.

Richie McCaw holds aloft the Webb Ellis Cup during the victory parade in Auckland.

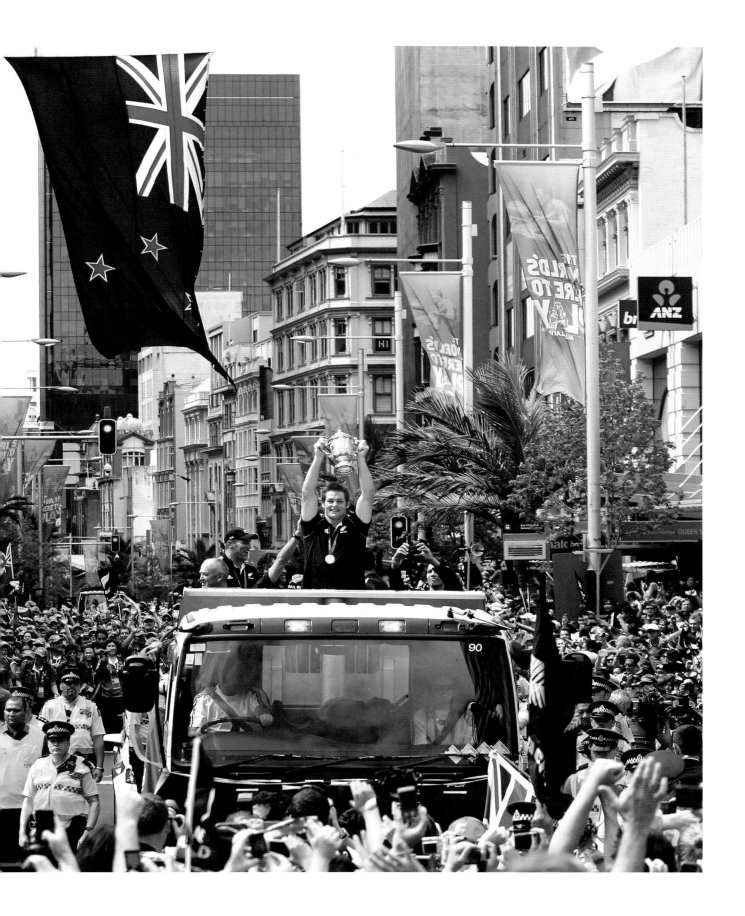

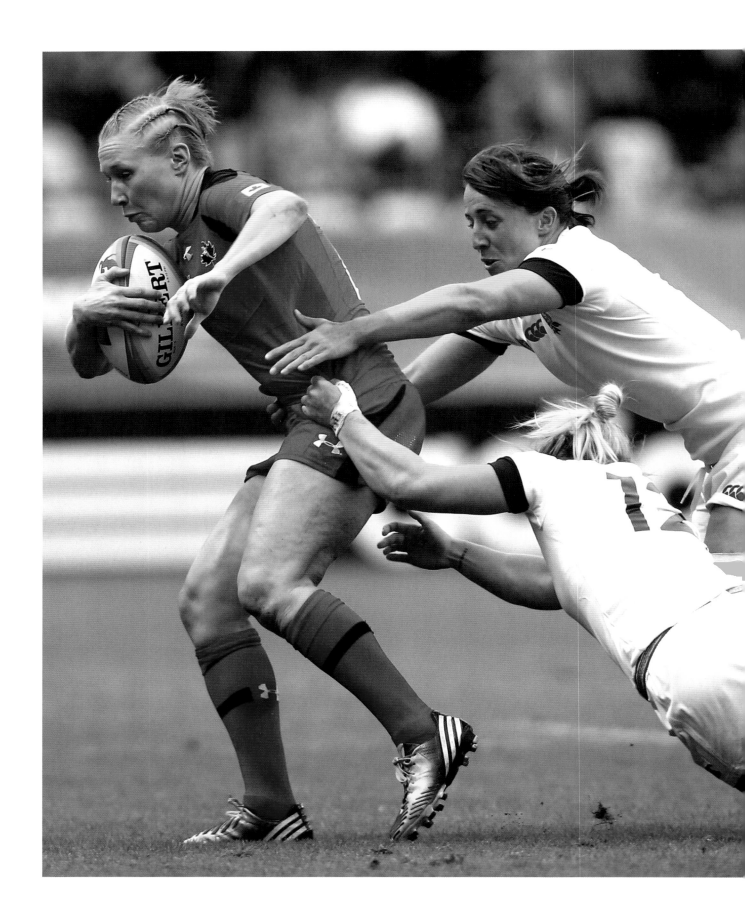

Dreams do come true

France 2014
England 21 Canada 9
17 August 2014
Stade Jean Bouin, Paris | Final

FROM DANIEL SCHOFIELD

It was a sometimes sensational, always tense final. It would be wrong to suggest this was a case of Goliath simply swatting David aside. England may have pedigree on their side but Canada, in their first final, had professionals on theirs. That, in the women's game, is crucial.

Whereas players such as Magali Harvey are full-time athletes, England's are all amateurs and will return to their jobs as plumbers, vets and lifeguards in the coming days. Some, such as Danielle Waterman, even quit their jobs to prepare for this tournament, living a hand-to-mouth existence.

"It's everything that I have probably ever dreamed of," Katy McLean, the inspirational captain, said. "You start tournaments like a World Cup and you dare to hope. Especially with how England have done in World Cups, you don't hope too much."

Katy McLean, England's captain, and Rachel Burford (12) combine to stop Canada's Mandy Marchak.

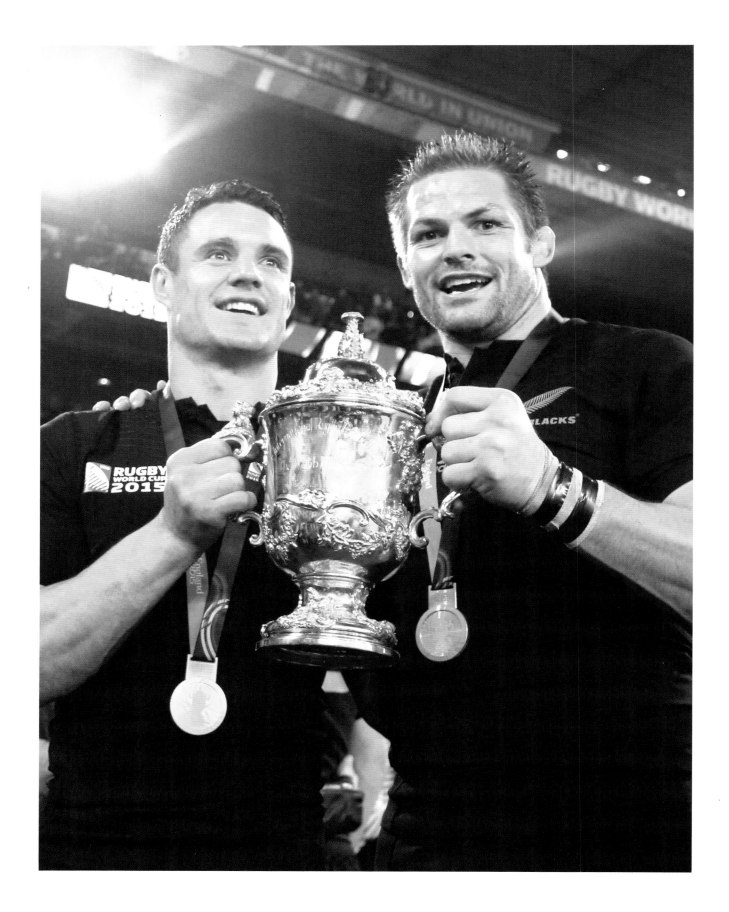

McCaw and Carter exit on a high

England 2015
New Zealand 34
Australia 17
31 October 2015
Twickenham, London | Final

BY STEVE JONES

Are New Zealand the greatest sporting team in the world, in any sport? Few in the capacity crowd of 80,125 at Twickenham yesterday, present for a magnificent World Cup final, would argue against that theory.

With their 34-17 win over an Australia team who resisted almost fanatically, New Zealand became the first team in World Cup history to retain their title as well as the first nation to win it three times. They have banished all memories of the grim years between 1987 and 2011 when they never won the world crown. Such was their brilliance last evening, it is hard to imagine them being beaten in Japan 2019.

The man of the match was the sublime Dan Carter, the fly half who had been off his game in the last few years. He ran the show like a master puppeteer, scoring 19 points including a remarkable drop goal from 41 metres. That steadied his team after the Wallabies had come charging back from 21-3 down to 21-17. [...]

New Zealand captain Richie McCaw lifted the Webb Ellis Cup at the end, receiving it from Prince Harry. "It is a hugely proud moment," he said. "We did not want to peter out and live off the glory of 2011. We gave ourselves the opportunity today and didn't want to let it slip...our performance was outstanding."

Dan Carter (left) and Richie McCaw close the door on their international careers.

Black Ferns win battle of giants

Ireland 2017

England 32
New Zealand 41

26 August 2017
Kingspan Stadium, Belfast
Final

OWEN SLOT, CHIEF RUGBY CORRESPONDENT

If you weren't swept up by the drama and spectacle of the Women's World Cup final, then you have no rugby in your veins. It was an epic: great rivalry, great contest, great drama, high levels of technique, emotionally taut, a loud, joyful crowd, really noisy, a festival feel with tears and medals at the finish.

Comparisons between the women's game and the men's are generally invidious, but here was one that immediately struck: as an entertainment, this was better than many a game you see in the Aviva Premiership. They said they wanted this final to be a showcase for the women's game and that is what they got.

Some declared afterwards that it may have been the greatest women's test match. We will allow time to have its say on that but you could not walk away from the Kingspan Stadium in Belfast on Saturday evening without wanting more, as in: why can't we have more of that?

Rival captains, Fiao'o Fa'amausili (New Zealand) and Sarah Hunter (England) and the winner's prize.

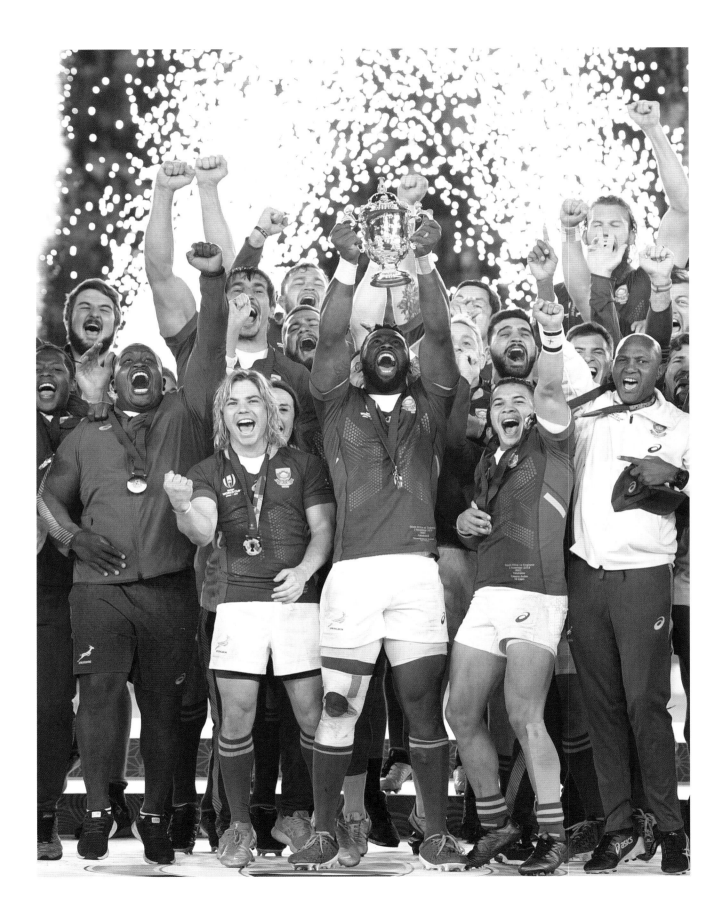

Springboks mine gold

Japan 2019
England 12 South Africa 32
2 November 2019
International Stadium, Yokohama
Final

FROM JANE FLANAGAN

STUART BARNES

South Africa thrives on pulling off miracles: only hours after its economy was barrelling towards being declared junk status by the international ratings agencies, it achieved rugby world supremacy.

The nation that appeared doomed to civil war a generation ago, as it weaved its way from white rule to racial equality, is once again on the brink. "On any given day South Africa can be both the best and the worst place on earth to live," Anthea Stephens, 44, said, clearing up from her 12-hour World Cup final party in Johannesburg. "We live life on a very wide band width – everywhere else is boring."

For a nation worn down by political corruption, rolling blackouts, poverty, record unemployment and 57 murders a day, the triumphant Springboks have provided a joyous distraction. Much more so even than in 1995, when Nelson Mandela wore a captain's shirt as a racially-skewed national side won its first Rugby World Cup, a year after all-race elections.

There was just one black player on the pitch in their side back then and millions in the newly-minted democracy were reluctant to match their leader's enthusiasm. This time round, all South Africans can see something familiar in a transformed XV: black players from the townships, hulking Afrikaners from the farms and those labelled by apartheid's architects as "coloured".

Siya Kolisi, South Africa's first black captain, celebrates victory.

As Siya Kolisi was preparing to lift the Webb Ellis Cup he appeared to be imploring his coach, Rassie Erasmus, to share centre stage for that magical moment. The first black captain of South Africa wanted, I think, to unite black and white in a way that the historical white Springbok insignia really does not deserve.

Whatever was spoken, Erasmus refused and the skipper stood there, a few seconds of even greater significance than Francois Pienaar's trophy lift in Johannesburg in 1995. Enormous credit must go to both men, the one for wishing to share the moment, the other for sending South Africa's first black captain on his own. It appeared to be a delightful and dignified display of unity.

Kolisi, the leader, proved himself every bit as important as the outstanding Duane Vermeulen, Faf de Klerk and Handré Pollard. Here was a brief glimpse of innate human decency in times that have become increasingly shrill, egotistical and selfish. Well done, coach and captain.

Black Ferns hang on

New Zealand 2021
New Zealand 34
England 31
12 November 2022
Eden Park, Auckland | Final

ELGAN ALDERMAN

Not even a 30-game unbeaten run and four years of million-pound investment could bring glory for the Red Roses on Saturday. They fought valiantly, equal partners in a brilliant contest, but Rugby World Cup finals involving New Zealand are a simple game: 30 women chase a ball for eighty minutes and, at the end, the Black Ferns win.

Five finals against New Zealand this century, five defeats for England. The big show focuses Kiwi minds. They have lost ten times to England in women's rugby but, even when they drift and fester, they always get their act together when a trophy is on offer. [...]

More than 42,000 fans were at Eden Park. England, down to 14 players after Lydia Thompson's 18th-minute red card, had a chance to win it with a lineout in the final play. They went for a telegraphed front ball and Joanah Ngan-Woo stole it from Abbie Ward. [...]

Ruahei Demant, New Zealand's captain, was player of the match but Stacey Fluhler was the patron saint of the highlights reel, duping Emily Scarratt for her own try and popping majestically to Ayesha Leti-I'iga for the match-winner. Fluhler hurt her ankle in the process, hobbling off with a smile so wide it started in Auckland and finished in London.

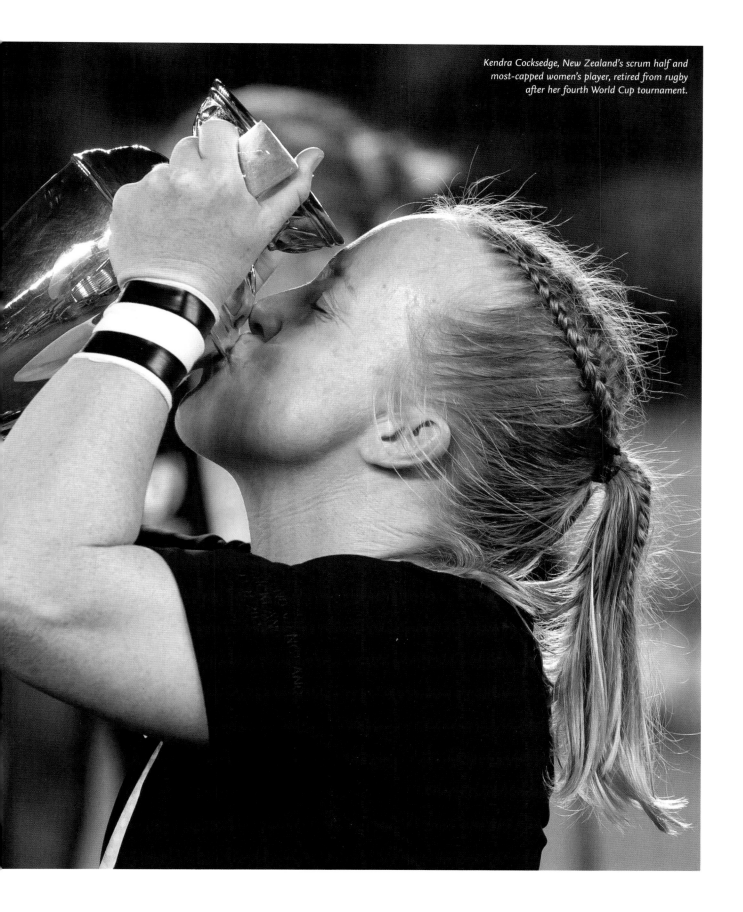

Kendra Cocksedge, New Zealand's scrum half and most-capped women's player, retired from rugby after her fourth World Cup tournament.

THE TRIES

John Kirwan

New Zealand and Australia 1987
New Zealand 70 Italy 6

22 May 1987
Eden Park, Auckland | Pool 3

New Zealand could not have made a more emphatic statement on the opening day of the inaugural World Cup. They passed fifty points for the first time in an international and showed every other team that they were primed and ready. The man who took them past fifty was John Kirwan, the long-limbed Auckland wing who, after retirement from playing, included Italy among his coaching appointments.

The Italians were already a well-beaten side by the time they restarted the match – yet again – and David Kirk caught the ball deep in his own 22. He passed to Grant Fox and the fly half found Kirwan snorting up to his left. At that stage the wing was some 90 metres away from Italy's try line but he swerved off his left foot past the first three tacklers, eluded a vain grasp at his shirt collar and simply outpaced the despairing defence to finish.

It was, the television commentator declared, "a try they'll never forget at Eden Park" and more than thirty years later it remains one of the most instantly recalled tries of the tournament.

DAVID HANDS

John Kirwan on his way to two tries against the hapless Italians.

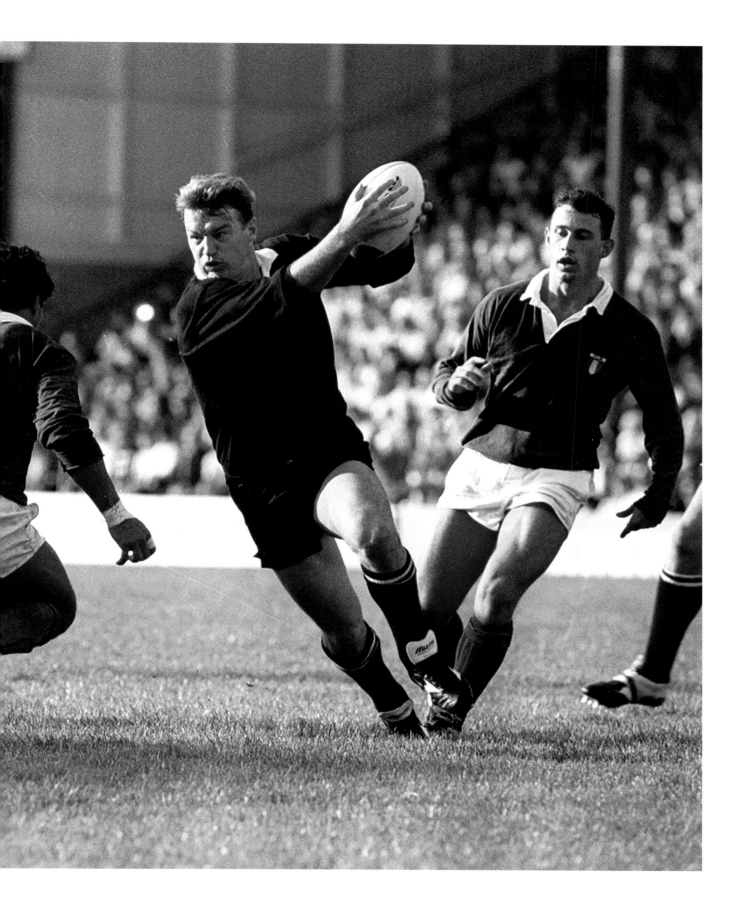

Serge Blanco

New Zealand and Australia 1987
Australia 24 France 30
13 June 1987
Concord Oval, Sydney
Semi-final

This was a wonderful finale to a wonderful game watched by a miserable crowd of around 18,000 out in Sydney's western suburbs. Today the video referee would have been hard at work, assessing whether Serge Blanco's initial pass to Patrice Lagisquet – which started the whole 11-pass move off just outside France's 22 – was forward, or whether there had been a little fumble from Laurent Rodriguez, the No 8, before he provided Blanco with the scoring pass.

Back then Brian Anderson, the Scottish referee, called it as he saw it and France, forwards and backs, chimed in. Lagisquet's kick ahead might have been cleared up by David Campese but wasn't, Pascal Ondarts, the prop, picked up a loose ball off his toes, Denis Charvet made a penetrating run down the right, Michael Lynagh saw another loose ball snatched away from him and Lagisquet, again, beat two men before Rodriguez and, finally, Blanco, who beat the desperately covering Tommy Lawton into the corner.

DAVID HANDS

Serge Blanco scores the try that breaks Australian hearts.

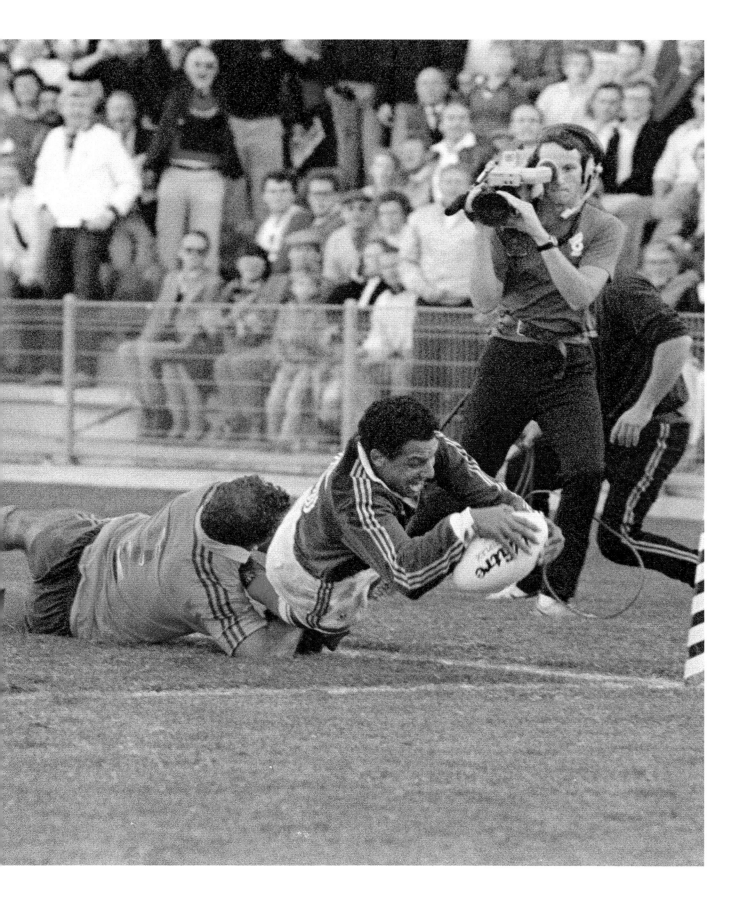

To'o Vaega

Britain, Ireland and France 1991

Wales 13
Western Samoa 16

6 October 1991
Cardiff Arms Park, Cardiff
Pool 3

BY GERALD DAVIES

Those with their hearts firmly on their sleeves will rue the decision 35 seconds after the interval by the French referee, Patrick Robin, in allowing Western Samoa's first try, scored by Vaega.

As the wing kicked ahead and chased with Robert Jones for the touchdown, the Welsh scrum half got to the ball first. Robin was unsighted but awarded the score instead of what rightly should have been a Welsh drop-out on the 22-metre line.

Ieuan Evans, the Wales wing, said of the Samoans' first try: "I was only three yards away and Robert [Jones] clearly put his hands on the ball first. The referee was back on the 25 but we have to abide by his decision."

By a fingernail – To'o Vaega, the Samoa centre (left), dives with Robert Jones for the controversial touchdown.

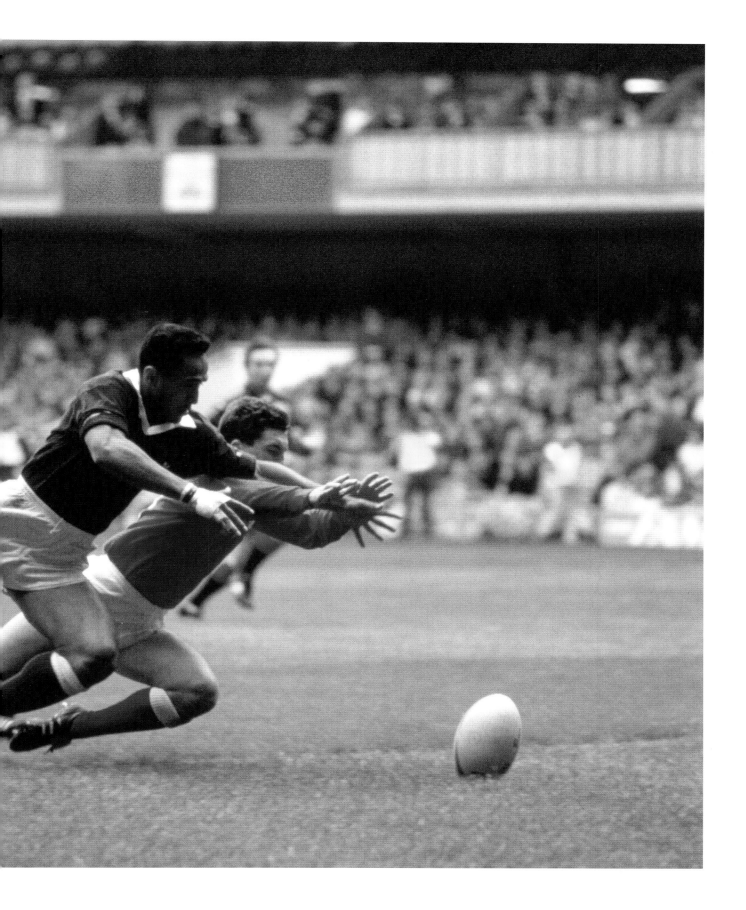

Gordon Hamilton

Britain, Ireland and France 1991
Ireland 18 Australia 19
20 October 1991
Lansdowne Road, Dublin
Quarter-final

Gordon Hamilton, the NIFC flanker, won only ten caps in a relatively brief international career, but his one test try will always be remembered. It was the try that might have removed Australia, the eventual winners, from the tournament but for the resourcefulness the Wallabies showed week in, week out.

With Australia leading 15-12, Ireland moved the ball from a scrum in their own half. Jim Staples, the full back, kicked into the opposition half and Jack Clarke, the wing, picked up to find Hamilton steaming up in support. There were still nearly forty metres to go with David Campese in hot pursuit but Hamilton, knees pumping, had the speed and impetus to cross through Rob Egerton's covering tackle.

The conversion by Ralph Keyes gave Ireland a three-point lead but five minutes remained on the clock, and that was time enough for Australia.

DAVID HANDS

Gordon Hamilton sprints for the line to snatch the lead for Ireland.

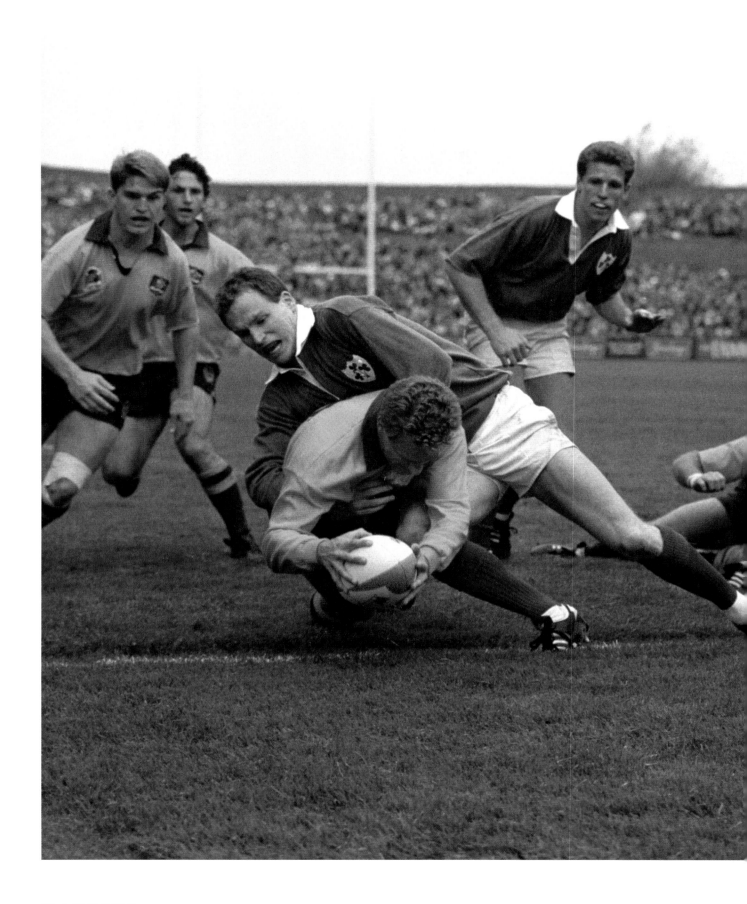

Michael Lynagh

Britain, Ireland and France 1991
Ireland 18 Australia 19
20 October 1991 | Lansdowne
Road, Dublin | Quarter-final

Michael Lynagh played for Australia in three World Cups, those of 1987, 1991 and 1995. First capped against Fiji in 1984 at the age of 20, he retired from the international game after captaining the Wallabies in the 1995 tournament, having won 72 caps — mostly at fly half, a handful of early appearances at centre — and scored 911 points, then a world record. After the game went professional he played for Saracens and made his home in London. Here he recalls the highlights of his career.

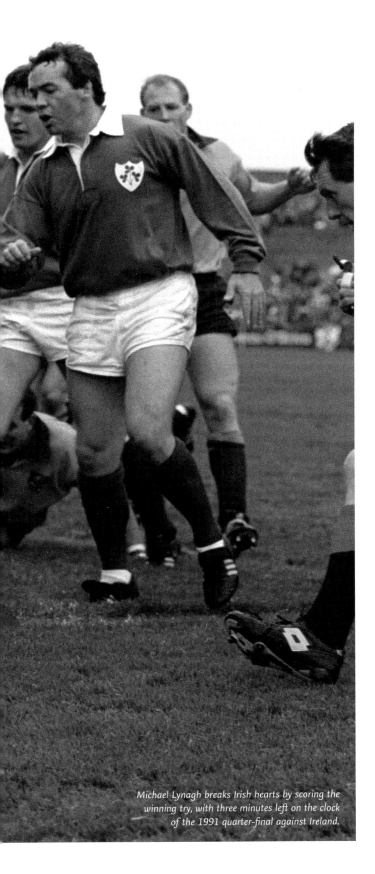

Michael Lynagh breaks Irish hearts by scoring the winning try, with three minutes left on the clock of the 1991 quarter-final against Ireland.

When we left Australia for the 1991 tournament, it seemed like a case of 'good luck boys, see ya.' I don't think either we or the public thought we were anything resembling favourites to win and we hadn't had a particularly good four years since going out of the 1987 World Cup.

On our arrival in the UK, it also seemed a bit like 1987 in that the teams were located all over the place. There wasn't the planning that we see these days. In 1987, most of the games were in New Zealand and although the Wallabies were on home soil, when we were based in Sydney the New South Wales contingent could go to work and go home while the Queenslanders sat around the Camperdown Travelodge with too much down time.

It was a curious atmosphere and, when we lost to France in the semi-final — and what a game that was — we thought that was it, we could pack up and go home until John Breen, our manager, told us to have our bags ready to catch the 7am flight to Rotorua and the bronze-medal game with Wales. That made the low point of losing the semi-final even lower!

But in 1991 we had a good balance of experience and enthusiastic youngsters in the squad, it was a happy team with a lot of leadership available and good

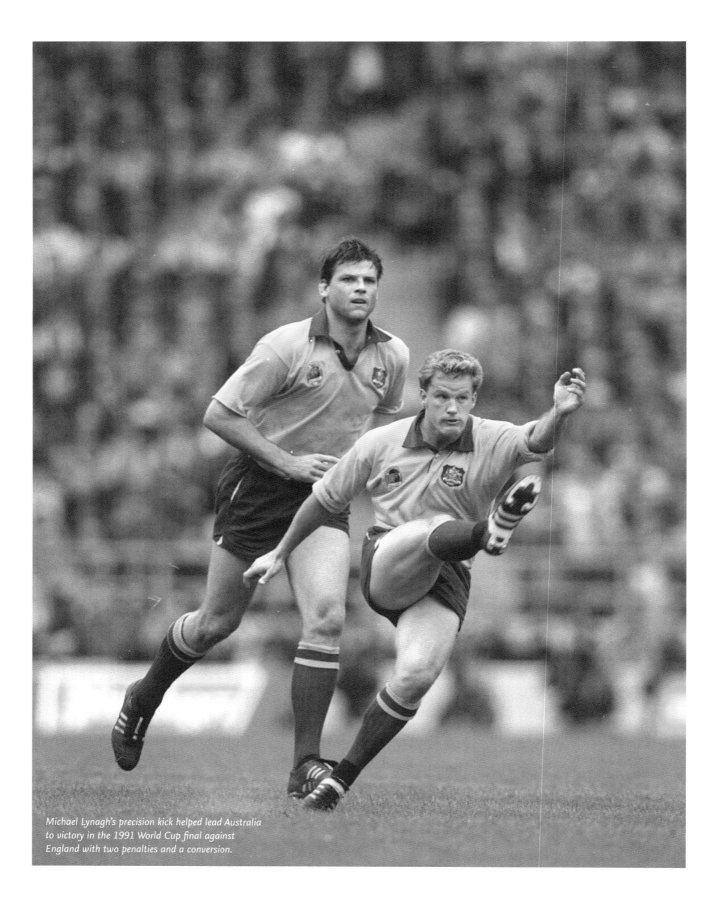

Michael Lynagh's precision kick helped lead Australia to victory in the 1991 World Cup final against England with two penalties and a conversion.

decision-makers on the pitch. We were pretty fit and fortunate with injuries. Nobody sat around poring over the draw, we took each game as a test match to be won, as would have been the case on a normal tour in the amateur days. The World Cup had not yet become the be-all and end-all whereas now it seems almost acceptable to lose international matches during the four-year cycle so long as you come good at the World Cup.

We didn't set the world on fire initially, struggling against Argentina and Western Samoa. The day we played the Samoans at Pontypool it was so wet I don't think the game would have been played today. But then we started to hit our straps against Wales [Australia won 38-3] and, in the quarter-final with Ireland, we felt pretty comfortable.

Nick Farr-Jones, our captain, had to leave the field and I took over the captaincy; a couple of tries were disallowed for small errors but Ireland were still there and, all of a sudden, Gordon Hamilton scores the try that gave them the lead. Cue mayhem and a pitch invasion. My first thought was to find out from the referee, Jim Fleming, how much time was left and I was told four minutes.

This was the time to pass a confident message to the team and I was certain about what we had to do: kick long, force them to give us a lineout and let our backs look after the rest. The move involved David Campese cutting back against the grain, inside Tim Horan, and if he was tackled, he was close to the forwards and we would get the scrum. Tim was for a drop goal but we had worked on a move during the week involving Marty Roebuck from full back and Jason Little looping.

Brendan Mullin, the Ireland centre, grabbed Jason but Campo was in support and my role was always to support the ball carrier on his inside. Campo was tackled a metre short but he rolled the ball back, I picked up and that was it. That, for me, was the best moment of the tournament because the whole team bought into the plan just when we needed something special.

The result gave us a lot of confidence going into the semi-final against New Zealand, which was also in Dublin, and the first half of that game was probably the best period of playing during my whole involvement with Australia. Both our tries were off the cuff, people

on the field reading the situation and reacting. Before the first, I think New Zealand were more concerned about covering the outside backs and when I took the ball up, Campo appeared off his wing and just kept going all the way to the line.

We had a centre-field scrum before the second try and I was going to run right and kick left. But I saw space on the right, chip-kicked, the ball sat up for Campo and he made the miraculous pass that put Tim through. Tim was such a great communicator on the field that Campo would have been in no doubt where he was the whole time.

That took us to the final with England at Twickenham but we'd beaten them well on their summer tour that year and we simply weren't going to let this opportunity pass us by. There might have been a few barbs in the build-up before the game but I don't think we had any influence on the way England played, going away from the set-piece game that had served them so well. It was a tight game, we had to work hard in defence but we came out on the right side.

Four years later, England got their revenge but we weren't that far away. If 1991 was Campo's tournament, 1995 was Jonah Lomu's – you just give players like that the ball and let them show their match-winning qualities. But the way we prepared changed. Bob Dwyer, our coach in both tournaments, wanted to take our preparations to another level. We'd a good record over the previous three years (though both Tim and Jason had picked up bad injuries in 1994) and I don't think we as players were ready to go up another level.

Professional players now would have no problem with the degree of involvement Bob wanted but, back then, it was still regarded as unusual. The first game, against South Africa, was a huge occasion – the first World Cup appearance of the Springboks [they did not participate in 1987 and 1991], the involvement of Nelson Mandela after the death of apartheid, the crowd desperate for success in a sport which is so much a part of the country's history.

As it turned out, we lost to the ultimate winners and, in the quarter-finals, to England in a match that could have gone either way. Even if we'd won, I don't think we would have got past New Zealand. Neither us, nor England, were quite good enough that year.

MICHAEL LYNAGH

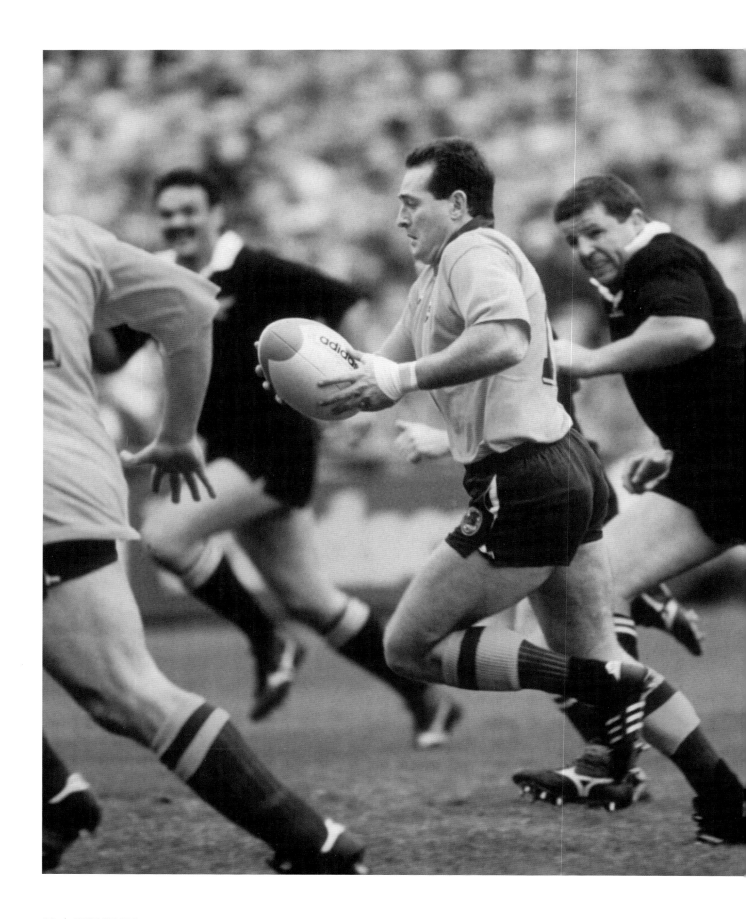

David Campese

Britain, Ireland and France 1991
Australia 16
New Zealand 6
27 October 1991
Lansdowne Road, Dublin
Semi-final

FROM DAVID HANDS, RUGBY CORRESPONDENT

Then there was Campese. The great entertainer, who tormented New Zealand when first he played against them in 1982, turned the knife once more in what seems likely to be his last appearance against them.

He scored the opening try, he sent in Horan for the second and reduced Timu, who might have been better used at full back with Tuigamala on the wing, to impotence. Campese's try, with only seven minutes gone, was the result of Lynagh's midfield break and the wing's appearance in the stand-off half position.

His diagonal run created so much doubt among defenders that he could ignore his support to reach the corner. The same combination accounted for Horan's try after Lynagh had kicked a penalty. The stand-off half chipped delicately, Campese gathered the ball and lured Timu towards him before flipping a no-look pass to Horan on the outside.

David Campese, vainly pursued by New Zealand's Sean Fitzpatrick, heads for the corner and a try.

Jonah Lomu

South Africa 1995
New Zealand 43
Ireland 19

27 May 1995
Ellis Park, Johannesburg
Pool C

FROM JOHN HOPKINS

Glen Osborne, Andrew Mehrtens and Jonah Lomu won this game for their country on Saturday, scoring 33 points between them. These three men, whose ages total 66, must have gladdened the hearts of Colin Meads and Brian Lochore, those two older New Zealanders who sat stony-faced in the stands in their black blazers and white shirts, and who are master-minding their country's attempt to win a second World Cup. [...]

It was Lomu, 20 and playing only his third game for his country, who stole the show. His running in attack was frightening in its ferocity, and more than compensated for poor and naive defence. There is not another player in rugby union who combines such strength and speed in attack.

This quietly-spoken and polite executioner weighs over 18 stone. His lower torso and massive thighs are the source of his power. Nobody who saw it will forget the 80-yard run he made from deep in his own half to set up a try for Josh Kronfeld midway through the second half. Brendan Mullin, Denis McBride, Jonathan Bell and Maurice Field all tackled him, and all were brushed aside. [...]

What would Ireland do if they had to face Lomu again? "We'd get a shotgun for him," Terry Kingston, the captain, said. As so often, Ireland were left to sing their hearts out over another defeat that won them many friends but too few points.

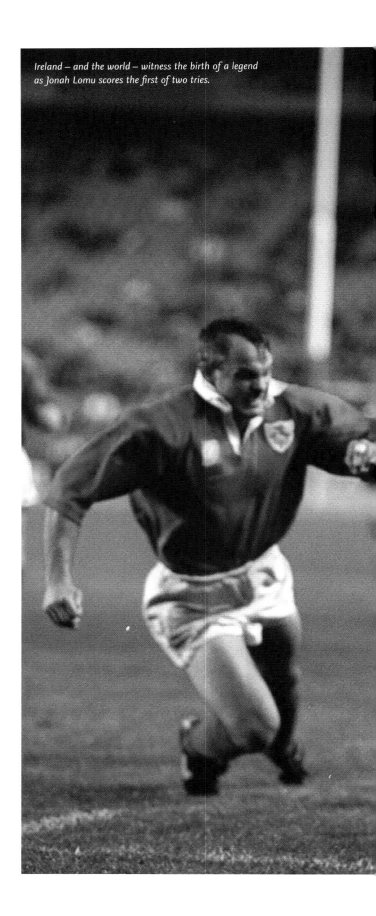

Ireland — and the world — witness the birth of a legend as Jonah Lomu scores the first of two tries.

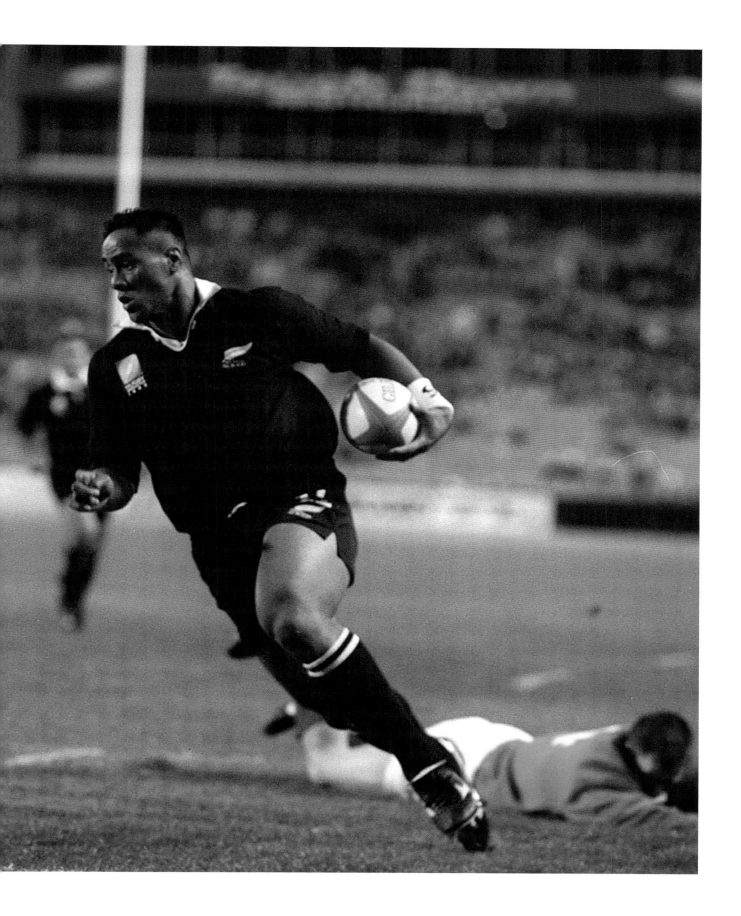

Chester Williams

South Africa 1995

South Africa 42
Western Samoa 14

10 June 1995
Ellis Park, Johannesburg
Quarter-final

FROM DAVID MILLER

The new, equal, multiracial South Africa needs non-white national sporting heroes: their own Owens, Ali or Pelé. The black majority, only marginally familiar with rugby union, thought that they had found one in Chester Williams, the electrifying winger from Paarl, near Cape Town. Now, they know that they have.

Williams, who is so reticent and unassuming that you wonder how he plays this violent game, stepped back into the World Cup spotlight after voluntary withdrawal through injury. South Africa, black and white, prayed he would do well. He did more than that, he wrote a page in history.

His four tries against Western Samoa, in the quarter-final at Ellis Park, Johannesburg, on Saturday, came at regular intervals. There were moments, against these sturdy South Pacific islanders, when he seemed blessed with wings. When you look at his slender legs, his brilliance is almost unnatural.

There was an especially poignant moment, encapsulating the slogan "One team, one country" immediately after his third try. As Williams walked back to the halfway line, eyes down in modesty, the massive Kobus Wiese, the lock so symptomatic of the white Springbok past, lumbered across to extend the handshake of approval.

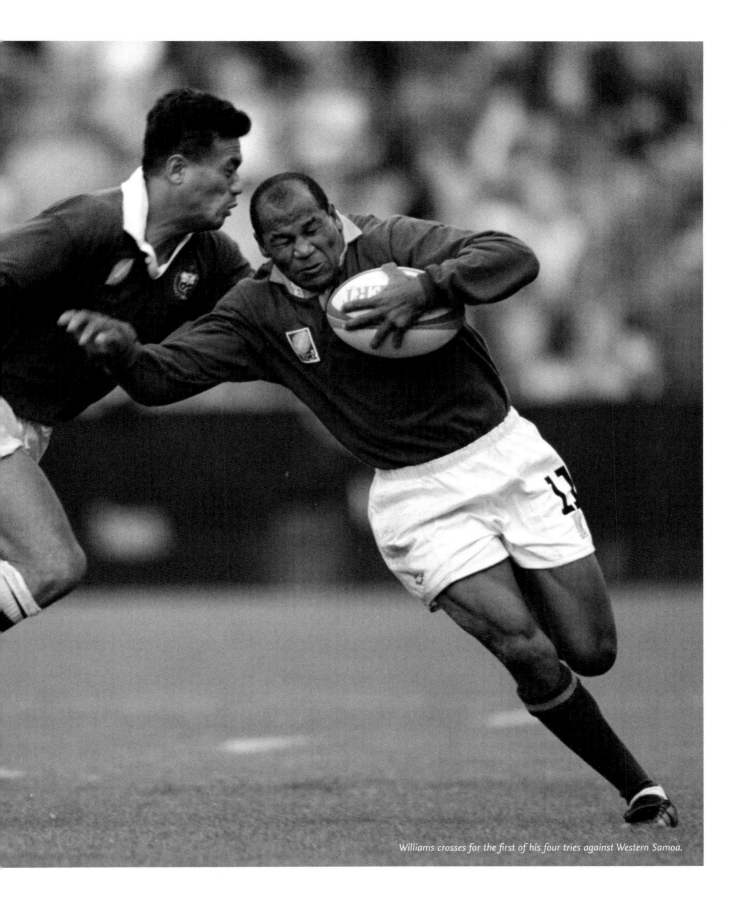

Williams crosses for the first of his four tries against Western Samoa.

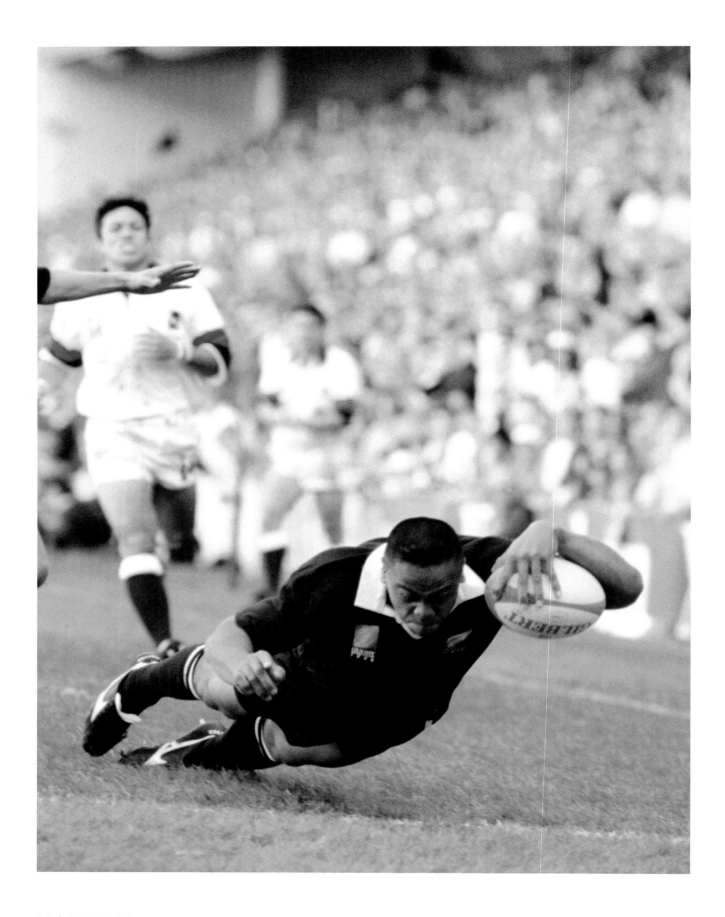

Jonah Lomu

South Africa 1995
New Zealand 45
England 29
18 June 1995
Newlands, Cape Town
Semi-final

FROM DAVID HANDS, RUGBY CORRESPONDENT

And when they awoke from the nightmare, England found it was all true. Yesterday, at Newlands, where a week earlier they had sent the 1991 champions, Australia, packing from the Rugby World Cup, they conceded everything but pride to a New Zealand side that will return to the high veld of Transvaal on Saturday to contest the 1995 final with South Africa.

Never before have England conceded 45 points, but nor have they come up against the monstrous behemoth that is Jonah Lomu. The 18-stone wing scored four of New Zealand's six tries and not one England defender was able to lay a hand on him; whatever price the newly-rich rugby league scouts placed on his head before the weekend, they can double it now.

Nor should England pretend that the 16-point margin represents the true difference between the teams. They were out-thought, outrun, outmuscled and, if New Zealand had been playing the final, they would surely have focused far more intently during the last quarter when England scored their four tries. [...]

The game had gone way beyond them by then, starting from the moment New Zealand kicked off away from their forwards and towards Lomu's wing, where Tony Underwood and Carling collided. Having seized the tactical and territorial initiative, the All Blacks seldom relinquished it. Within three minutes, Bachop's long pass had found Lomu and the wing's hand-off disposed of Underwood, his deceptive pace dealt with Carling and his sheer strength overwhelmed Catt.

Jonah Lomu has burst past Tony Underwood (background) and run through Mike Catt for the first of his four tries.

Keith Wood

Britain, Ireland and France 1999

Ireland 53 USA 8

2 October 1999
Lansdowne Road, Dublin
Pool E

FROM MARK BALDWIN

Two bald statistics stood out from Ireland's efficient, unflashy defeat of the United States on Saturday evening – the four tries claimed by the irrepressible Keith Wood and the four times the Ireland wings were given the ball.

It was supremely ironic that Wood's final touchdown, giving him a record number of tries for a hooker in an international, should have come as a result of loitering out on the right wing.

Eric Elwood, the replacement fly half, chipped delicately behind Brian Hightower and Wood accelerated past the wing to collect the bouncing ball and dive over to wild cheers. Justin Bishop and Matt Mostyn [Ireland's wings] must have wondered what it was all about.

Keith Wood smiles on his way to a record for a hooker.

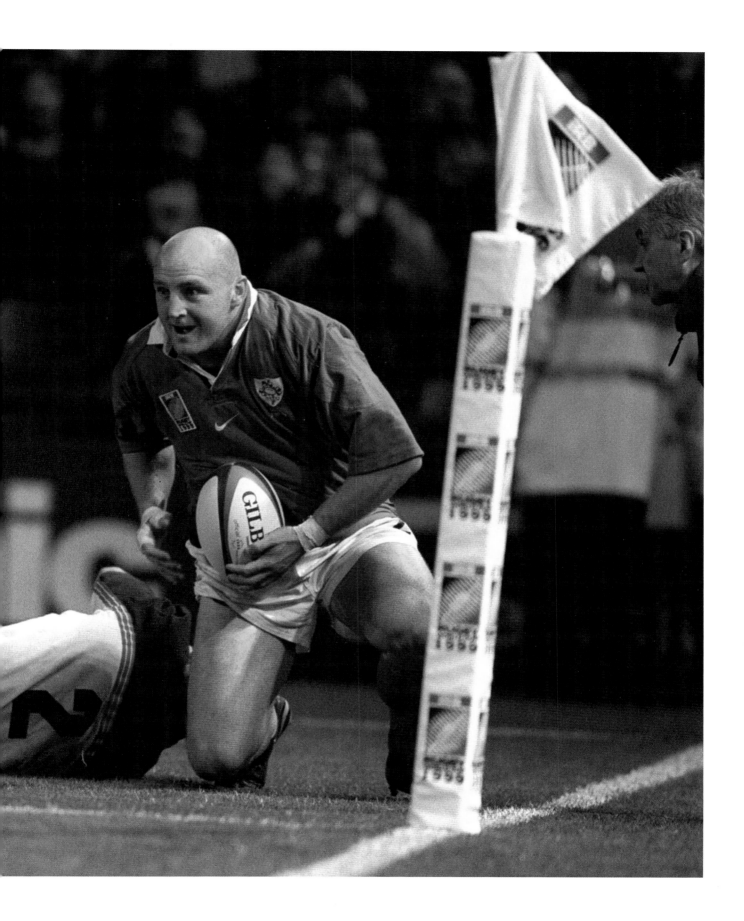

Stephen Bachop

Britain, Ireland and France 1999

Wales 31 Samoa 38

14 October 1999
Millennium Stadium, Cardiff
Pool D

BY JOHN HOPKINS

The game that will live for ever in Samoa's rugby history contained two breakaway tries, one by Stephen Bachop from near halfway and the other by Pat Lam, their inspirational captain, from 80 yards. [...]

It was the two tries by Bachop, both converted by Silao Leaega, that hurt Wales most, taking Samoa from 18-10 behind to 24-18 ahead. The first was well constructed and involved Leaega and Bachop before the fly half slashed inwards to score under the posts.

The second was Bachop's interception of a pass from Scott Quinnell. Though Jenkins kicked his third penalty of the half to narrow the deficit, the writing was on the wall for Wales.

Stephen Bachop, Samoa's fly half, runs in the try that puts Wales on the road to defeat.

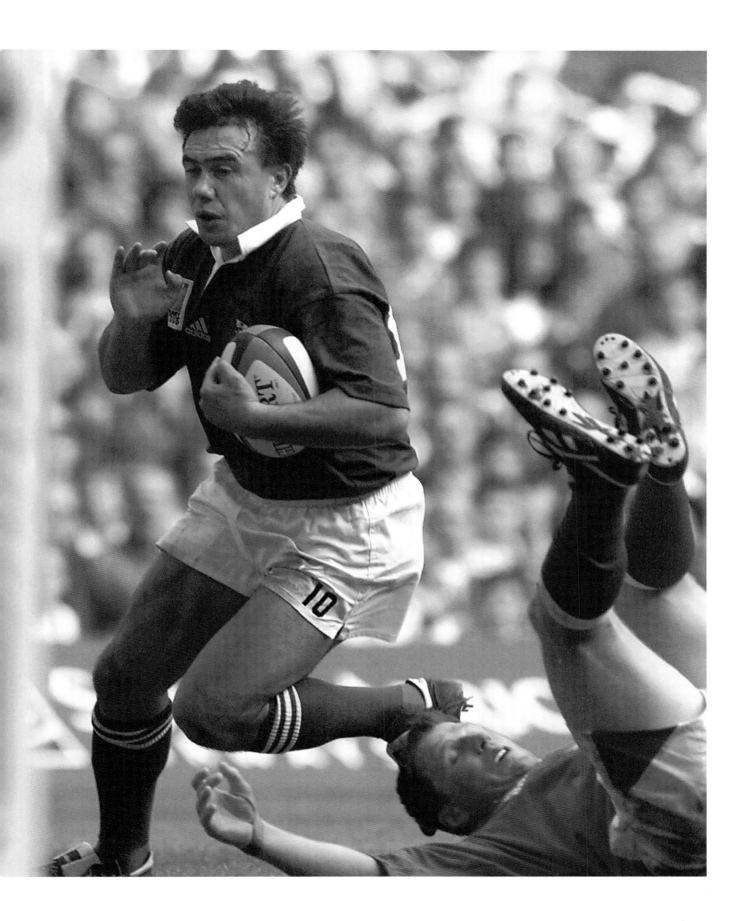

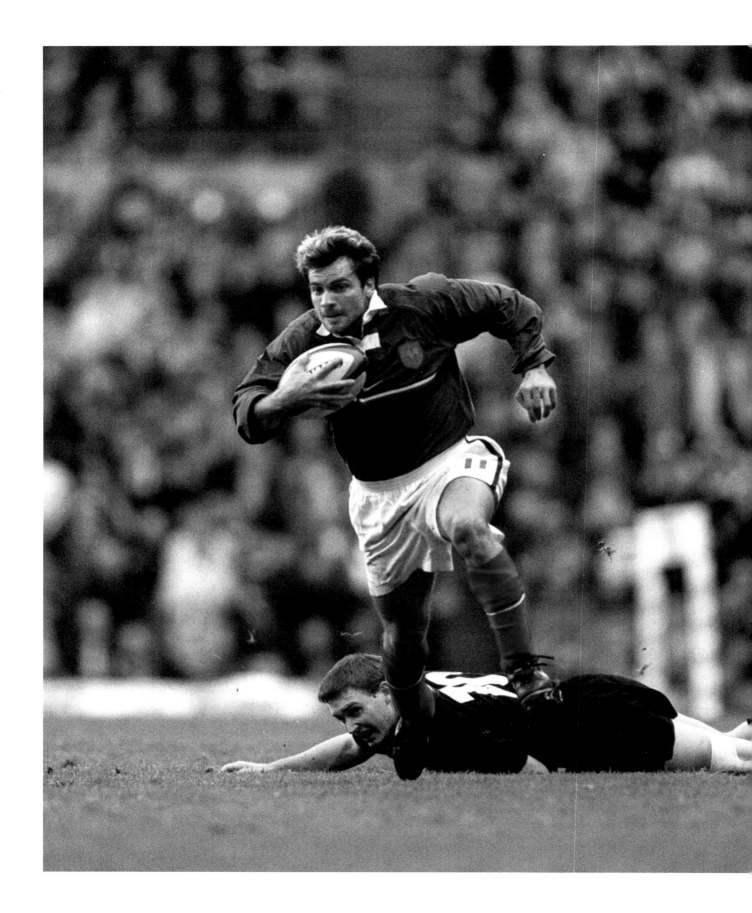

Christophe Dominici

Britain, Ireland and France 1999

France 43
New Zealand 31

31 October 1999
Twickenham, London
Semi-final

BY DAVID HANDS, RUGBY CORRESPONDENT

If one man inspired them it was Christophe Dominici. This was meant to be a match in which, once more, Jonah Lomu would roll over northern-hemisphere opponents and, with two tries, the big man did not disappoint.

But Dominici more than matched him for courage and skill; it was he who created the position which brought France that crucial, morale-boosting early try by Lamaison, he who suddenly asked questions of New Zealand's short-side defence, he who scored the try which served notice to the All Blacks that their path to the final was not guaranteed. [...]

The gap having narrowed to two points, Wilson suffered a moment of madness. Instead of heading for the left flank and Lomu, the full back checked and turned back into the arms of the France forwards; he lost the ball and Galthié sent a high ball spiralling towards the left wing. Dominici leapt above the defence and made 40 metres to the line for the try.

Christophe Dominici leaves Andrew Mehrtens stranded as he runs in his try.

Brian Lima

Australia 2003
Samoa 60 Uruguay 13

15 October 2003
Subiaco Oval, Perth | Pool C

FROM DAVID HANDS, RUGBY CORRESPONDENT

Against the stronger nations, Samoa will struggle for ball. They have worked hard on strengthening their pack but their greatest threat still comes when they run the ball wide with their rangy forwards coming in behind, as Maurie Fa'asavalu did so effectively to score two first-half tries. His efforts were matched by Brian Lima, whose career now encompasses four World Cups and periods in New Zealand, Wales, France and now Japan. [...]

The contest was effectively over by the interval, which accounts for some subsequent lacklustre play by Samoa before they roused themselves to score two tries deep into injury time. Lima's first try crowned a sweeping move that ran left then right and involved nearly all the team before Opeta Palepoi gave his centre the scoring pass. His second owed much to the supporting angle of his run after Terry Fanolua had broken the Uruguay defensive line.

Samoa's Brian Lima on the way to two tries against Uruguay.

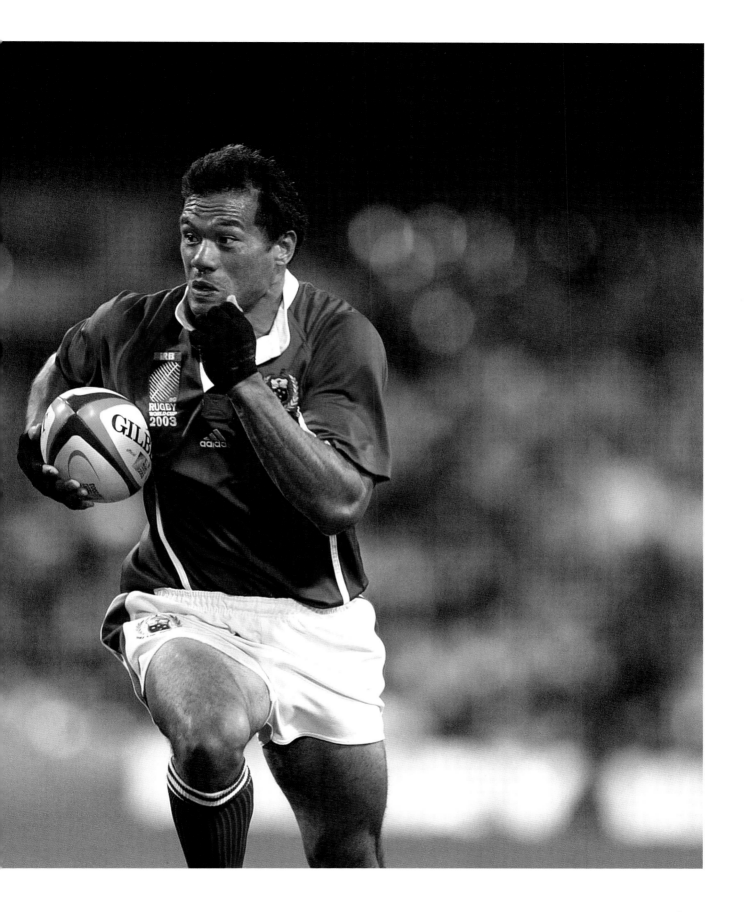

Shane Williams

Australia 2003
New Zealand 53 Wales 37
2 November 2003
Telstra Stadium, Sydney
Pool D

FROM DAVID HANDS AND OWEN SLOT

The clash of the hemispheres in Australia over the weekend lifted the fifth Rugby World Cup to new heights, though without much input from England. Instead, their Celtic cousins threw down the gauntlet in two games of marvellous diversity, Ireland taking the host nation and holders of the Webb Ellis Cup to the limit and Wales, with as lustrous a performance as they have given in years, handing the much-fancied New Zealand team the shock of their lives in Sydney yesterday.

Suddenly, England's expected smooth procession into the last four is littered with Welsh potholes. John Mitchell, the All Blacks coach, had said that the tournament was about to warm up but he may not have believed that Wales would apply the blowtorch. "We were in need of a test like this," Mitchell said, although no-one thought that they would get it from a team that lacked at least five of its best players.

Yet, in the best contest so far, Wales scored four tries to come from behind at the Telstra Stadium and lead New Zealand – to whom they lost by 52 points in Hamilton four months ago – midway through the second half. Wales have never scored more than 17 points against the All Blacks in any of the previous 19 games between the countries and New Zealand have only twice conceded more points in their history, so the final scoreline of 53-37 spoke volumes.

Here were teams whose one wish was to play rugby as they believe it should be played, encouraged to do so by André Watson, the referee. Wales, resolutely refusing to kick ball away, received inspiration from one almost forgotten player, Shane Williams, and another virtual unknown, Jonathan Thomas.

Six minutes into the second half, Wales were in the lead. Ceri Sweeney broke into open field, Charvis appeared at his elbow, made ground deep into New Zealand's 22 and, from a ruck ten metres out, an overhead pass by Gareth Thomas gave the deserving Williams his try.

Shane Williams touches down against New Zealand.

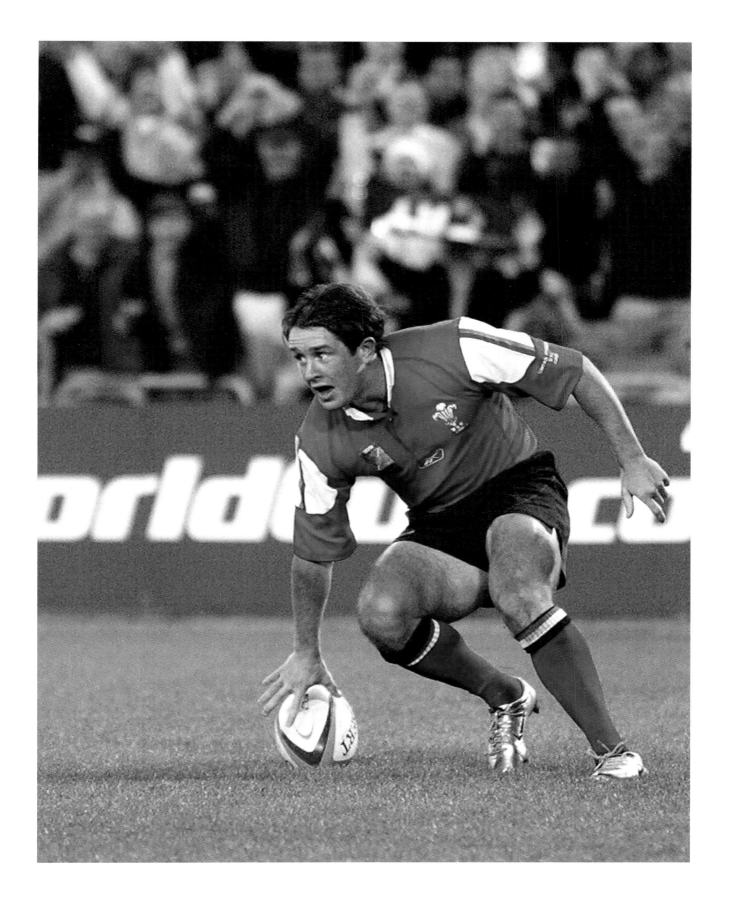

Stirling Mortlock

Australia 2003
Australia 22
New Zealand 10
15 November 2003
Telstra Stadium, Sydney
Semi-final

FROM DAVID HANDS

Australia isolated Carlos Spencer by cutting down his neighbours, Justin Marshall and Aaron Mauger, and sending the powerful Stirling Mortlock surging through Leon MacDonald, the makeshift centre. [...]

There has been talk of espionage throughout this World Cup, but New Zealand could have been forgiven for believing that Australia had attended their team meetings, so perceptive was their judgement of play. Jerry Collins punched his way through the first line a couple of times but the No 8's game declined into immaturity for which he was duly penalised, leaving only the remarkable Richie McCaw to play to his reputation in a side thrown back on its heels.

It is in such conditions that tries such as Mortlock's occur. New Zealand established an attacking lineout in Australia's 22 and Spencer, running left, threw a pass cutting out two players. But Australia's defensive line had come up so quickly that Mortlock was able to intercept with a clear field ahead.

Stirling Mortlock sets off on the run that brought Australia their try.

Jason Robinson

Australia 2003
**Australia 17 England 20
(after extra time)**
22 November 2003
Telstra Stadium, Sydney | Final

BY STEPHEN JONES

England came stronger and stronger. Jonny Wilkinson kicked two penalties to give them the lead, and they should have pulled clear. But Lote Tuqiri managed to scramble back to deny Josh Lewsey, and then came a horrendous England moment. Martin Johnson and Richard Hill drove the ball on as Australia quailed under pressure, Lewsey and Matt Dawson moved it right and Ben Kay dropped a scoring pass with the Wallaby line yawning in front of him.

Yet Wilkinson kicked his third penalty and England cut Australia to pieces for their try. Dawson and Lawrence Dallaglio attacked, Dallaglio went speeding through, flipped a clever inside pass to Wilkinson and the No 10 sent Jason Robinson flying over in the corner. Deadly execution.

*Jason Robinson slides over as
Mat Rogers arrives too late.*

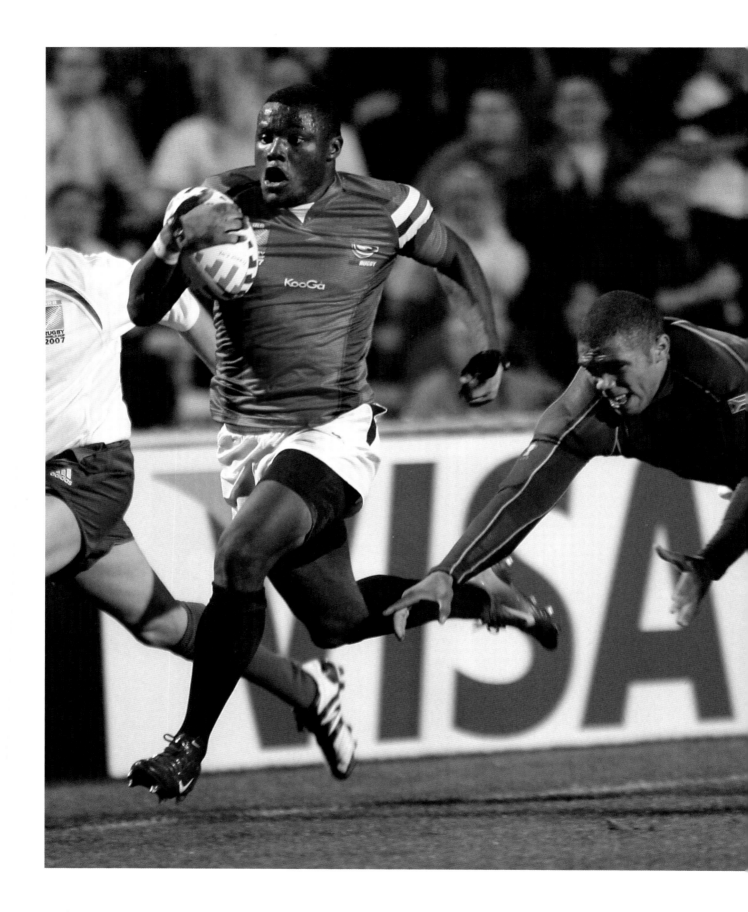

Takudzwa Ngwenya

France 2007
South Africa 64 USA 15
30 September 2007
Stade de la Mosson, Montpellier
Pool A

It was not supposed to be a contest nor, in overall match terms, was it. South Africa had already scored 24 points and were attacking their opponents' 22 late in the first half when Todd Clever, the American flanker, made the interception which began one of the tries of the tournament.

Clever's pass found Alec Parker, the lock, who fed Mike Hercus, and the fly half threw a long, looped pass to Takudzwa Ngwenya – Zee to his friends – on the right wing. Facing him was South Africa's speedster, Bryan Habana, but Ngwenya, with fifty metres still to go, swerved in then out and beat Habana for pace to score the try which was subsequently voted the try of the year by the International Rugby Board honours panel.

DAVID HANDS

'Zee' Ngwenya leaves Bryan Habana sprawling on his way to a wonderful try.

Thierry Dusautoir

France 2007

France 20

New Zealand 18

6 October 2007
Millennium Stadium, Cardiff
Quarter-final

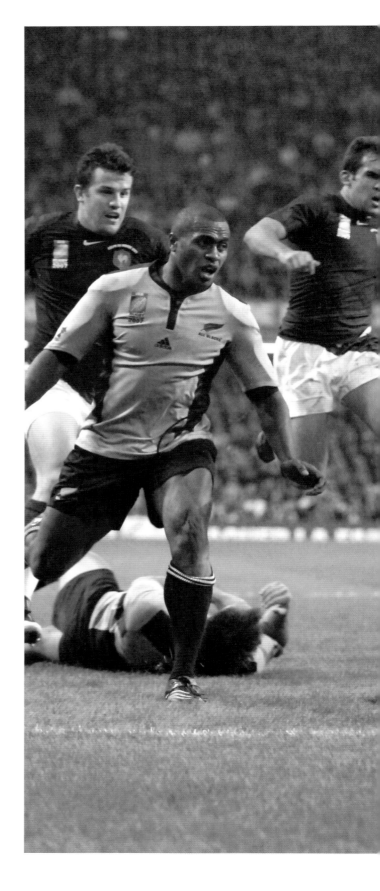

If any Frenchman deserved a try from this match it was Thierry Dusautoir. The flanker played the match of his life, his tackling blunting New Zealand's attack even when, in the first half, France's tactical approach was limited largely to kicking the ball and chasing.

Lionel Beauxis kicked a penalty just before the interval and another just after, when New Zealand's Luke McAlister was sent to the sin bin for a tackle off the ball. With a man advantage, France struck: Imanol Harinordoquy was held at one corner but, two phases later, Vincent Clerc sent Dusautoir through a hole to score and the great comeback had begun.

DAVID HANDS

*Thierry Dusautoir crosses for the try that
set New Zealand on the road to ruin.*

Sireli Bobo

France 2007
South Africa 37 Fiji 20
7 October 2007
Stade Vélodrome, Marseille
Quarter-final

Two favourites, New Zealand and Australia, had departed over the quarter-final weekend. Could Fiji provide a third in South Africa? Ultimately they could not but they shook the Springboks to their bootstraps, drawing level at 20-20 during the third quarter while Seru Rabeni was in the sin bin.

Running the ball ten metres from their own line, Norman Lagairi found space in midfield and though South Africa scrambled back on halfway, they could not stop Mosese Rauluni, Fiji's scrum half and captain, erupting into clear territory. He found his wing, Sireli Bobo, on his elbow and Bobo had the strength to finish in Fourie du Preez's covering tackle to complete what one commentator, breathless with hyperbole, described as the 'greatest five minutes in Fijian history'.

DAVID HANDS

Sireli Bobo grounds the ball as Fourie du Preez tries to get a hand under it.

Lucas Gonzalez Amorosino

New Zealand 2011
Argentina 13 Scotland 12
25 September 2011
Wellington Regional Stadium,
Wellington | Pool B

FROM LEWIS STUART

Scotland could, and should, have beaten Argentina after a towering performance from their forwards in the pouring Wellington rain had edged them 12-6 ahead with less than ten minutes to go. Instead, with the fervent Argentina fans roaring their team on, the Scots had one of those blips that they thought they had ironed out of their system.

A bungled restart, a needless penalty, Felipe Contepomi, the Argentina captain and centre, given time and space to run and then four players letting Lucas Gonzalez Amorosino slip through their grasp as he danced his way along the touchline like a tango master and skipped over the try line.

Contepomi had to slot the conversion, but everybody in the stadium knew what was coming. "I trusted the work I had done in practice," he said. "I hit it well and it went over."

Lucas Gonzalez Amorosino touches down for the try that broke Scotland.

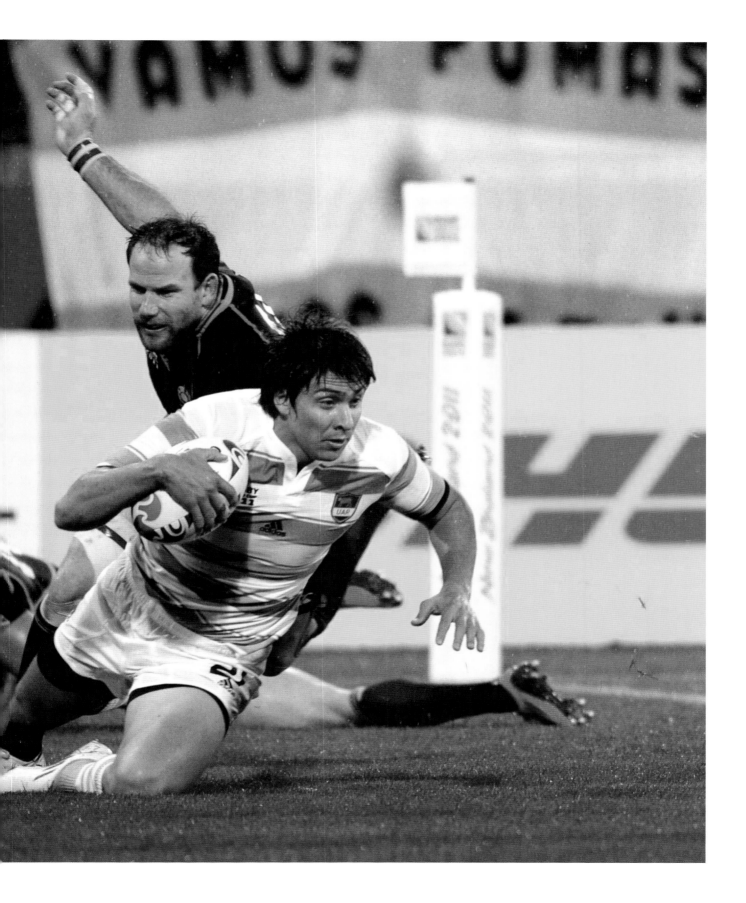

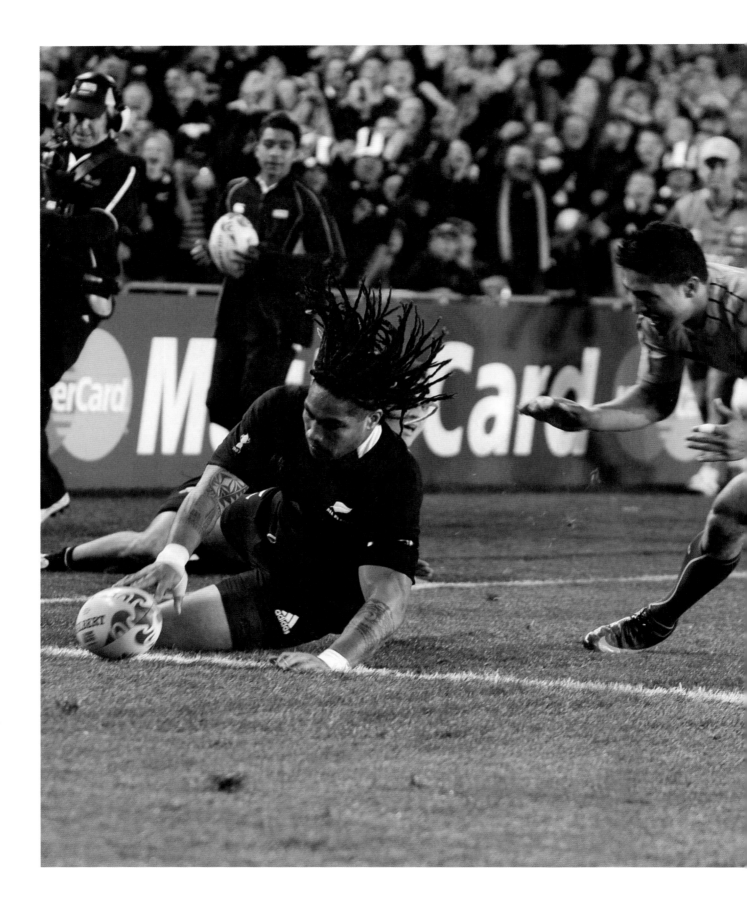

Ma'a Nonu

New Zealand 2011
New Zealand 20
Australia 6
16 October 2011
Eden Park, Auckland
Semi-final

FROM OWEN SLOT, CHIEF SPORTS CORRESPONDENT

The try itself was a piece of splendour. The ball came from a ruck left, Dagg ran an angle into the line, inside Pat McCabe and handing off Rocky Elsom, and when he was finally caught by Quade Cooper, he managed to absorb the tackle and simultaneously offload with his outside hand before rolling into touch. Ma'a Nonu gratefully claimed the pass and that was that.

Ma'a Nonu touches down for New Zealand's try.

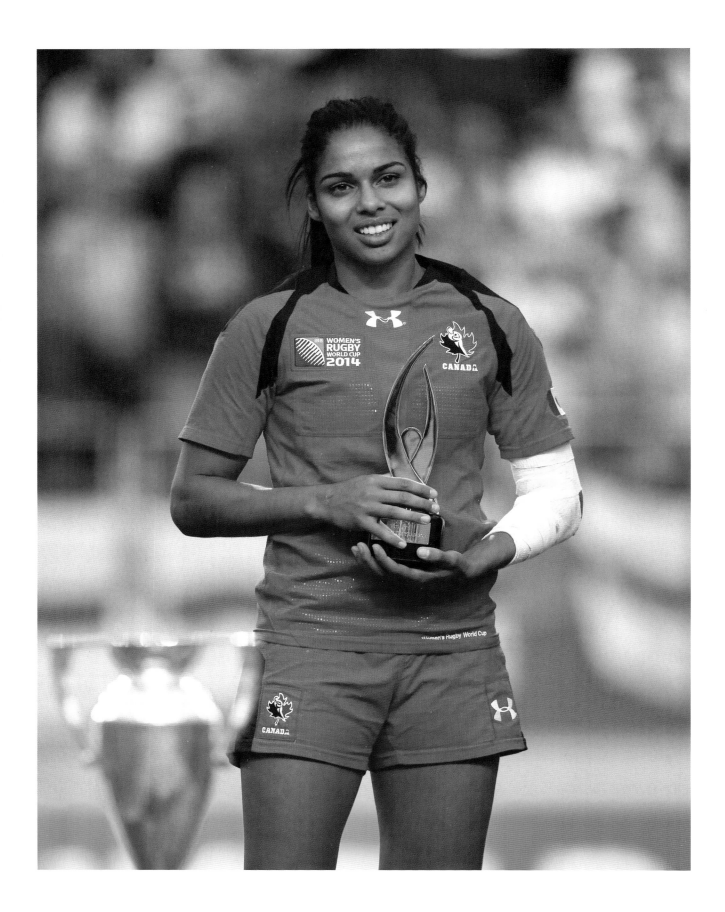

Magali Harvey

France 2014
France 16 Canada 18
13 August 2014
Stade Jean Bouin, Paris
Semi-final

Remarkably for a country with so long a history in the women's game, France have never reached a World Cup final and here, on their own turf, they were denied by a wonderful showing from Magali Harvey, the Canada right wing, who scored 13 of her side's 18 points. Three days before her 24th birthday Harvey, also her team's goalkicker, scored two penalties to keep a tight first half to 6-6. A try by Elissa Alarie, the full back, put Canadian noses in front before France, pressing hard, were given a five-metre scrum.

But Canada's pack wrecked the heel, the ball was whipped away by Alarie, and Harvey was given possession 85 metres from the French line. She had space to burn off her marker, then veered inside and out to leave France's full back stranded and had the pace to beat the covering tackle of France's right wing to score. The try helped Harvey to recognition later that year as the International Rugby Board's women's player of the year.

DAVID HANDS

Magali Harvey receiving the award for the International Rugby Board's Women's Player of the Year in 2014.

Emily Scarratt

France 2014
England 21 Canada 9
17 August 2014
Stade Jean Bouin, Paris | Final

DANIEL SCHOFIELD

England's women conquered their demons last night by winning the World Cup for the first time in 20 years after Emily Scarratt's sensational individual try sealed a thrilling victory against Canada at the Stade Jean Bouin in Paris.

After defeats in the 2002, 2006 and 2010 finals to New Zealand, it was never going to be as straightforward as the bookmakers suggested it would be for England. An 11-point lead was reduced to just two at one stage as England became afflicted by nerves in the second half. The team that had been almost blemish-free in their 40-7 semi-final victory against Ireland on Wednesday suddenly became haunted by knock-ons.

It was Scarratt who pulled them back from the brink. The centre had already kicked three penalty goals when, in the 73rd minute, she carved her way past four Canadian would-be tacklers before being enveloped by her deliriously grateful team-mates.

Catch me if you can – Emily Scarratt leaves half of Canada behind en route to the line.

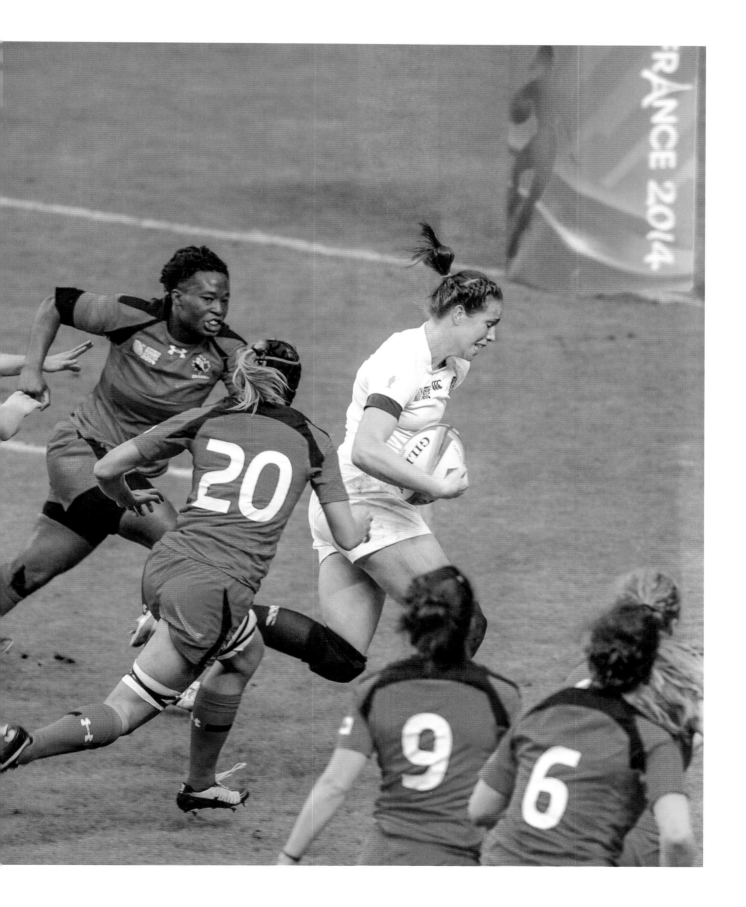

Karne Hesketh

England 2015
South Africa 32 Japan 34
19 September 2015
Brighton Community Stadium,
Brighton | Pool B

BY MARK PALMER

An inspirational performance from full back Ayumu Goromaru, whose 69th-minute score tied the scores at 29-29, will win the headlines, but it was collective grit and technical class that won the game. To see them camped in the South Africa 22 in the closing moments, striving for the line and glory, was to see the wonder of the World Cup in microcosm.

Japan had no right to win this game but nobody told their players, and it was South Africa who were out on their feet, and right out of ideas, come the close. A series of five-metre scrums ensued, with the Springboks a man down following the sin-binning of Coenraad Oosthuizen, and if ever a stadium tried to will the ball over the whitewash it was this one.

The TMO was required to judge that one forward surge hadn't quite made it, but still Japan came, and after stretching the South Africa defence this way and that, they created space on the left for replacement Karne Hesketh (who joined the game only in the 79th minute) to cross in the left-hand corner and spark wild celebrations.

Karne Hesketh scores the match-winning try despite JP Pietersen's tackle.

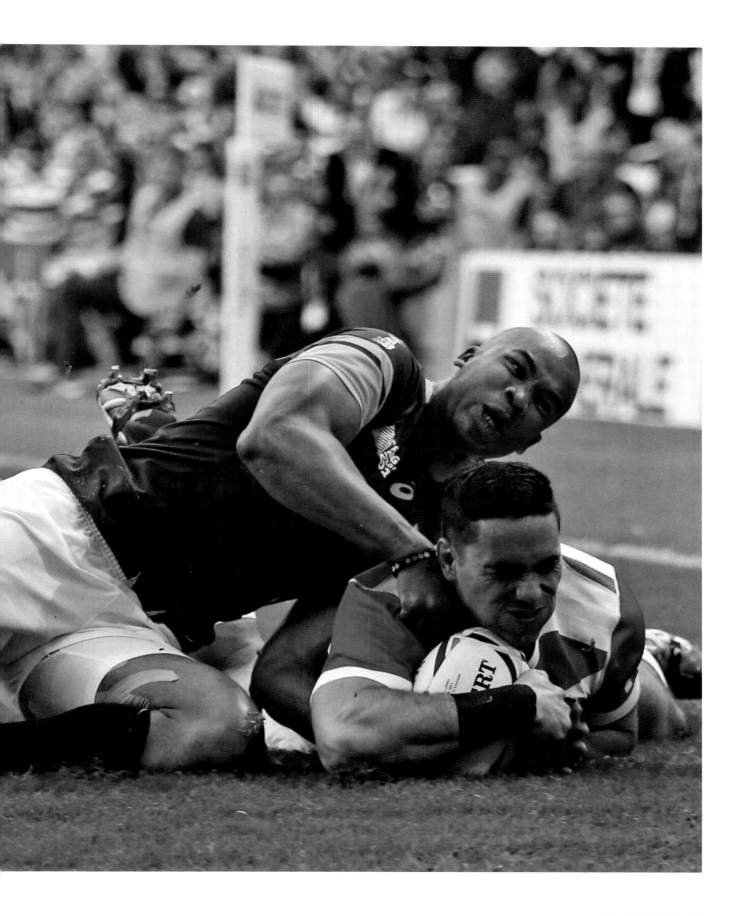

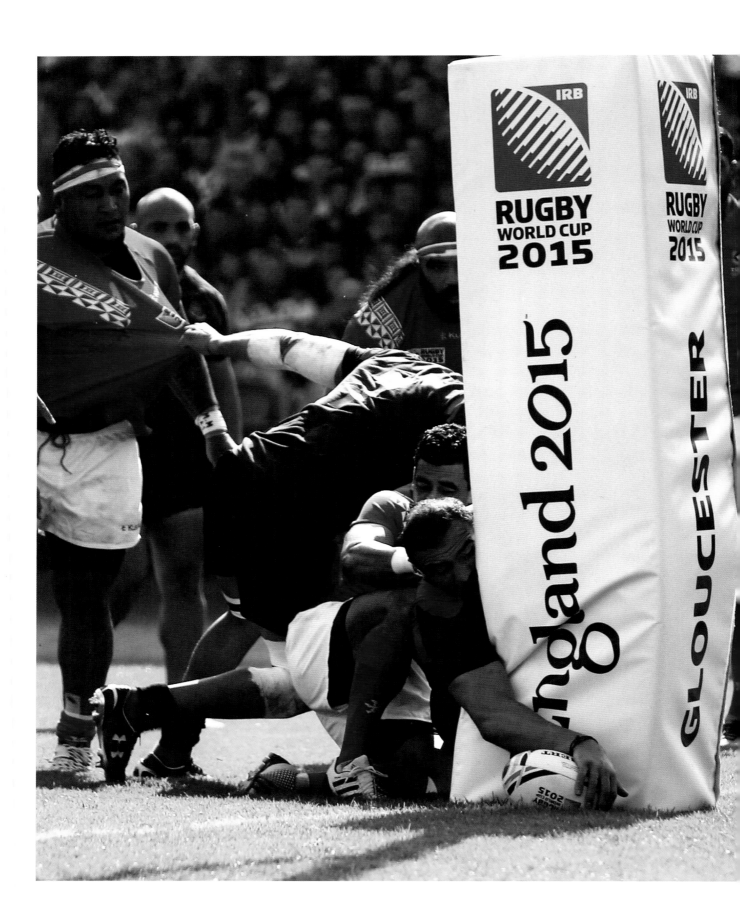

Mamuka Gorgodze

England 2015
Georgia 17 Tonga 10
19 September 2015
Kingsholm, Gloucester | Pool C

BY RICK BROADBENT

Their thrilling win over Tonga was their best – Georgia's only previous World Cup victories had come against Romania and Namibia – and was inspired by Vasil Lobzhanidze, an 18-year-old scrum half who became the youngest player in the tournament's history.

Georgia's ambition is to finish third in their pool and so qualify automatically for the 2019 tournament in Japan. They are in good shape to do so now thanks to a bellicose pack that could arm-wrestle the best. The leader is Mamuka Gorgodze, the No 8 from Toulon who made 27 tackles and wound up as man of the match.

He scored the opening try before Lobzhanidze was heavily involved in a second for Giorgi Tkhilaishvili, the flanker. "This is the greatest day of my career," Gorgodze said.

Mamuka Gorgodze stretches round the post to score against Tonga.

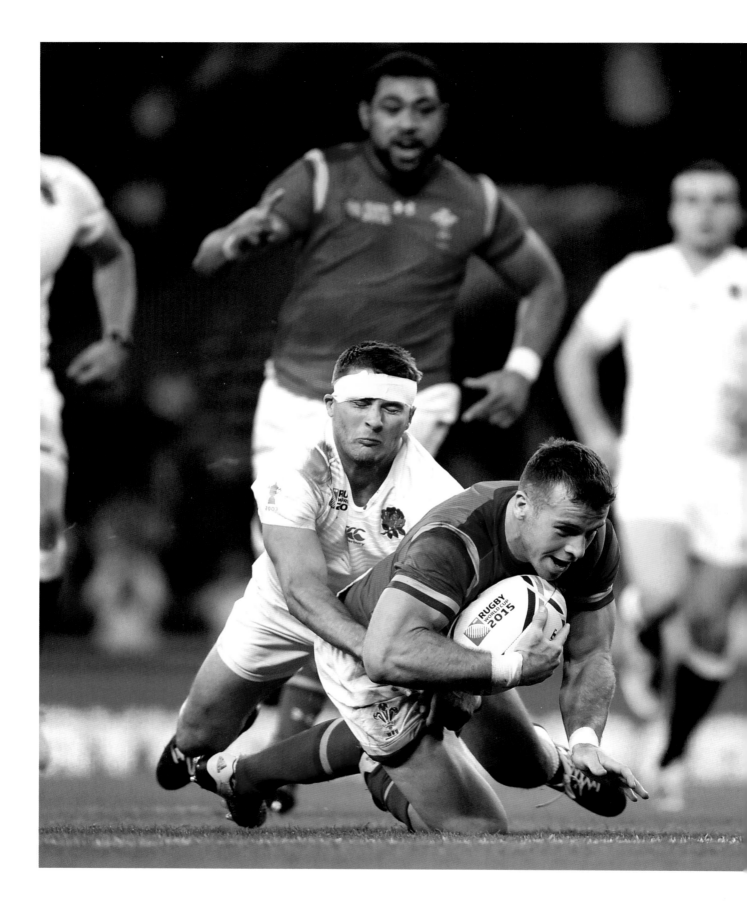

Gareth Davies

England 2015
England 25 Wales 28
26 September 2015
Twickenham, London | Pool A

BY STEPHEN JONES

It was now when the lack of England leaders, the lack of composure, the lack of midfield excellence to stretch the lead, came home to roost. It was also when the Welsh courage and experience was at a height because their dressing room suddenly began to look like a casualty clearing station.

And inside the last 10 minutes, to their unrestrained joy, Wales came level. Dan Biggar and Jamie Roberts worked well to send Lloyd Williams away down the left and the delicious chip kick ahead found Gareth Davies rushing up the middle to score and the kick made it 25-25.

Sensation then added to sensation. England coughed up another breakdown penalty just inside their own half, Biggar kicked a monster goal and suddenly, the England lion was a jackal looking for scraps.

Gareth Davies touches down for the critical Wales try despite Richard Wigglesworth's tackle.

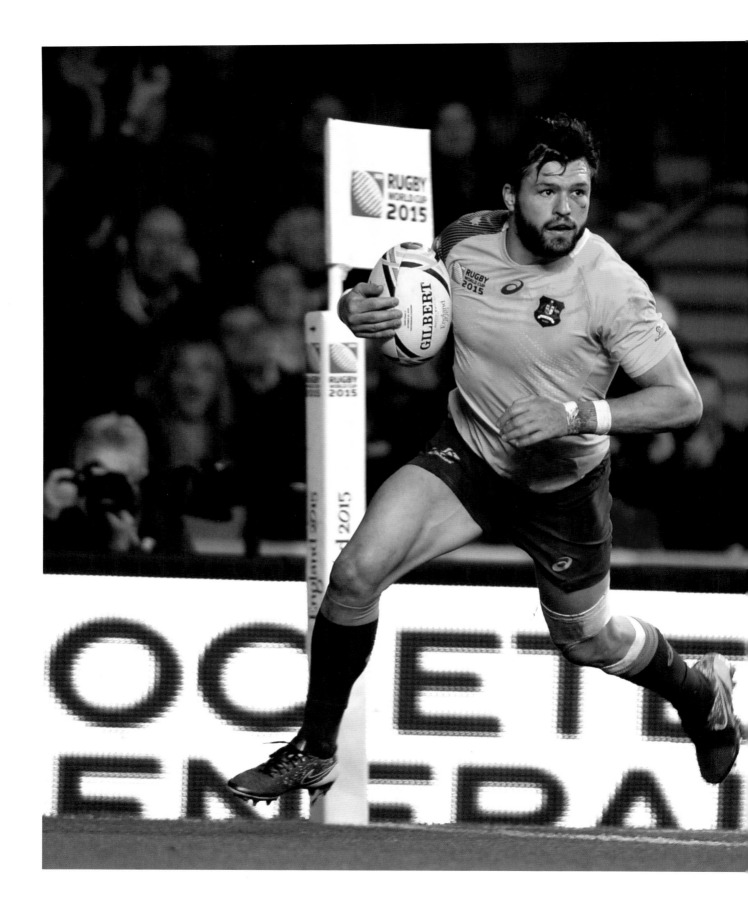

Adam Ashley-Cooper

England 2015
Argentina 15 Australia 29
25 October 2015
Twickenham, London
Semi-final

OWEN SLOT, CHIEF RUGBY CORRESPONDENT

A magnificent occasion, then, for the second semi-final, which delivered Australia into the first all-Antipodean final, although they required 72 minutes before they settled the contest… thanks to Drew Mitchell.

Mitchell danced past defenders though he could not quite go all the way himself. It was from a flat pass on halfway that he stepped in off his left foot, again and again, confounding the Argentina defence until he was brought down five metres short.

But he was able to chuck an ugly pass that Adam Ashley-Cooper, as alert near the end as he had been for the perceptive passes of his midfield colleagues earlier, picked up off the turf to run in unopposed to complete his hat-trick.

Adam Ashley-Cooper trots over for his hat-trick against Argentina.

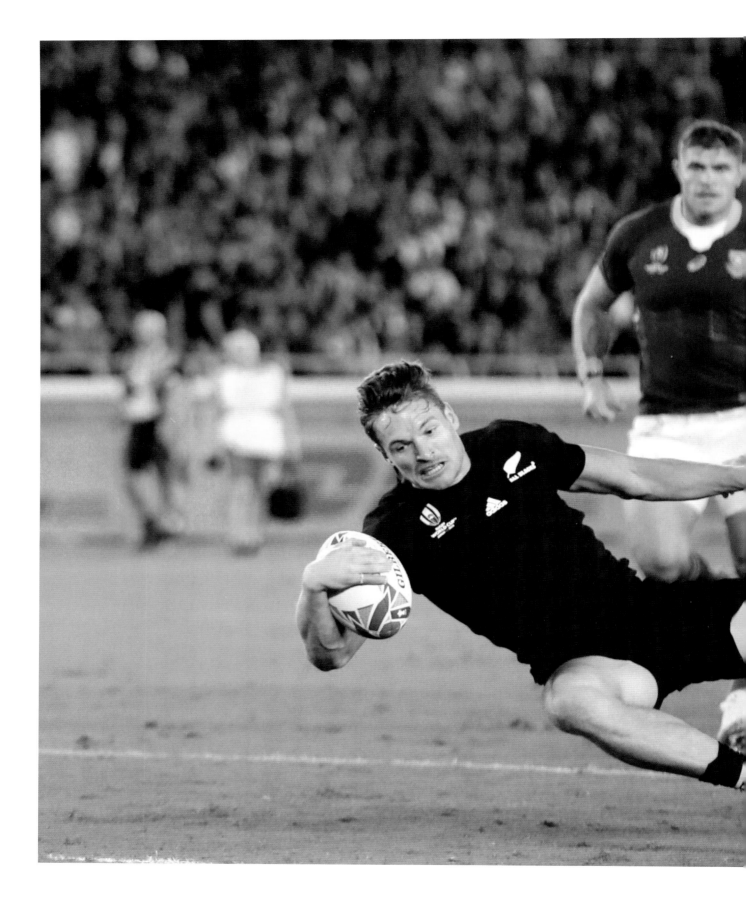

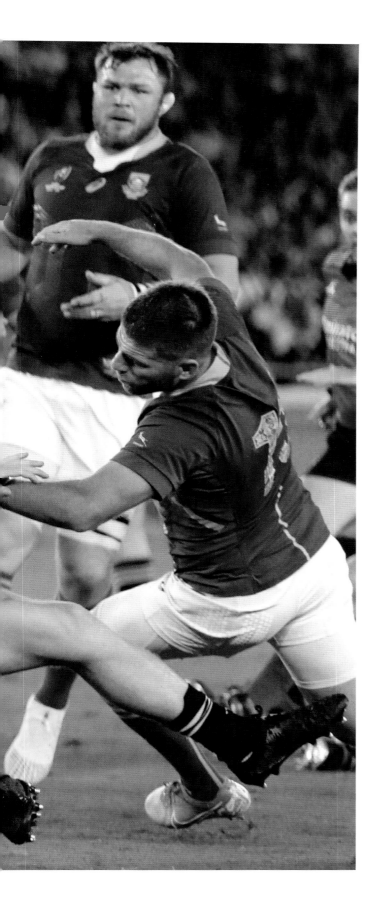

George Bridge

Japan 2019

New Zealand 23
South Africa 13

21 September 2019
International Stadium, Yokohama
Pool B

PETER O'REILLY

The surprise packages were on the wings, where 22-year-old Sevu Reece and 24-year-old George Bridge announced themselves as rookies of outlandish talent.

New Zealand's wings were central to what will surely be one of the tries of the tournament. Reece was the instigator, catching Richie Mo'unga's cross-kick near halfway and then making Makazole Mapimpi look flat-footed with a slippery shuffle and some hot acceleration.

The Kiwis' alertness to the sudden possibilities that present themselves is what sets them apart: Aaron Smith's support run, Beauden Barrett's dart through a half-gap, Bridge's perfectly timed support run. Try.

*Started by one wing, scored by another —
George Bridge crosses for the try.*

Keita Inagaki

Japan 2019
Japan 28 Scotland 21
13 October 2019
International Stadium, Yokohama
Pool A

FROM OWEN SLOT, CHIEF RUGBY CORRESPONDENT

Then the show became electric. Kenki Fukuoka on the burst, just brought down by Chris Harris, dying with the ball and then, releasing the most sympathetic offload so that Kotaro Matsushima, in support, could take the ball without breaking stride and register their first try.

Was that better than the second? The one where the hooker offloaded to the lock who found the full back who gave the scoring pass to his loose-head prop? Matsushima began it, bouncing through tackles in midfield before the forwards chimed in: Shota Horie and James Moore made headway, William Tupou roared up from behind and his inside pass found the prop, Keita Inagaki, four metres from the line and the try.

Top of the props – Keita Inagaki
completes a sensational score.

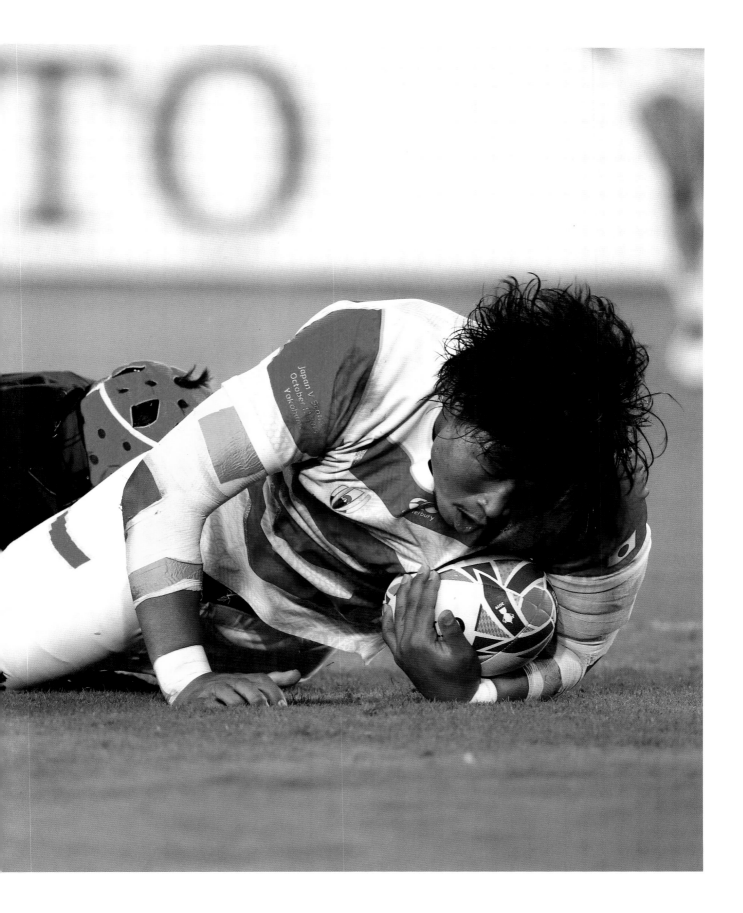

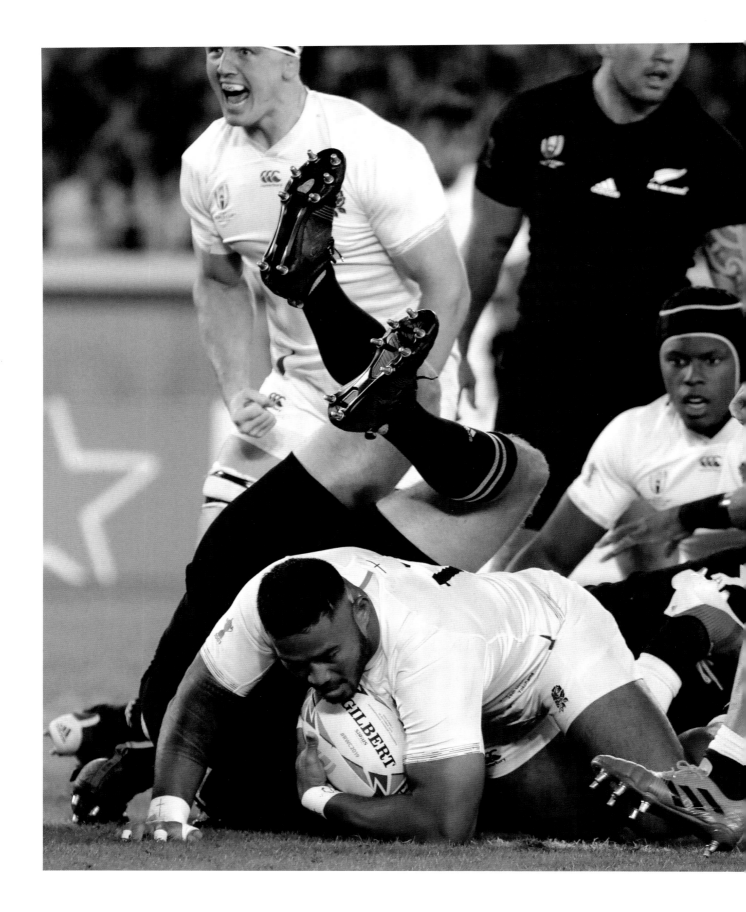

Manu Tuilagi

Japan 2019
England 19
New Zealand 7

26 October 2019
International Stadium, Yokohama
Semi-final

STEPHEN JONES

Perhaps the most remarkable thing was that England succeeded in outplaying the rapid opposition by playing even quicker. Their lovely passing and tip-passing and their sense of adventure caused havoc. This was a grim way for Kieran Read, the New Zealand captain entering retirement, to lose his chance of a third successive World Cup.

Their midfield was dreadful, their bench lacking class, and all they had was a Plan A. Maybe they had never needed Plan B before, but they needed it yesterday, together with Plan C and Plan D. We sensed something was in the wind as Joe Marler bore down on the haka, crossing the halfway line, which he was not meant to do during the performance, and piratically cocking his ear towards Nigel Owens [the referee], who was trying to send him back.

It took England 98 seconds to create their try – and what a try. Boldly, they moved the ball wide, Elliot Daly slipped his marker and sent Anthony Watson away down the right. Watson played well all day and when he was finally overwhelmed England rucked the ball back, Ford sent it wide to his left, and Daly intervened again.

The ball was sent back to midfield, Youngs orchestrated a few forward drives and then Tuilagi dived over to score to the left of a ruck with the defence absent.

Manu Tuilagi squeezes over in only the second minute.

Makazole Mapimpi

Japan 2019
South Africa 32
England 12

2 November 2019
International Stadium, Yokohama
Final

STEPHEN JONES

The game itself was something of a disappointment. Like so many previous World Cup finals, it sat rather uneasily on the broad shoulders of the rest of the tournament. But South Africa had the edge right through an hour or so of penalty goal ping-pong, and they settled it with a try as the 70th minute approached.

Malcolm Marx and other forwards took the ball to the left and Marx slipped Makazole Mapimpi away down the left wing. The clever Mapimpi took the ball on and chipped ahead, and Lukhanyo Am took it on the bounce and burst for the line. He may well have got there himself, but he twisted and passed to Mapimpi, who scored.

There was to be no red rose revival. Cheslin Kolbe rounded Owen Farrell with some ease towards the end to score a beautiful try from nothing, which really rubbed it in.

Makazole Mapimpi is about to touch down and, behind him, Faf de Klerk is already celebrating.

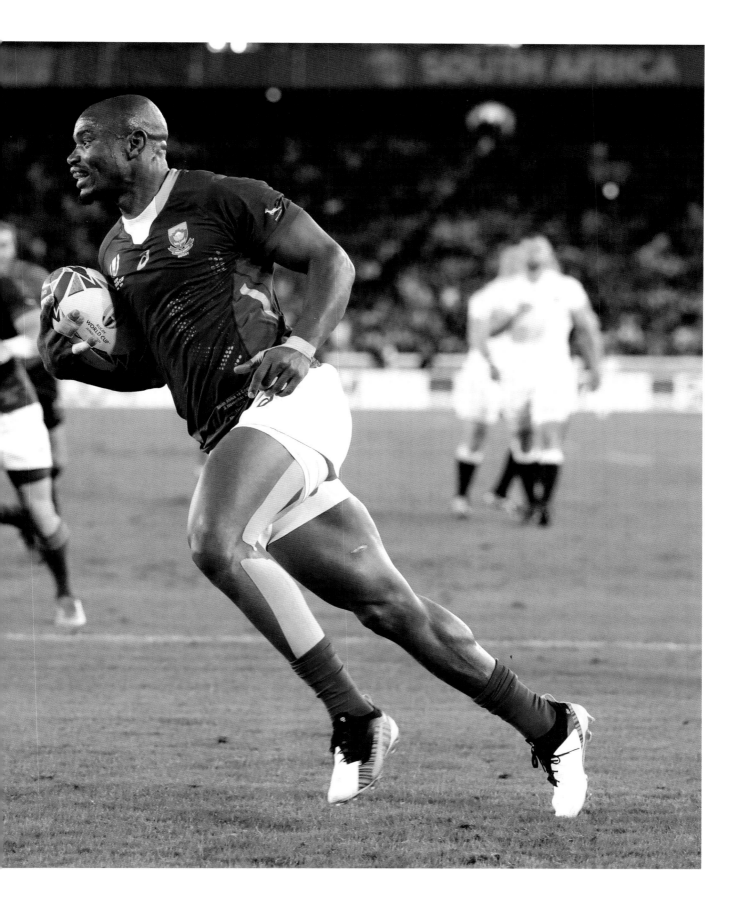

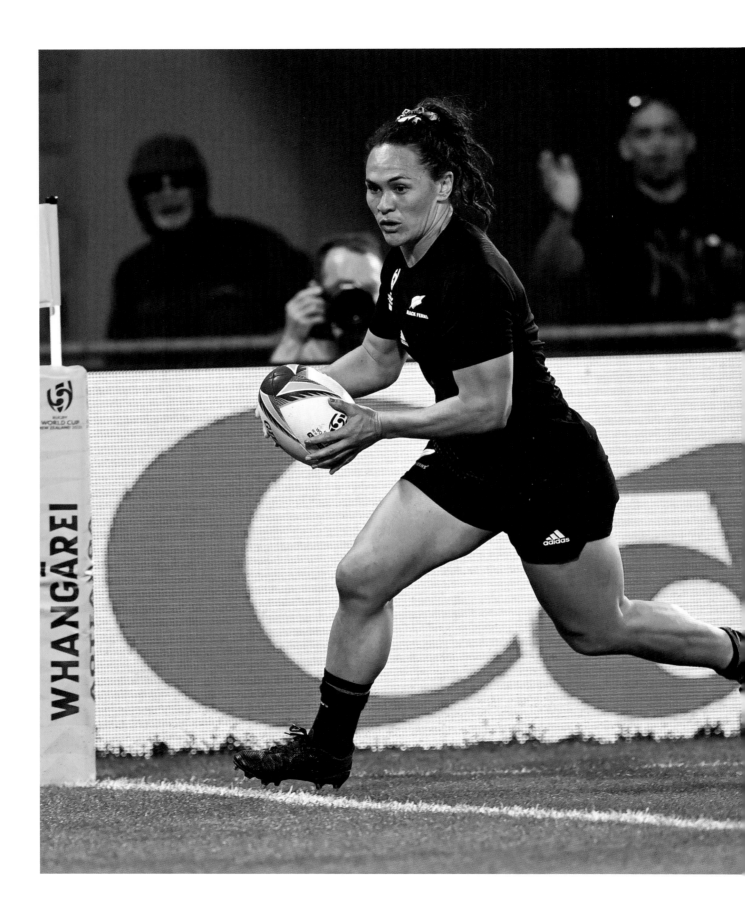

Portia Woodman

New Zealand 2021
New Zealand 55 Wales 3
29 October 2022
Northland Events Centre,
Whangarei | Quarter-final

Portia Woodman, the fast and elusive Black Ferns wing, has scored many better tries than the two she registered against Wales in Whangarei but they did not carry her into the unique territory she now occupies as the leading try scorer in World Cup tournaments, men's or women's.

The first, a routine finish, drew her level with England's Sue Day on 19 tries; the second, which required rather more work, took her out on her own on twenty. The leading men's try scorers are another New Zealander, Jonah Lomu, and South Africa's Bryan Habana, both on 15, so Woodman stands at the top of a lofty pedestal.

DAVID HANDS

Portia Woodman runs in against Wales to take her place at the head of World Cup try scorers.

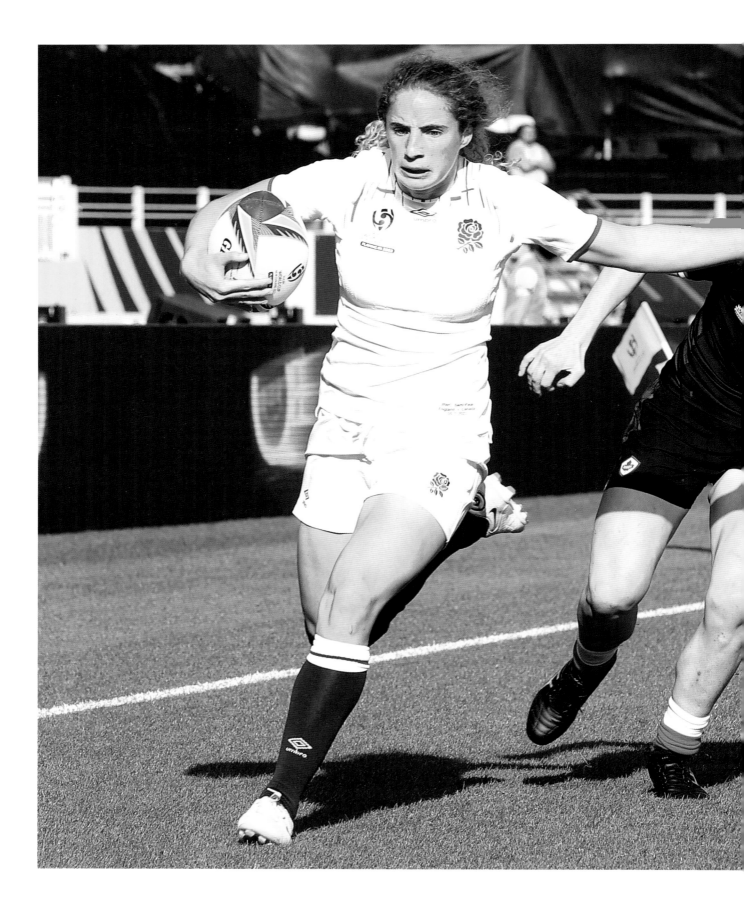

Abby Dow

New Zealand 2021
England 26 Canada 19
5 November 2022
Eden Park, Auckland
Semi-final

Nearly eight months earlier, Abby Dow sustained a broken leg which looked likely to keep her out of contention for England's World Cup squad. So hard did the Wasps wing work, though, that she not only made the squad but provided the women's tournament with arguably the finest try in its 31-year history.

France score tries such as this, Fiji too, sometimes New Zealand or Australia but not England. They tend to be more prosaic but, struggling against a committed Canada side, England needed a touch of magic and they found it. When Claudia MacDonald, England's left wing who had come through serious injury problems of her own, received the ball she was in her own in-goal area but spotted a gap in Canada's defensive line.

Stepping off her left foot she beat four defenders before looping a pass to Dow on the right. There were 70 metres still to go but Dow pinned back her ears and burned off the cover, needing only a hand-off to deal with the last challenge of her opposite number, Paige Farries. Nick Mullins, commentating on television, came up with the immortal line: "Abby Dow. Abby Wow."

DAVID HANDS

*Abby Dow fends off the belated challenge of
Canada's Paige Farries before touching down.*

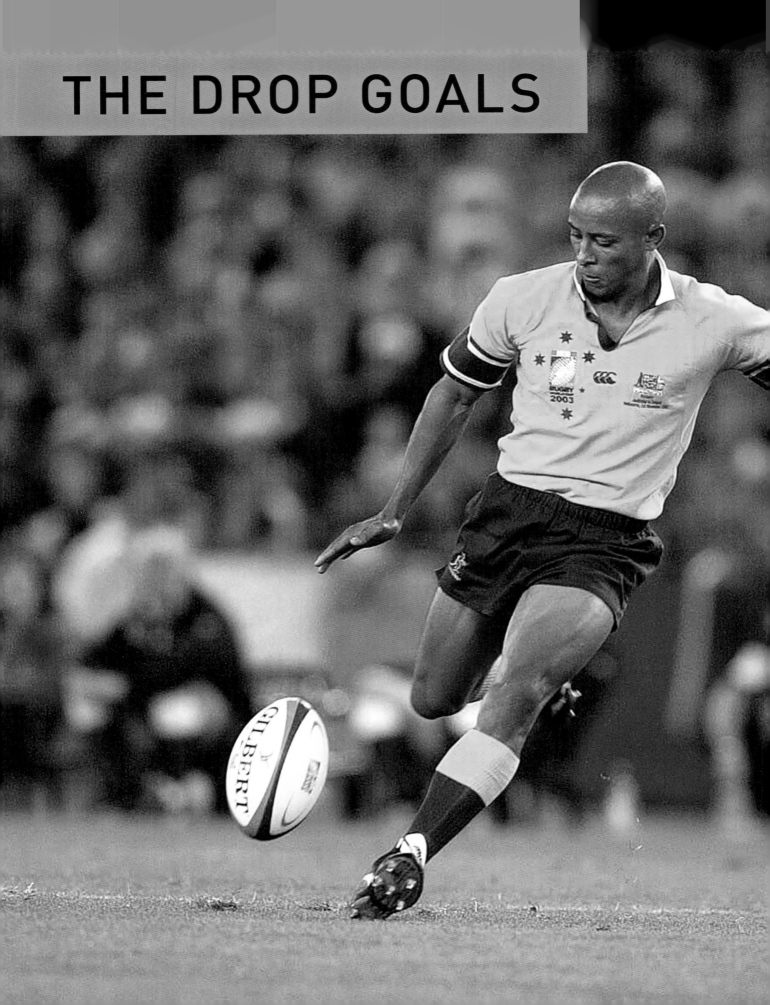

THE DROP GOALS

Practice makes perfect

Britain, Ireland and France 1991
Scotland 6 England 9

26 October 1991
Murrayfield, Edinburgh
Semi-final

BY ROB ANDREW

The pass which Richard Hill threw to me with only eight minutes of the Rugby World Cup semi-final remaining had already arrived a thousand times before. For years, after almost every England training session, we have gone off on our own, set up camp in or around the imaginary opposition's 22-metre line, and rehearsed dropped-goal moves.

The technique has been polished incessantly. It had to be. Just such a contingency, we always knew, could, one day, win an important game such as a World Cup semi-final. We did not need to speak to know what each other felt had to be done from that scrum.

There was just a look from Richard and he probably picked up a similar expression on my face. It had to be a dropped goal. And it had to go over, because it was the perfect position for such a score, and we were locked with Scotland at 6-6. If there is ever a sitter for a dropped goal, then that position provided it: a nice, clean scrum.

Rob Andrew's boot swings and Craig Chalmers, Scotland's fly-half, cannot block it.

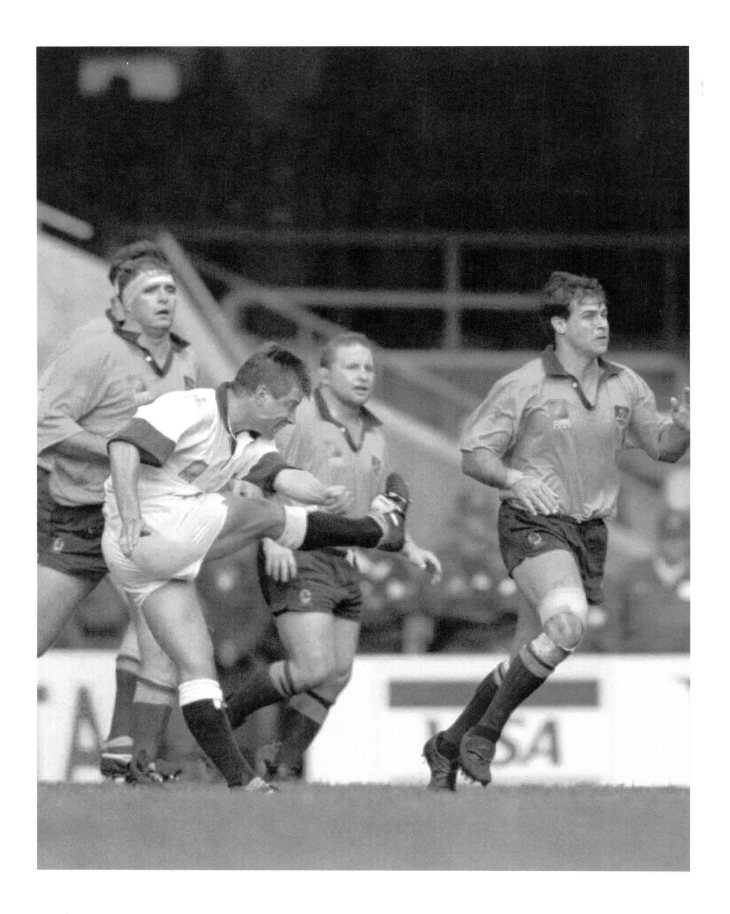

Andrew wins it at the death

South Africa 1995
England 25 Australia 22
11 June 1995
Newlands, Cape Town
Quarter-final

FROM DAVID HANDS, RUGBY CORRESPONDENT

ROB ANDREW

Was there ever a game that England sought to win so much, and won? Having done so, they must climb the same mountain all over again when they play New Zealand next Sunday, on the same Newlands ground here, in the semi-final of rugby union's World Cup.

For any English sportsman, on the southern tip of Africa or anywhere else, there have been few more heart-stopping moments than yesterday, when the 1991 finalists locked horns for the first time since that dull November day at Twickenham when Australia won the Webb Ellis Cup.

The measure of England's achievement was that not only did they dismiss the most worthy of champions from the 1995 tournament, but they also did so after losing a ten-point lead. Once, twice, they had to come from behind and, with three minutes of added time having ticked away – and with the first extra-time game of any World Cup looming – Rob Andrew's right boot connected with one of the sweetest dropped goals he will kick throughout his career.

As Dean Richards passed me running up to the lineout he said: "What do you need for the dropped goal?" I told him we needed to catch the ball and drive it then see what the position was.

The idea was to make a bit more ground, perhaps move a little way into midfield, tie in the Australian back row then keep the head down, hit – and hope. It worked, and it earned England a place in the World Cup semi-finals.

Australia's forward trio of Rod McCall, Dan Crowley and David Wilson, are powerless to stop Rob Andrew's winning goal.

Brooke's heart-breaker

South Africa 1995
New Zealand 45
England 29
18 June 1995
Newlands, Cape Town
Semi-final

If ever there was a day when you knew everything you touched would turn to gold, this was it. Not content with watching Jonah Lomu smash England hopes asunder with four tries, Zinzan Brooke brought his training-ground downtime to the semi-final at Newlands and casually dropped a goal from nearly 50 metres.

Forwards are not supposed to do this on important occasions. But Brooke, New Zealand's multi-talented No 8, used to practise his goal-kicking (like a lot of forwards) at the end of training sessions as light relief from the hard grind of lineout and scrummage, ruck and maul. Here at Newlands, with the All Blacks firmly in the driving seat, he collected a clearing kick by Will Carling, England's captain, just inside his own half and near touch.

Running forward a few metres, he let fly for the posts and, as the ball crossed the bar, wheeled away, arms raised in triumph. How ironic that, a week later in the final, it was an extra-time drop goal that beat New Zealand.

DAVID HANDS

Zinzan Brooke celebrates the drop goal that added to England's woes.

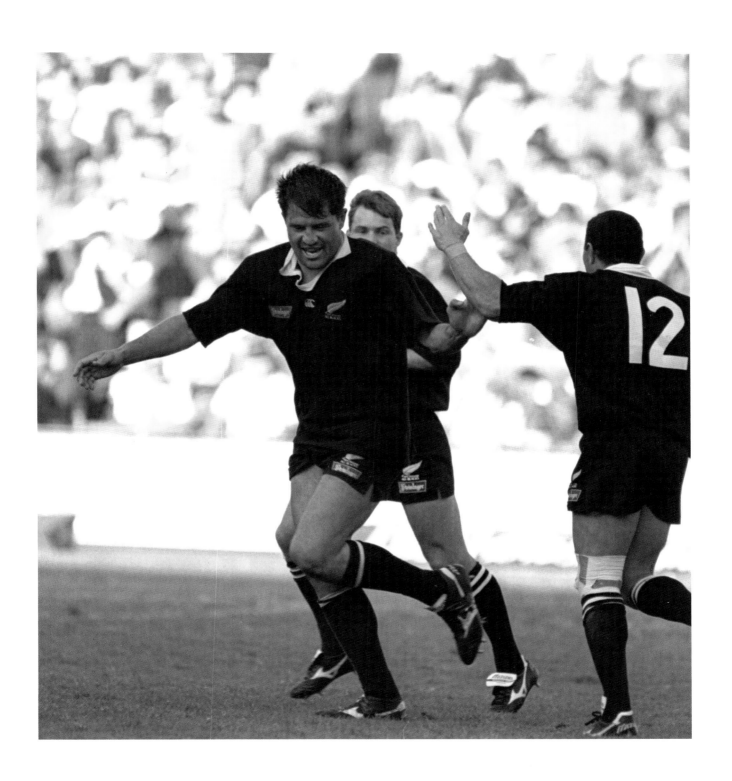

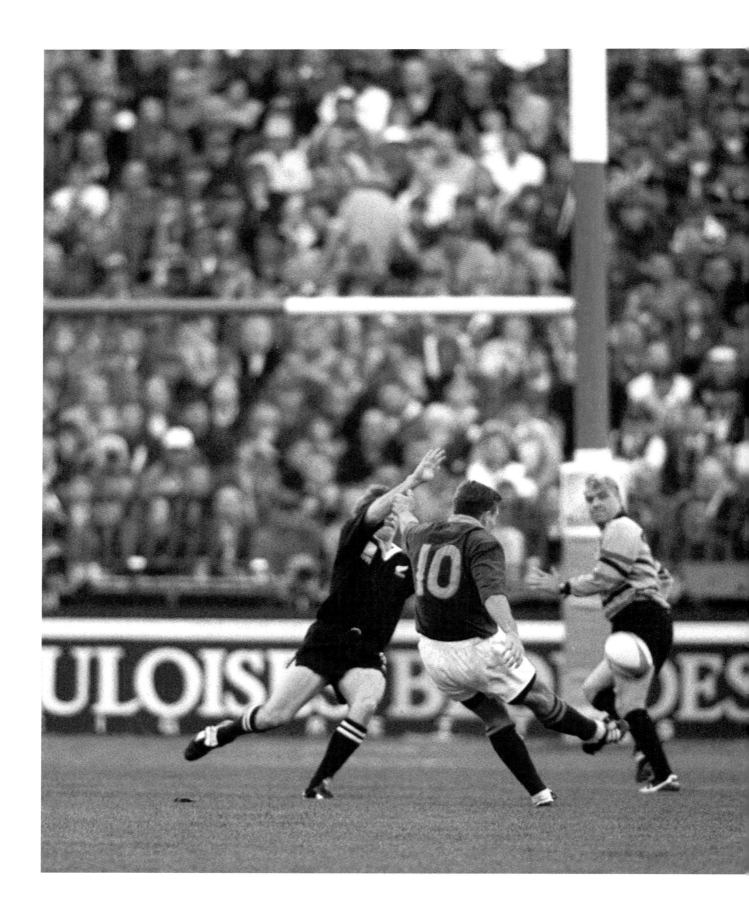

Stransky lifts a nation

South Africa 1995

South Africa 15
New Zealand 12
(after extra time)

24 June 1995
Ellis Park, Johannesburg | Final

FROM DAVID HANDS, RUGBY CORRESPONDENT

South Africa's win was not that of the new rainbow nation but that of the generations which have preceded them. It was ground out of intense defence, an awe-inspiring desire to succeed, and Joel Stransky, a kicking stand-off half who must rank alongside – if not ahead of – Jonah Lomu as the player of the tournament.

Stransky, 27, the restaurant owner from Cape Town, is the man that the selectors chose not to take to New Zealand last year; the man who played against Western Samoa in a warm-up international only when Brendan Venter withdrew and Hennie le Roux was switched to centre. He was nearly overlooked for the tournament yet he dominated South Africa's displays, from first, against Australia, to last, against New Zealand. [...]

A long penalty goal from Andrew Mehrtens, who had missed a straightforward dropped goal just before full time, renewed All-Black optimism in the first period of extra time, but Stransky levelled with his third penalty goal and, with seven minutes of the tournament left, dropped the goal from 30 metres which prompted a riot of celebration.

Joel Stransky's kick eludes Andrew Mehrtens, and Ed Morrison, the referee, turns to watch the result.

Tonga on island of joy

Britain, Ireland and France 1999
Tonga 28 Italy 25
10 October 1999
Welford Road, Leicester | Pool B

BY DAVID HANDS, RUGBY CORRESPONDENT

This World Cup may have drama to come but little will surpass the wonderful encounter at Welford Road last night. Clive Woodward, the England coach, was among 10,200 entranced spectators as the supposed minnows of pool B, Italy and Tonga, slugged it out to the final whistle, when a dropped goal from fully 45 metres by Sateki Tu'ipulotu, the Tonga full back, won the match.

Tu'ipulotu did Woodward no favours. The islanders, with only their second World Cup victory – the first was four years ago over Ivory Coast – will now come at England at Twickenham on Friday thirsting for an improbable victory that would lift them to second place. [...]

Tonga had a final shot left in their locker. They regrouped and, from the restart, reclaimed possession. Sililo Martens saw his full back in space and there will seldom be a sweeter strike than Tu'ipulotu's, which left the islanders and their enthusiastic supporters delirious with joy. On Saturday, Twickenham was All Black; yesterday, Leicester was All Red.

Sililo Martens (left) rushes to congratulate Sateki Tu'ipulotu after the full-back's winning score.

De Beer drops out England

Britain, Ireland and France 1999
England 21
South Africa 44
24 October 1999
Stade de France, Paris
Quarter-final

FROM DAVID HANDS, RUGBY CORRESPONDENT

Amazing. There has not been a game like it, not a game in which one individual seizes the day so decisively. Jannie de Beer, South Africa's answer to the matadors of Spain, plunged darts into England's hide at such regular intervals in the Stade de France here yesterday that, by the end, John Bull was on his knees, having conceded more points to South Africa than in any of the previous 16 matches. [...]

South Africa developed momentum from the instant that Joost van der Westhuizen, that predatory poacher of tries, scored his 29th for his country just before the interval. Then came De Beer. Two dropped goals within two minutes was coincidence enough, but for the fly half to kick five in brisk succession was enough to break the hearts of better sides than England.

How do you defend the dropped goal? Australia could not do it when they lost that nerve-tingling quarter-final with England in 1995, nor New Zealand against Joel Stransky in extra time in the final that year. It was, for De Beer, one of those luminous days that he will probably never repeat, but it is significant both that South Africa had trained this week to win field positions from which he could do so and that they had worked out what England's response would be.

Nick Mallett said, in effect, the same as John Hart, his New Zealand counterpart, a fortnight ago after the pool match with England: "We worked very hard on the way England played, we spent many hours this week trying to work how best to defend against Dallaglio out wide, against Hill and Back," the South Africa coach said. "The key element was that I have such experienced players."

Jannie de Beer kicks another goal despite the efforts of Neil Back.

Larkham snatches victory

Britain, Ireland and France 1999

Australia 27
South Africa 21
(after extra time)

30 October 1999
Twickenham, London
Semi-final

BY DAVID HANDS, RUGBY CORRESPONDENT

This was not the flowing epic the World Cup hoped for but it was epic just the same. All the points may have come through the boot in the extended semi-final on Saturday but when it was over, Australia were in the final and no-one at Twickenham, Australian or South African, would have complained that they had not been utterly absorbed to the last drop.

The last drop. The dropped goal by Stephen Larkham that finally broke South African hearts. Four years ago, Joel Stransky did it for South Africa to win an extra-time final; six days earlier, Jannie de Beer dropped five goals in South Africa's quarter-final defeat of England. Here, at English headquarters, he dropped for goal five times and succeeded only once.

Instead, with six minutes remaining of extra time, the gangling Larkham – who had missed with a far easier effort early in the game – broke the deadlock with a lazy, 43-metre goal that wobbled its way into history. There was an additional penalty goal, Matt Burke's eighth, but Larkham's was the blow that finally ripped the Webb Ellis Cup from the tenacious hands of the holders.

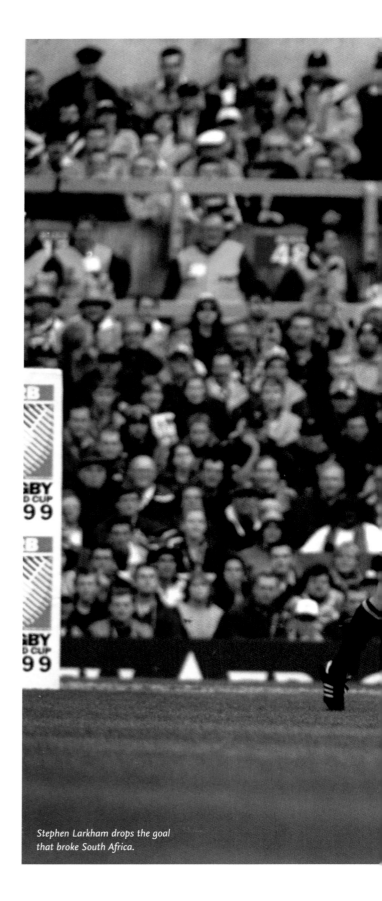

Stephen Larkham drops the goal that broke South Africa.

Lamaison draws France back

Britain, Ireland and France 1999
New Zealand 31
France 43
31 October 1999
Twickenham, London
Semi-final

BY DAVID HANDS, RUGBY CORRESPONDENT

There was also the mighty dropped goal. This is destined to be the World Cup of the drop: first Jannie de Beer, then Stephen Larkham, now Christophe Lamaison. Two such goals within two minutes carried France from the very brink of defeat; Jonah Lomu had not so much scored his second try as been ushered over the line and the All Blacks must have believed the game was won. [...]

Then came France's finest hour and Tana Umaga's darkest. With Jeff Wilson limping after a heavy tackle, confusion reigned in New Zealand's back division; Umaga's series of fumbles allowed France to drive into the opposing 22. Twice, from virtually the same position, they teed up Lamaison for his dropped goals which the fly half embellished with his second and third penalty goals.

Christophe Lamaison drops for goal contributing to a match tally of 28 points.

France's turn to suffer

Australia 2003
England 24 France 7
16 November 2003
Telstra Stadium, Sydney
Semi-final

FROM DAVID HANDS, RUGBY CORRESPONDENT

In such a game, to score points early lifts a team, so the first of Jonny Wilkinson's three dropped goals was greeted with glee by his colleagues. Two minutes later, France took the lead when Serge Betsen was left free at the tail of a lineout on England's 22 to gallop to the line and although Richard Hill's sliding tackle forced a long look at the video replay, the try was awarded and Michalak duly added the conversion. [...]

The lineout provided the platform for the two scores that gave England their five-point interval lead. Martin Johnson started the maul from which first Ben Kay, then Lawrence Dallaglio, broke away and gave Wilkinson the ideal opportunity for a 30-metre dropped goal. When Phil Vickery found himself at the tail of a lineout for a mistimed France throw, he roamed deep into opposition territory, Betsen failed to roll away from the ruck and Wilkinson found his mark from 44 metres. [...]

France were not beaten badly for possession but in terms of mental strength they were a distant second. England's organisation close to the set pieces was far superior and when Neil Back found a chink of light, Wilkinson was left with space to step inside and drop his third goal – a record for an England player.

The second of Jonny Wilkinson's three drop goals soars towards its mark.

And one more time...

Australia 2003

Australia 17
England 20
(after extra time)

22 November 2003
Telstra Stadium, Sydney | Final

BY JONNY WILKINSON

For the first time, I've not gone away thinking about what I did wrong in the game, where I maybe could have done a bit better or how those drop-kicks missed. Deep down, I know I could have done certain things better on the pitch, I know that I missed three dropped goals, I've certainly got that thought tucked away in the back of my mind, but there is a sense of fulfilment here which I recognise is unusual for me. [...]

The [winning] dropped goal? I know it's the moment that people will remember, but my thoughts on that are the same as my thoughts on all my penalties. I only get the points because I have team-mates who do the work and put me in the position to get them. Maybe instead of my kicking that dropped goal, we should talk about Matt Dawson who took the ball up beforehand and did all that work to get us there.

It's on its way — Jonny Wilkinson's drop goal wins the World Cup.

Carter's left boot kicks out Australia

England 2015
New Zealand 34
Australia 17
31 October 2015
Twickenham, London | Final

BY ALEX LOWE

It was Dan Carter's left foot that did the damage; a sweet dropped goal followed by a 50-metre penalty goal that halted Australia's spirited revival and ensured that New Zealand made history by retaining the World Cup. The coup de grace was with his right.

Even in the dying moments of his 112th and final game for the All Blacks, Carter still had something to prove. The last two points of his record-breaking international haul of 1,598 – the conversion of Beauden Barrett's late breakaway try – were struck with his 'wrong' foot.

Dan Carter's left-footed drop goal maintains New Zealand's path to victory.

DOWN SIDE

Into battle

Britain, Ireland and France 1991

France 10 England 19

19 October 1991
Parc des Princes, Paris
Quarter-final

BY DAVID HANDS, RUGBY CORRESPONDENT

There was a sour taste to the Rugby World Cup last night after Russ Thomas, its chairman, had decided that no further action was being taken against Daniel Dubroca, the French coach, following allegations that he had called the referee "a cheat" and manhandled him after England's 19-10 win in the quarter-final in Paris on Saturday.

France, the 1987 World Cup finalists, departed amid acrimony: their retreat undignified and sullied by the accusations of assault on the referee, David Bishop, and a media campaign suggesting that his "one-eyed" approach had been a contributory factor to their defeat. [...]

It was the culmination of an ill-disciplined French performance – in the face, it should be said, of an extremely physical English display designed to put them under pressure. At least twice Bishop appeared ready to award penalties to France, only to reverse his decision because of acts of violence. [...]

The match constituted a sad departure after 93 internationals for Serge Blanco. The great French full back, whose 38 tries make him the second highest international try-scorer, after David Campese, ended his career a forlorn, limping figure, an insignificant presence offering histrionics rather than inspiration or an example of leadership to his team. Exposed to an unforgiving English presence under the high ball, Blanco indulged in physical fisticuffs on the field and verbal ones off it.

Wade Dooley and Micky Skinner confront the France No 8, Marc Cecillon after a punch lays out Nigel Heslop, England's wing.

There are no easy kicks at goal

Britain, Ireland and France 1991

Scotland 6 England 9

26 October 1991
Murrayfield, Edinburgh
Semi-final

BY DAVID HANDS

But the self-imposed limitations of England's game were so nearly not enough, and it is impossible to believe that they will be enough in the final on Saturday. Had Gavin Hastings not missed the simplest of penalty kicks, it would have been Scotland with a 9-6 lead in the final quarter.

Moreover, in the phase of play immediately preceding that 20-metre kick, Scotland had won three successive rucks and created a yawning open side, with men to spare against a desperate defence. It could, and should, have been a try, but Scotland could not use their overlap and the chance was lost.

The expression on Gavin Hastings' face after he had kicked wide tells its own story. This was the nearest Scotland have come to a place in the World Cup final. Their best performance since then came in 2015, when they lost in the quarter-finals by a single point to Australia.

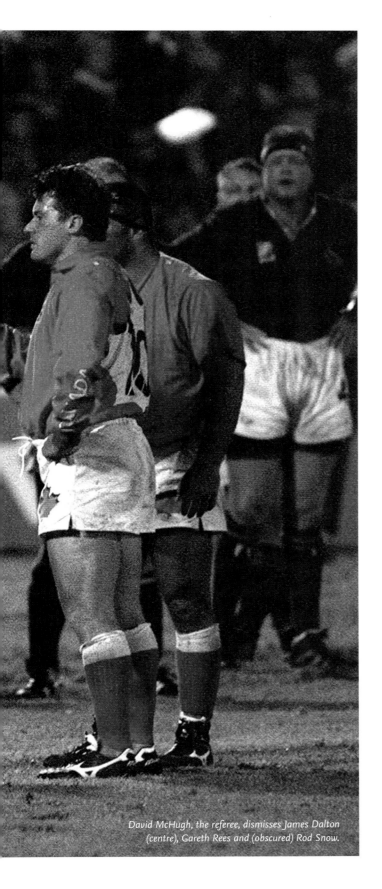

David McHugh, the referee, dismisses James Dalton (centre), Gareth Rees and (obscured) Rod Snow.

A night of red cards

South Africa 1995
South Africa 20 Canada 0
3 June 1995
Port Elizabeth | Pool A

FROM DAVID MILLER

South Africa's prospects of winning the third World Cup, and their moral worthiness, were cast in doubt by their involvement in the first all-out brawl of the competition here on Saturday night. Having looked as immensely powerful against Canada as they had against Australia on the opening day, they then surrendered self-control, dignity, and the respect of rival nations.

Their final match in pool A began and ended in darkness. A floodlight failure immediately before the start delayed the kick-off for 45 minutes. Ten minutes from the end, a brawl involving at least ten players resulted in James Dalton, the South Africa hooker, being sent off with the Canada captain, Gareth Rees, and prop, Rod Snow. At least three on each side might realistically have been dismissed by David McHugh, the Irish referee.

After a study of the video by the disciplinary commission, the referee's action was upheld and all three players suspended for 30 days. Snow was exonerated for gouging but instead found guilty of punching, by his own admission. The South Africans appealed against the sentence on Dalton, a decision being expected last night. It would be weakness in the extreme were the appeal to be upheld. Without discipline, the whole competition is devalued. The appeal is as regrettable as the brawl.

Tragedy at Rustenburg

South Africa 1995

Tonga 29 Ivory Coast 11

3 June 1995 | Rustenburg
Pool D

Max Brito, the Ivory Coast wing, will undergo surgery in Pretoria today for the serious injuries he sustained in the match against Tonga on Saturday. He was taken to hospital after being caught at the bottom of a maul early in the Rugby World Cup pool D game.

Brito, 27, was yesterday in a stable condition in the intensive care trauma unit of the Unitas hospital in Pretoria. Magdel du Preez, a spokeswoman for the hospital, said: "He sustained a spinal injury between the fourth and fifth vertebrae. After the accident, both legs and his left arm were paralysed. He is breathing on his own."

Max Brito is carried from the field at Rustenburg. Brito, appearing in only his third international, was paralysed from the neck down. After receiving treatment and compensation, he returned to his home in France, eventually coming to terms with his handicap. He died in December 2022, aged 54.

What might have been

France 2007
South Africa 15
England 6
20 October 2007
Stade de France, Paris | Final

FROM DAVID HANDS

Would England have won if Stuart Dickinson, the video referee, had not decided that Mark Cueto's left foot was in touch a second before he reached over in the left-hand corner three minutes into the second half? Cueto was sure that it was a fair try, the conversion of which would have given his side a one-point lead. There was plenty of time left, but England have shown how dogged they can be in defence of a lead and breaching South Africa's line would have lifted their spirits.

It was a crucial decision, as was the award of a penalty against Ben Kay, apparently for obstruction, as Toby Flood ran out of defence. It allowed Francois Steyn to kick, from 48 metres, what Jake White [South Africa's coach] described as "the most important three points he will score in his life".

Mark Cueto touches down after Danie Rossouw's tackle.

Welsh hopes shattered by red card

New Zealand 2011

France 9 Wales 8

15 October 2011
Eden Park, Auckland
Semi-final

FROM OWEN SLOT

For all the successes that Sam Warburton, the Wales captain, has achieved during this World Cup, it is not stretching the point of the red-card decision against him to say that maybe his greatest is in preventing other players from suffering catastrophic spinal injury.

This is not hyperbole. It is the reason that the spear tackle has become so unswervingly administered. Spear tackles, tip tackles, lift tackles, whatever your terminology, are given zero tolerance because they are so dangerous. As a poster boy for what is illegal, Warburton could not have given the lift tackle broader and more negative publicity.

A semi-final of a World Cup played in front of a vast global TV audience. It would be the height of ignorance for any player at any level not to have learnt a lesson in the eighteenth minute of that semi-final. This is not to argue against the chorus who have been yelling that Warburton's sending-off ruined the match and denied Wales their destiny. Of course it did. However, players are getting bigger, faster and stronger and the legalised violence in which they engage is proving increasingly attritional.

Sam Warburton (no 7) up-ends Vincent Clerc in mid-air and is subsequently sent off by the referee, Alain Rolland.

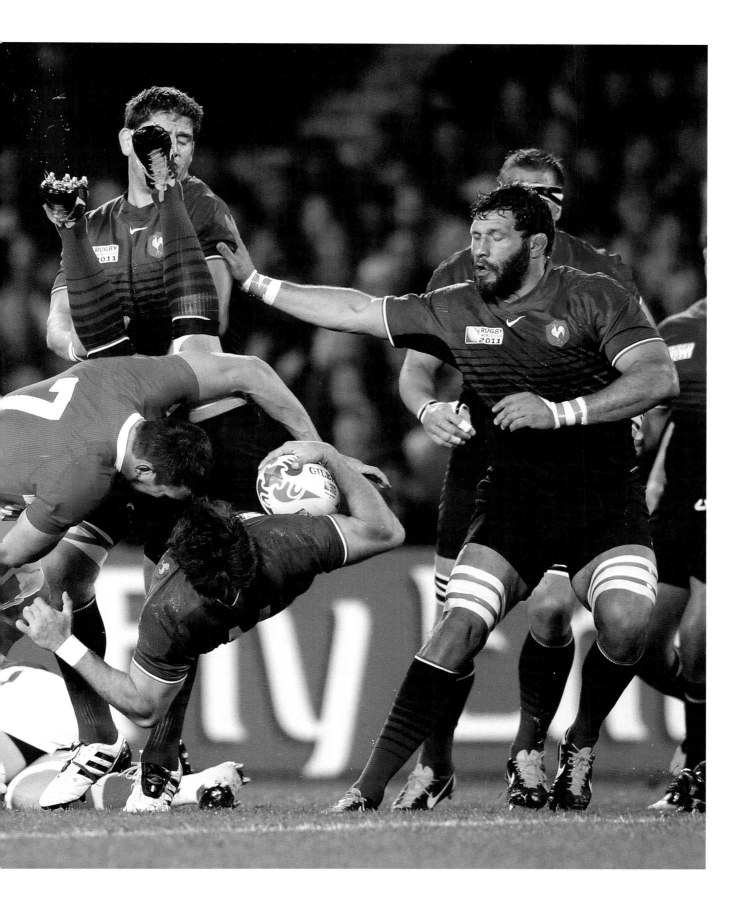

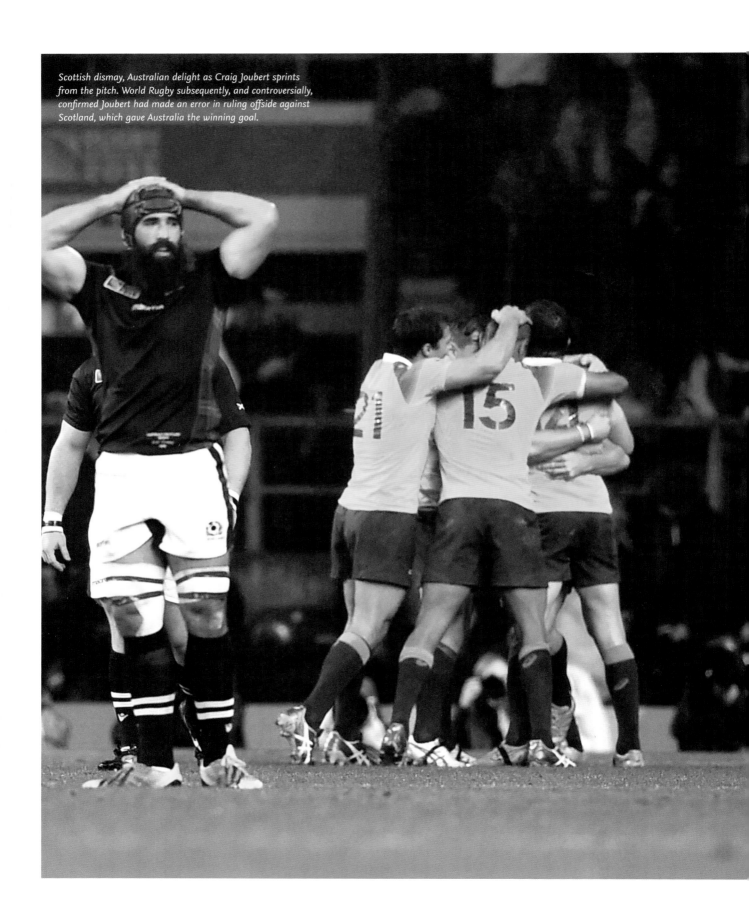

Scottish dismay, Australian delight as Craig Joubert sprints from the pitch. World Rugby subsequently, and controversially, confirmed Joubert had made an error in ruling offside against Scotland, which gave Australia the winning goal.

Beating the retreat

England 2015

Scotland 34 Australia 35

18 October 2015 | Twickenham, London | Quarter-final

BY OWEN SLOT, CHIEF RUGBY CORRESPONDENT

In the end, you didn't know whether to laugh or to cry, to cheer or boo. For the record, most of Twickenham went for the latter. Brilliant, knife-edge thrilling drama, yes. Yet the image that frames this game is Craig Joubert, the South African referee, blowing the final whistle and legging it out of the stadium, bottles pelted in his direction as he went.

Here we had last-gasp drama, hopes rising, hopes dashed and then the mother of all controversies, Gavin Hastings apoplectic in the Radio 5 live commentary booth and every rugby specialist, amateur and newcomer, thumbing through Law 113 to divine the truth: did Joubert wrongly referee Scotland out of an astonishing long-shot place in the semi-finals?

The answer, after much review, is affirmative. Joubert did cost Scotland the match and the biggest upset ever in World Cup knockout rugby history. [...]

For Scotland the scoreline is harder to read because of the catalogue of refereeing decisions that went against them. That final killer penalty decision allowed Bernard Foley to kick Australia back into the lead that they had lost and to hold on to a 35-34 scoreline for the last minute.

Yet Joubert had also showed Sean Maitland a controversial yellow card for an intentional knock-on, a period during which Australia had scored ten points. Another penalty that Foley kicked came after Joubert bought a cute piece of play from Will Genia who threw a pass, purposefully, against a retreating Mark Bennett.

THE UPSETS

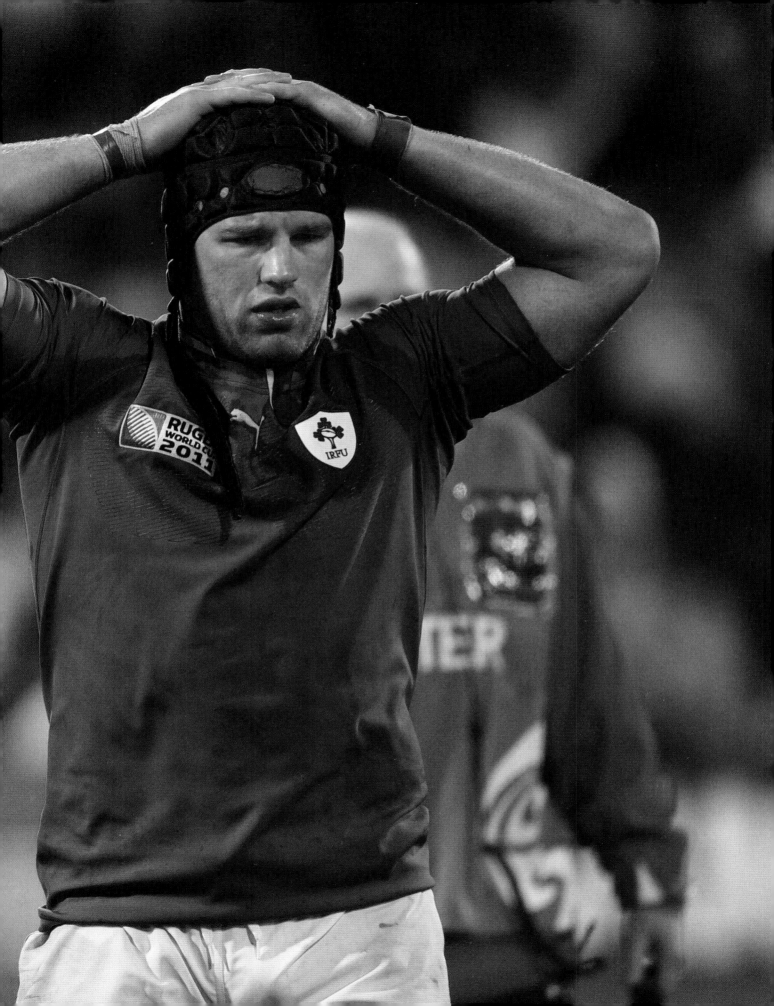

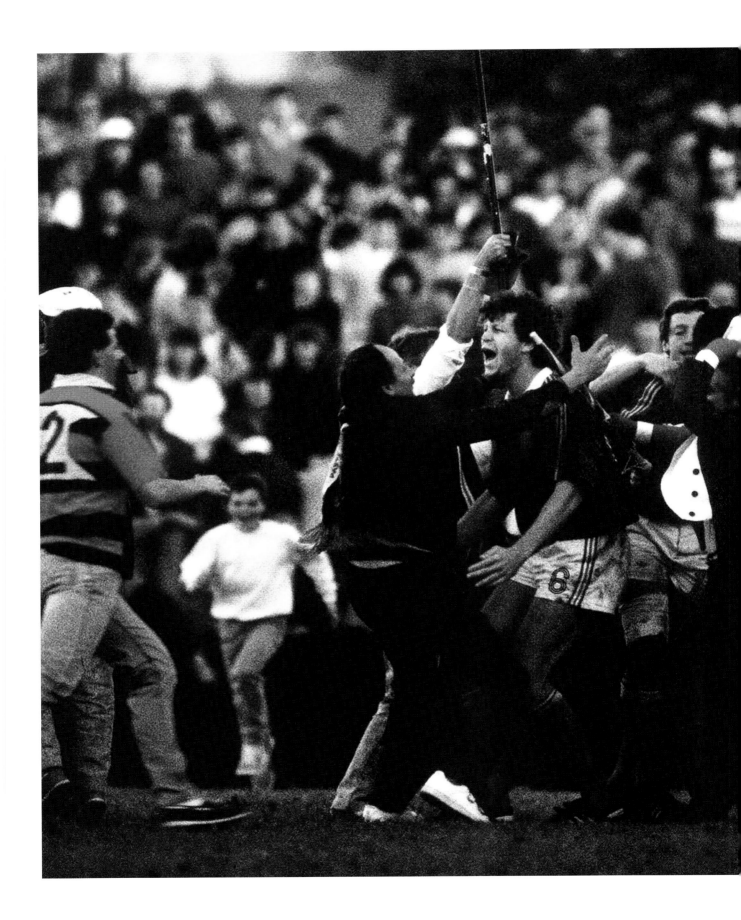

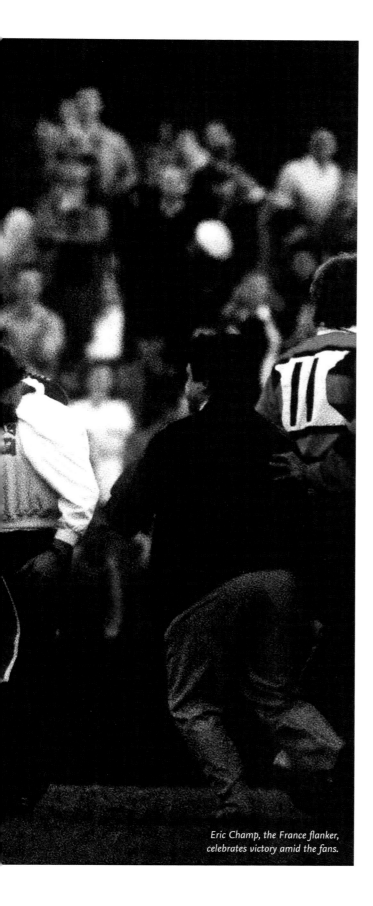

France hit the high notes

New Zealand and Australia 1987
Australia 24 France 30
13 June 1987
Concord Oval, Sydney
Semi-final

FROM DAVID HANDS, RUGBY CORRESPONDENT

It was a French colleague, en route to Concord Oval, who referred to the "superbe ambience" of a Sydney jazz club he had discovered. Five hours later his countrymen, blowing their own magnificent brand of hot music, had created an ambience all their own as they made their way into the final of the inaugural World Cup.

Has there been a game like it, given the context? Within the space of four months France have been involved in two of the great games of rugby – the first against Scotland in Paris, the second at Concord, where a try by Serge Blanco five minutes into injury time reduced the confident Australian challenge to the play-off for third place on Thursday. [...]

France's victory must be ranked alongside their epic 9-5 win in South Africa in 1958, and their 24-19 win over New Zealand in Auckland in 1979. "I'm sure this victory has done an immense amount of good for the game," Alan Jones, Australia's coach, said. "But to have been part of that is something we're grateful for and if it's given a fillip to European rugby as a result of the fact that France has tilted at a rather large windmill and brought it down then that's also good.

"We've got to be international in our perspective. Our disappointment mustn't be allowed to cast a pall over what has been, I guess, a fairly spectacular game."

Wales snatch victory at the death

New Zealand and Australia 1987
Wales 22 Australia 21

18 June 1987
Rotorua International Stadium,
Rotorua | Third place play-off

FROM GERALD DAVIES, ROTORUA

No-one gave Wales a chance here yesterday. All the pre-match talk was of figures. What, in other words, would Australia's final total be in the match to decide third and fourth places? Would they surpass New Zealand's? The meat of the debate, such as it was, centred on this. Yet, by the end, amid mounting drama, Wales at last found a gap but only just in the fourth minute of injury time, to win by two goals, a try and two penalties to two goals, two penalties and a drop goal to find themselves to everyone's surprise, including their own, in third position. [...]

Australia had been reduced to 14 men after only four minutes when David Codey, the flanker, was sent off. Codey had been warned in the first minute as a result of his violent play against Gareth Roberts. Three minutes later, extremely stupidly, he was found trampling dangerously at a ruck. [...]

As the game reached its climax, Jonathan Davies hoisted a high kick into the Australian 22, John Devereux jumped to recover it and see the ball return. Ieuan Evans took it on by running in-field and Mark Ring and Paul Thorburn did the rest to send Adrian Hadley in for the score. Yet, even after Thorburn had converted it, Australia mounted one last magnificent attack with Matt Burke making most of the running from his own half. It very nearly took the cup of celebration from Wales's lips.

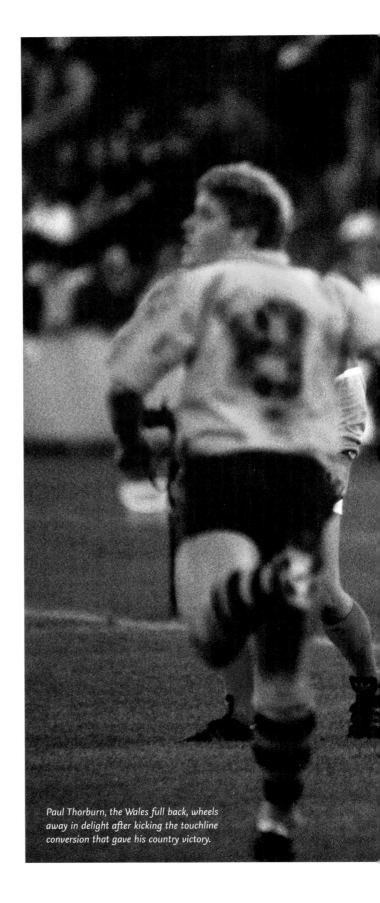

Paul Thorburn, the Wales full back, wheels away in delight after kicking the touchline conversion that gave his country victory.

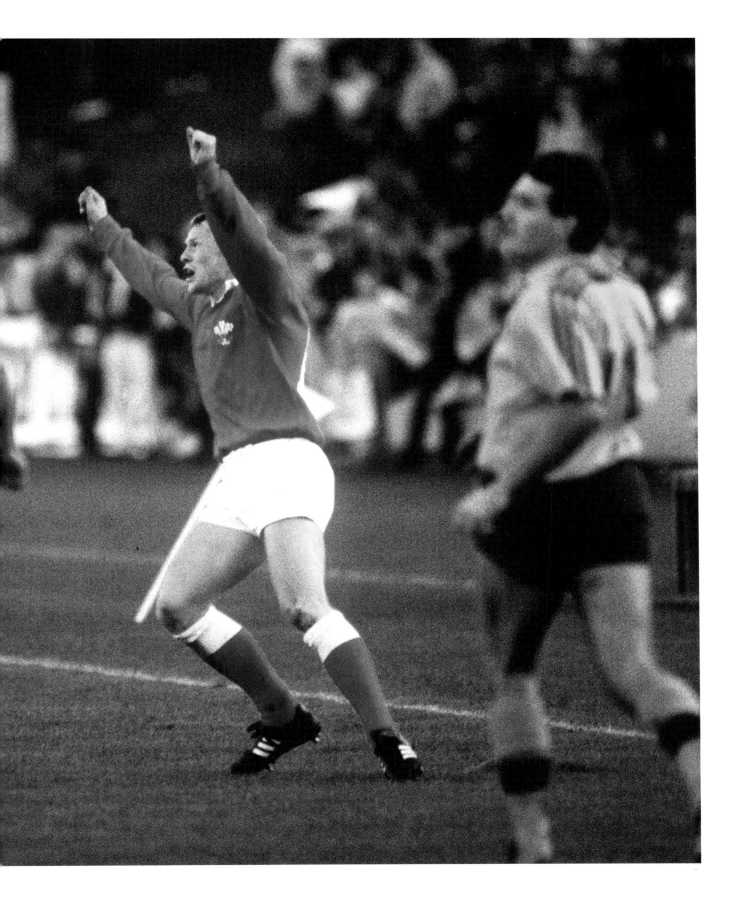

Samoan strengths become apparent

Britain, Ireland and France 1991
Wales 13
Western Samoa 16

6 October 1991
Cardiff Arms Park, Cardiff
Pool 3

BY GERALD DAVIES

Western Samoa created a piece of rugby history at Cardiff Arms Park yesterday. In their first appearance on the World Cup stage the small nation, with barely 2,000 players, succeeded brilliantly in inflicting a defeat on one of the traditional bastions of the game.

With an intense performance of powerful forward play, commitment to winning and keeping available possession, the Samoans sent Wales, with their reputation grievously dented once more, reeling back to their camp to ponder what happens next. Indeed, this outstanding victory by a goal, a try and two penalty goals to a goal, a try and a penalty goal, raises the question as to what other surprises are in store in the remaining matches in pool 3.

On being asked back in the summer, on Manly Beach outside Sydney, to define the strengths of Western Samoa, their manager, Tate Simi, replied with a smile that none of the World Cup countries believed they had any. With an even broader smile, his team should have left no one in any doubt after yesterday's match what these strengths now are.

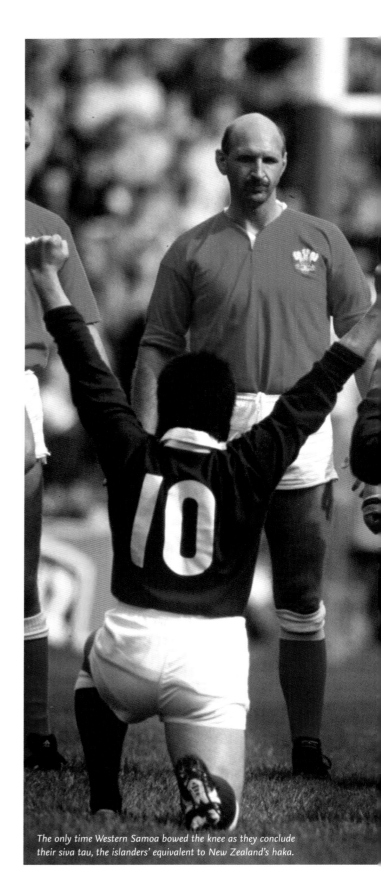

The only time Western Samoa bowed the knee as they conclude their siva tau, the islanders' equivalent to New Zealand's haka.

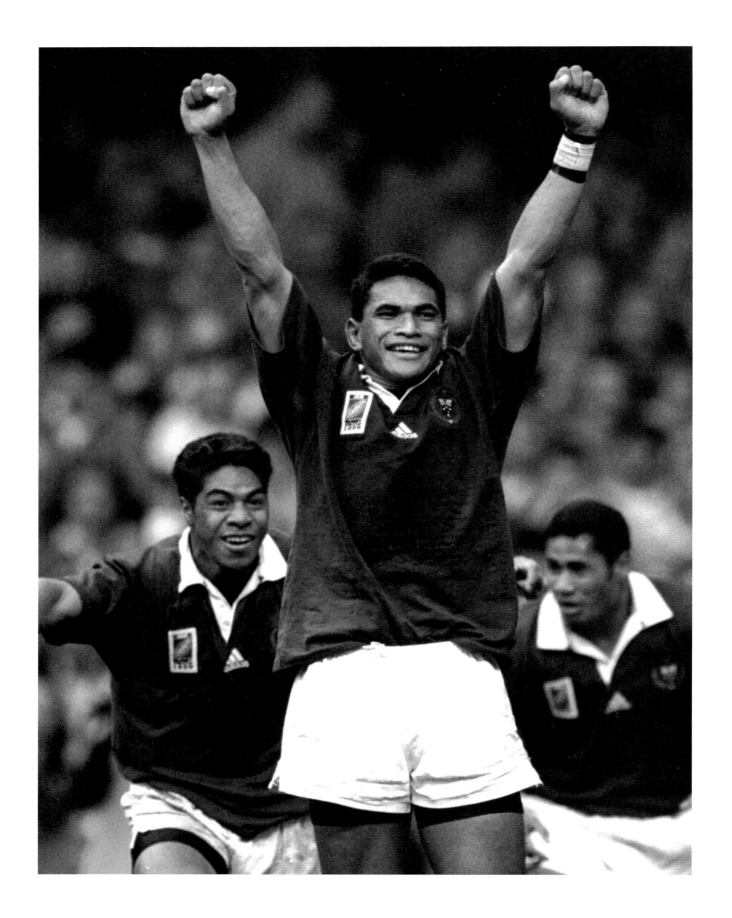

And for an encore...

Britain, Ireland and France 1999

Wales 31 Samoa 38

14 October 1999
Millennium Stadium, Cardiff
Pool D

BY JOHN HOPKINS

The match yesterday lacked nothing in tension from the moment that Samoa took the lead in the first minute to the moment when Ed Morrison, the referee, blew his whistle to signify the end and every Samoan replacement – and a good many others – ran on to the pitch to celebrate. Samoa had, for the second time in the 1990s, humbled Wales in their capital city, this time scoring five tries to one and two penalty tries in reply.

This was the shock result that Graham Henry, the Wales coach, had feared and it came with his team on the very cusp of immortality. Victory would have given them a run of 11 successive wins, more than any other team in Welsh history. But instead of celebrating that and the fact that Neil Jenkins set a world record of 927 points in international rugby, Wales had to take a back seat to Samoa's celebrations.

The men from the Pacific islands, who had been so disappointing in the wind and rain of Llanelli last Sunday when they were beaten by Argentina, played the game of their lives and rediscovered their pride with a performance that was stunning in its tactical appreciation and execution. "I am bursting with pride," Bryan Williams, the Samoa coach, said.

"We were in the pool of death. We had to re-group after last Sunday. There was no cause to celebrate that game. I think this victory means more to us than the one in 1991. We were more of an unknown quantity then and Wales were in some disarray. Now Wales have obviously been beating everyone and victory was against the odds. We were not so much the under-dogs as the under-puppies."

Semo Sititi (centre) and his team celebrate Samoa's moment of triumph.

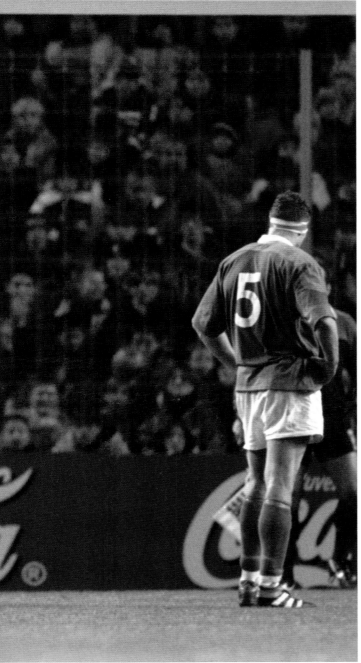

Wyllie approach leaves Irish eyes smarting

Britain, Ireland and France 1999
Argentina 28 Ireland 24
20 October 1999
Stade Félix Bollaert, Lens
Quarter-final play-off

FROM MARK BALDWIN

Alex Wyllie, the Argentina coach, is wily by nature as well as by name. He is also known throughout rugby as 'Grizz', because of his battle-scarred appearance and no-nonsense attitude. This victory, wrecking Irish dreams and the first real shock of the World Cup, had his signature written large all over it.

A brilliant 72nd-minute try by the left wing, Diego Albanese, quite out of character with what had gone before, followed by a magnificent touchline conversion by the supreme place-kicker, Gonzalo Quesada, settled a contest that will be remembered, too, for an extraordinary finish.

Quesada, with his seventh penalty a minute from the end of normal time, seemed to have clinched the game for the Pumas. But, as nine minutes of injury time appeared, Ireland realised that a try would be enough. A series of penalties allowed them to batter the Argentina line, but to no avail. The Pumas' defence was heroic as wave after Irish wave crashed down on it and, when Stuart Dickinson, the referee, blew the final whistle, Paul Wallace was literally inches from glory as he burrowed for Argentina's line.

Gonzalo Quesada kicks one of seven penalty goals to crush Irish hopes.

Finally France cut loose

Britain, Ireland and France 1999

France 43
New Zealand 31

31 October 1999
Twickenham, London
Semi-final

BY DAVID HANDS, RUGBY CORRESPONDENT

Magnifique. The French, as always, have a word for it and at Twickenham yesterday, that word was victoire. In one of the greatest reverses rugby union has seen in its entire history, never mind the brief 12-year history of the World Cup, France overturned the tournament favourites, New Zealand, with a display of such blazing commitment that it is they who will play Australia in the final on Saturday.

Nothing this year has hinted that France had a display such as this within them. One scrappy win in the Five Nations Championship, a disastrous tour of the southern hemisphere during which they lost 54-7 to the All Blacks in Wellington, defeat by Wales in their warm-up game and less than confident progress through their World Cup pool. And now they are the country which has scored most points against any New Zealand team.

Only in 1986, against New Zealand in Nantes, and in 1987 in the World Cup semi-final against Australia in Sydney can one recall France producing a comparable performance. Here, from a position 45 minutes into the game where they trailed 24-10,

they scored 33 points without reply; seldom have New Zealand looked so disorganised in defence and so naive in leaving yawning gaps into which the French poured.

Olivier Magne, the Brive flanker, utterly outclassed Josh Kronfeld who, hitherto, was a candidate for player of the tournament. Fabien Pelous and Olivier Brouzet, who came into the game as a replacement, have never produced such wonderful displays at the heart of the rolling French maul. Pelous helped create a platform from which Fabien Galthié – who was not even selected for the original World Cup squad – and Christophe Lamaison utterly dominated their opposite numbers.

In answering every question of their critics, only one query remains: whether, as in 1987, France have now played their final and can raise their game in Cardiff against an Australia side for whom defensive organisation is a creed.

France rejoice at Twickenham after beating tournament favourites,
New Zealand, in the 1999 World Cup semi-final.

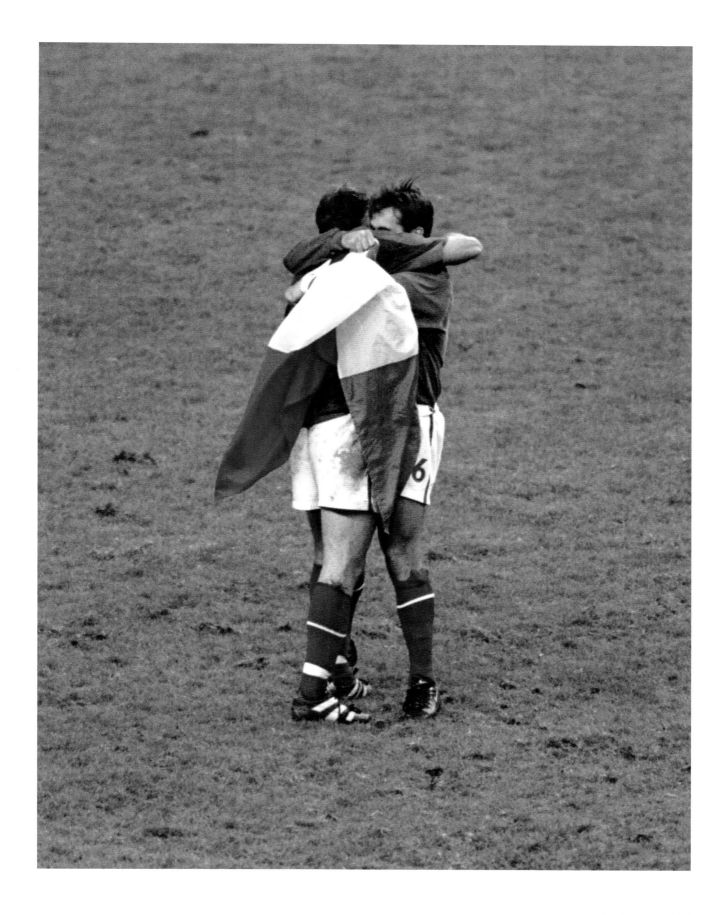

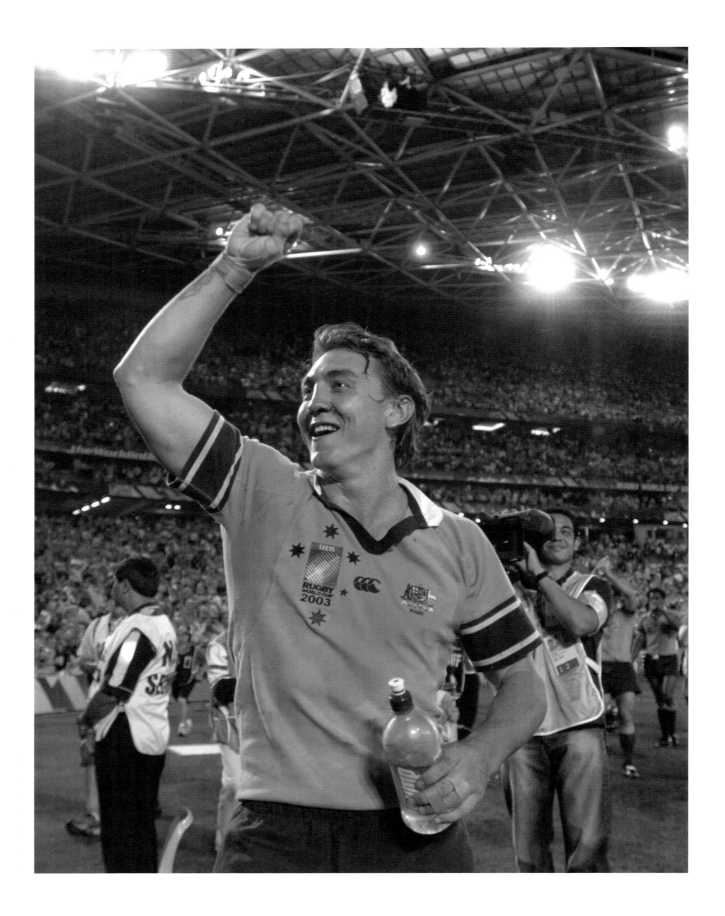

Australia put bodies on the line

Australia 2003

Australia 22
New Zealand 10

15 November 2003
Telstra Stadium, Sydney
Semi-final

FROM DAVID HANDS, RUGBY CORRESPONDENT

The meteorological department gave warning of warm weather in Sydney over the weekend. They did not advise that Australia would be running so hot at Telstra Stadium on Saturday that New Zealand would be left like so much washing in the breeze, black shirts hung out to dry by as devastating a game plan as the World Cup has seen.

This was not Twickenham 1999 all over again, when half an hour of French inspiration blew gaping holes in New Zealand aspirations. This was Australia taking the first semi-final by the throat from the moment the game began and sustaining their grip, against all expectations, for the entire match.

The question was asked, as Ben Darwin was carried off, as Stirling Mortlock and George Gregan limped off, as Nathan Sharpe wobbled off, whether they can possibly reach the same heights in the final, their third in five tournaments, on Saturday. The only answer is that this is Australia, that their capacity to find the winning performance in sport appears to know no limit, however battered and weary the bodies may have been yesterday.

That New Zealand, who scored 50 points against Australia here less than four months ago in the Tri-Nations, were left looking callow will provoke a flurry of demands for change, for the heads of John Mitchell and Reuben Thorne, as this team followed where those of 1991 and 1999 went before.

Mat Rogers shares the joy of winning with the crowd.

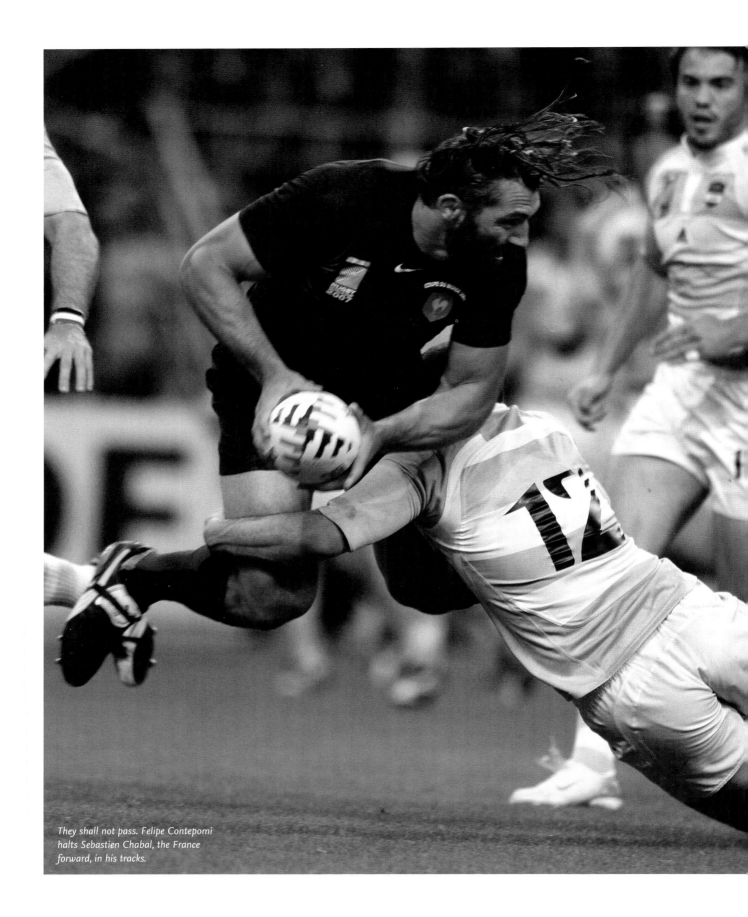

They shall not pass. Felipe Contepomi halts Sebastien Chabal, the France forward, in his tracks.

Lights go out in Paris

France 2007
France 12 Argentina 17
7 September 2007
Stade de France, Paris | Pool D

DAVID HANDS, RUGBY CORRESPONDENT

Le jour de gloire est arrivé? Not yet it hasn't. France, who have invested so many hopes in this sixth World Cup, fell at the first hurdle at the Stade de France as a grey Parisian day turned into the blackest of nights for the host country.

Argentina, however, have suddenly discovered the brightest of highways through pool D, that was long ago nicknamed the pool of death. Nor was their success by any means a fluke. Felipe Contepomi kicked his goals, but the entire side played with a confidence and understanding that was far beyond the frail French.

Raphael Ibanez, their captain, acknowledged as much and though the London Wasps hooker muttered that "there are three games left and we will give them everything", this was a shattering blow. Argentina can now make hay against Georgia and Namibia before they meet Ireland at the end of the pool phase and the significance of Ireland's meeting with France in Paris on September 21 will have escaped no-one.

The French will fling whatever is their equivalent of the kitchen sink at the Irish, but at the back of their minds will be the possibility that they might not even make it into the knockout rounds. No team that has lost a pool match has ever gone on to win any of the past five World Cups.

Wales washed away in Pacific tide

France 2007

Wales 34 Fiji 38

29 September 2007
Stade de la Beaujoire, Nantes
Pool B

FROM JOHN HOPKINS

If, before the start of this match, anyone still thought that Fiji were sevens experts and little else, then this was the game that should have rid them of that outdated view. It was quite sensational, the best of the tournament to date; one in which the lead changed hands six times and it was deservedly won by Fiji, who led by 12 points after 20 minutes, 22 points after 25 and by 15 at half-time.

There was something approaching fury in their scrapping for the ball in the contact area and their ability to pick up the ball and make ground with it was stunning. Although they reached the quarter-finals in 1987, their excitement after this game made you think this was a far greater achievement. It was their first victory over Wales in seven games. It has always been said that if you give the ball to Fiji, you are playing with fire. Wales found this to their cost.

Fiji celebrate their dramatic win over Wales. In the immediate aftermath of this match, Wales sacked Gareth Jenkins, their coach.

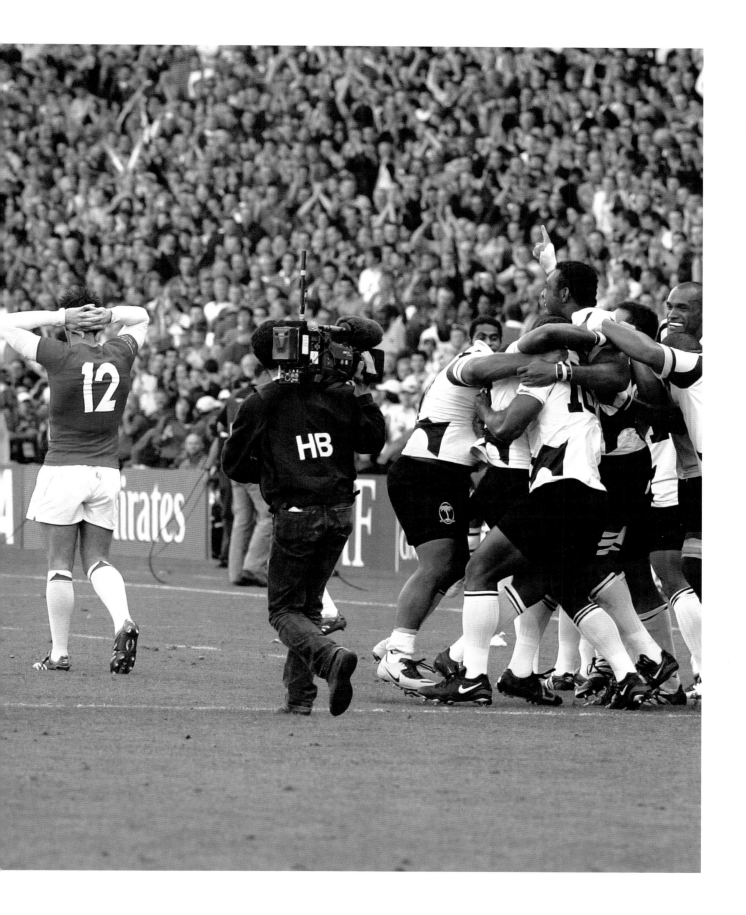

France stop All Blacks in their tracks

France 2007

France 20

New Zealand 18

6 October 2007
Millennium Stadium, Cardiff
Quarter-final

BY JOHN HOPKINS

Incroyable! France positioned a centre at full back, brought in a youngster with little experience at this level at fly half, played the wrong tactics, lost their most destructive forward and conceded 13 points in the first 29 minutes.

Could anything more have gone wrong? Yet France scored 20 points in 41 minutes and won by two points to reach the semi-final. Incroyable squared! After half an hour, France looked to be on track for a 30-point defeat. Luke McAlister had sliced them open twice and Ali Williams, having crossed the line, had a try disallowed. Surely, Bernard Laporte, the France coach, was preparing for his life after the World Cup as a minister in President Sarkozy's Government? Laporte was on his way home; the quarter-final was going to the All Blacks.

Instead, it was Graham Henry, the New Zealand head coach who may resign, who had to return home to face the music after his country's worst showing at a World Cup. He did it with dignity. "France had an astute game plan," he said. "They defended superbly, with huge passion."

Bernard Laporte, the France coach, embraces his wing, Christophe Dominici.

Ireland paint a green path

New Zealand 2011

Australia 6 Ireland 15

17 September 2011
Eden Park, Auckland | Pool C

DAVID HANDS

Suddenly all those theories about a predictable last eight in this World Cup have gone out of the window. Whereas the optimist could conjure up a final next month between England and the best of the southern hemisphere, now a green-painted path can be seen by which Ireland might not only reach their first semi-final, but the final itself.

Such thoughts will hardly be contemplated yet by Ireland's management as they rest in Taupo from Saturday's 15-6 win over Australia, the Tri-Nations champions. But those less inhibited about such predictions will foresee pool wins over Russia, in Rotorua next Sunday, and Italy, in Dunedin on October 2, giving Brian O'Driscoll and his warriors a likely quarter-final against Wales.

What Ireland have certainly done, on a weekend when the northern hemisphere bit back (albeit somewhat toothlessly in the case of England and France), is open up the draw into a north-south divide.

Caught in a green web – Brian O'Driscoll (left) and Keith Earls hold up Australia's Quade Cooper. Ireland lost 22-10 to Wales in the quarter-finals.

Tongans go crazy

New Zealand 2011
France 14 Tonga 19
1 October 2011
Wellington Regional Stadium,
Wellington | Pool A

FROM NICK CAIN

Tonga delivered the upset the 2011 World Cup desperately needed and France suffered the humiliation they deserved in the Pacific islanders' final match of the tournament in Wellington. The French had the big, fat, comfortable cushion of knowing that even if they lost this game, as long as they did not concede four tries and a shedload of points, they were still going through to the quarter-finals – and they played accordingly. Like drains.

That may be bad news for England before Saturday's quarter-final in Auckland because no sooner do France plumb the World Cup depths than they produce their one great game of the tournament. However, had Tonga truly believed that they were capable of scoring four tries, rather than relying for the most part on the boot of their fly-half, Kurt Morath, for points, they might have pulled off an even bigger upset, so dislocated were the French.

However, the Tongans, for all their fire and running, did not have the conviction to do it. "The win tonight, you people don't know what it means to me and to our people back in Tonga," said coach Isitolo Maka. "In Tonga right now our people are going crazy. We are going to get a lot of support when we get to Auckland tomorrow. For us to beat France is very special and it's good for Tongan rugby and for our people."

Tonga's players greet overjoyed fans after defeating France.

Ireland KO champs

France 2014
New Zealand 14
Ireland 17
5 August 2014
CNR, Marcoussis | Pool B

All great runs come to an end but no-one expected the Black Ferns, unbeaten in World Cups for 23 years, to go down to Ireland in pool play and fail to reach the knockout phase. It remains probably the greatest upset in the women's tournament, particularly after the New Zealanders took an early 8-0 lead.

But they could score only the one try, by Selica Winiata, and that from an Irish error, relying for points otherwise from the boot of Kelly Brazier. Ireland's No 8, Heather O'Brien, mauled her way over for her side's first try and a powerful counter-attack by Niamh Briggs, Ireland's outstanding full back, paved the way for an excellent finish in the corner by the wing, Alison Miller.

Briggs converted both tries and, with ten minutes remaining, kicked the penalty which made the difference between the sides although Ireland finished the stronger.

DAVID HANDS

Niamh Briggs kicks Ireland to victory.

Japan the rising sons

England 2015
South Africa 32 Japan 34
19 September 2015
Brighton Community Stadium,
Brighton | Pool B

BY ALEX LOWE

Steve Borthwick, the Englishman at the heart of the Japan team, warned Scotland that the Brave Blossoms will be ready to shock the world again when the sides meet at Kingsholm on Wednesday, despite the scandal of a four-day turnaround.

Japan produced the biggest upset in the history of world rugby on Saturday night when Karne Hesketh justified the bold decision by Michael Leitch – the influential captain who refused to settle for a draw – by arrowing into the corner for the try that defeated South Africa and tilted world rugby on its axis.

"Veni, vidi, vici," Keiichi Hayashi, the Japanese ambassador to the United Kingdom, tweeted after the game, as Brighton descended into a state of pandemonium. "History made," Japan supporters cried in the stands and hugged each other in the fan zone down on the beach.

While Brighton was turning Japanese, a country where the sporting landscape is dominated by baseball and football was being turned back on to rugby. Japan's triumph not only dominated the back pages but also led the news agenda.

Japan take their encore before an exultant Brighton crowd.

Wales seize the day

England 2015
England 25 Wales 28
26 September 2015
Twickenham, London | Pool A

BY GARETH THOMAS, FORMER WALES CAPTAIN

This was the greatest Welsh victory I have ever been privileged to witness. It was how Wales created that scoreline that was so impressive, the manner in which Wales won with no more backs left and Lloyd Williams, a scrum half, on the wing. You can pick out any number of individuals, but for me it was a team performance.

The turnaround began when Wales brought their replacements on and England gave the Welsh too much time to settle. England had Wales in a stranglehold but they relaxed. I believe they thought the win was going to come quite easily. They took the pressure off Wales.

There was a surge from Wales and that surge kept going. England did not fight back. They surrendered the momentum. Wales are always better when they are underdogs. When one Welshman has his back against the wall, let alone 23 proud Welshmen and 20,000 Welsh supporters screaming their heads off, then they are going to grab the momentum if it is offered to them – and it was.

Wales celebrate their win over England, who are left dejected after their pool A match defeat.

Romania hit back

England 2015
Canada 15 Romania 17
6 October 2015
Leicester City Stadium, Leicester
Pool D

MATT HUGHES

As the minor nations prepare to leave a tournament to which they have contributed far more than their humiliated hosts, DTH van der Merwe seems a fitting symbol of their encouraging progress. The Canada wing made history by becoming the first player from a Tier 2 team to score tries in four successive World Cup matches, although his exploits were not enough to prevent Canada finishing bottom of group D after Romania's stunning second-half fightback. [...]

It took a 77th-minute penalty from Florin Vlaicu to complete Romania's comeback from the perilous position of being 15-0 down with less than 30 minutes remaining. And after the final whistle their players conducted a lap of honour bearing national flags as if the presentation of the World Cup was imminent. In one respect, though, the celebrations were fitting as, while they probably did not know it, they had achieved the biggest comeback in World Cup history.

Florin Vlaicu, Romania's wing, kicks the goal that took Romania into the history books.

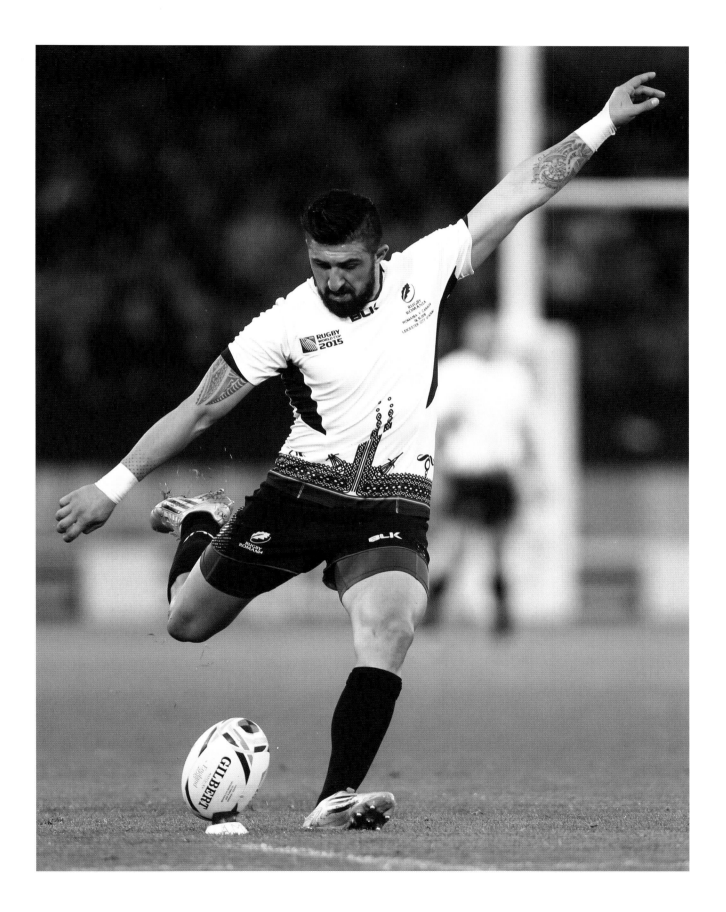

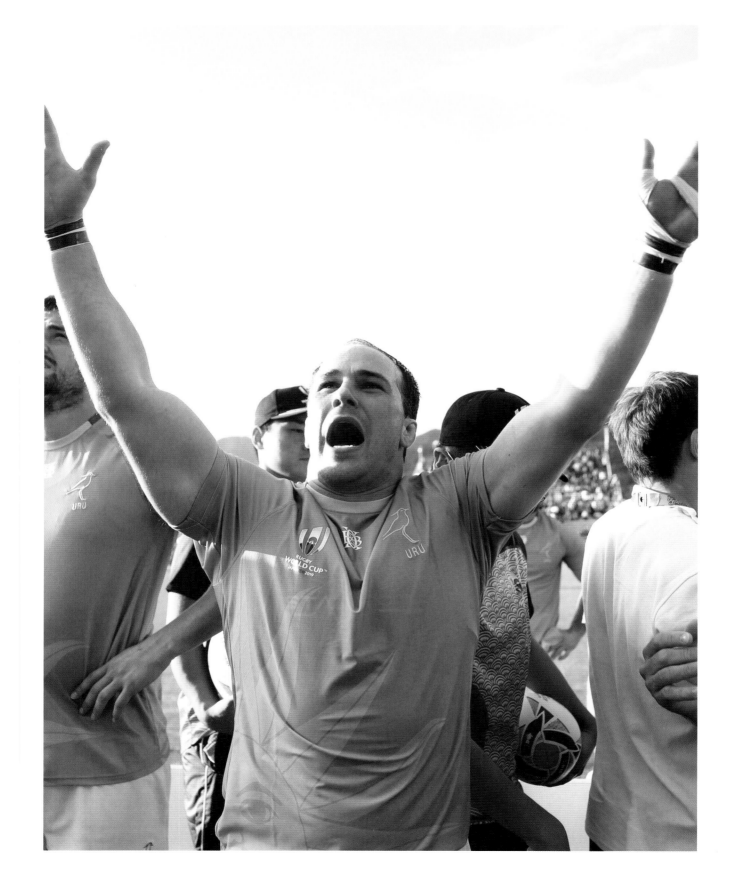

Uruguay's greatest day

Japan 2019
Uruguay 30 Fiji 27
25 September 2019
Kamaishi Recovery Memorial
Stadium, Iwate | Pool D

STEVE JAMES

The shock of the tournament and a magnificently uplifting victory for Uruguay, this result probably now gives Wales and Australia a free run to the top two qualifying spots in pool D. This was only Uruguay's third victory in World Cups, after wins over Spain in 1999 and Georgia in 2003, but it was undoubtedly their biggest triumph, their greatest day.

The fact that Uruguay were beaten 68-7 by Fiji at Hartpury College in a friendly less than 12 months ago makes the scoreline even more remarkable. Even though this was a sensational result, this was also about so much more than just the rugby. This match was played at the Kamaishi Recovery Memorial Stadium and indeed it is some recovery that this port town in the north-east of the country has made since the terrible tsunami that hit the area in 2011.

The stadium was built on the former site of two schools and has been seen as the focal point in the rebuilding of the rugby-mad area, a beacon of hope and healing. This match here was a celebration of both rugby and revival.

Uruguay deserved this. Their attitude, commitment and skill levels were quite superb. Yes, Fiji were handicapped by a short turnaround after losing to Australia five days previously; they made 12 changes to their side, and were obviously complacent and lackadaisical, but Uruguay's ambition, composure and desire never faltered. Los Teros believed they could win and they did. [...]

Juan Manuel Gaminara, the flanker and captain who had an outstanding match, was in tears afterwards. "I'm really proud of my country," he said. "We're not the biggest, we're not the tallest, but we came here to win. We've been preparing for this for four years. Thanks to all the people who are here and all the ones who came up early to see the match, [I] say hi to them, they believe in us. I don't want this to end. And also, thanks for this city. Its story is really amazing so it's really a privilege to play."

Juan Manuel Gaminara, Uruguay's captain, salutes his supporters.

OFF THE BALL

Home from home

Britain, Ireland and France 1991
Italy 30 USA 9
5 October 1991
Cross Green, Otley | Pool 1

It would not happen now, the World Cup having grown out of short trousers and capable of filling some of football's bigger stadiums, let alone traditional rugby strongholds. But in 1991, the tournament's second edition and the first in the northern hemisphere, no-one was quite sure how avid the public appetite was for matches between tier two and three countries.

Otley, though, already had a claim to fame, as the venue where England's Northern Division beat Graham Mourie's touring All Blacks in 1979. Roy Manock, one of Yorkshire's representatives on the RFU committee, lobbied hard for a match in his home county and his reward was the pool game between Italy and the USA, to be played in the small market town whose rugby team, these days, feature in the fourth tier of the English club game.

The capacity then and now is 5,000, the grass was a trifle longer than the Italians liked but a bumper crowd turned up and were rewarded with a sparkling contest and five Italy tries to one by the Americans, one of them an absolute gem from Ivan Francescato, the Italy scrum half. Cross Green was the most homely of venues but they still remember the day when the world turned up on their doorstep.

DAVID HANDS

Cross Green, the smallest ground to host a World Cup match.

Joy is unconfined

South Africa 1995
South Africa 27
Australia 18

25 May 1995
Newlands, Cape Town | Pool A

FROM MICHAEL HAMLYN

South Africans were jubilant after the Springboks trounced Australia, the reigning world champions, by 27 points to 18 in the opening match of the Rugby World Cup in Cape Town. Not even the arrival of democracy a year ago could match the supreme feelings of pleasure in the faces of all races in the streets around the Newlands rugby ground behind Table Mountain as the reality of the hosts' dream-like opening to the competition sank in. [...]

The restored Victoria and Albert entertainment area on the wharf rocked with celebration as what seemed to be the entire population of the Mother City enjoyed a jol, Afrikaans for a party. Blacks and Coloureds saw it as their victory as well, even though the side fielded only white players because of the injury of the winger, Chester Williams. [...]

The victory engulfed the nation in a nationalistic fervour more powerful than that which rallied the country at the inauguration of President Mandela. A Coloured man stood outside the ground last night and yelled: "We are going to kick their ass, again," expressing a thought in every spectator's mind, for Australia and South Africa may well meet again in the final.

South African supporters acclaim their side's victory.

Winning in the rain

South Africa 1995
South Africa 19
France 15

17 June 1995
Kings Park Stadium, Durban
Semi-final

FROM DAVID HANDS, RUGBY CORRESPONDENT

When the debate about playing a World Cup semi-final in conditions more appropriate to a swimming gala ends, the plain fact remains that South Africa have done what they set out to do. Like the host unions who preceded them – New Zealand, in 1987, and England, in 1991 – they have reached the final of the tournament and have the chance to win a sporting prize that means more to them than anything. [...]

For a comparison of playing conditions, the nearest that springs to mind is the water-splash international between New Zealand and Scotland in Auckland in 1975. Coincidentally, the experience gained by the South Africans during their tour to New Zealand last year left them in good stead. They adapted their game to the boggy field and stuck to it.

Take a mop to it – ground staff and their squeegees triumph over the conditions.

High-flying Springboks

South Africa 1995
**South Africa 15
New Zealand 12
(after extra time)**
24 June 1995
Ellis Park, Johannesburg | Final

O nly South Africa could have got away with it. First there was a growing roar which, for those perched in the media overspill area at the top of the main stand, seemed to be coming from behind us. Then an ear-splitting rumble which shook the entire stand before a Boeing 747 swept over the stadium almost, it seemed, within touching distance.

The players themselves, in the changing rooms, were shaken. In fact the aeroplane was 200 feet above the stadium, where the normal minimum clearance over a major city is 2,000 feet. But South African Airways, seeking a marketing boost, had negotiated the fly-by with the civil aviation authorities who cleared all other traffic within a five-mile radius out of the way.

On the underside of the wings were printed the words 'Good Luck Bokke': "I wanted us to send a message down to the stadium, that we were strong and we were going to win," Captain Laurie Kay, the pilot, told John Carlin in his book *Playing The Enemy*. "And so yes, we emptied all the power we could muster into the stadium."

DAVID HANDS

The Boeing 747 sweeps low over Ellis Park.

Romania rise to the occasion in Tasmania

Australia 2003

Romania 37 Namibia 7

30 October 2003
York Park, Launceston | Pool A

FROM ASHLING O'CONNOR

Tasmanians are the most overlooked of Australians but yesterday they were at the centre of the rugby world when Romania beat Namibia 37-7 in the first World Cup match to be held in the state known as the Apple Isle. There can never have been a more surreal match of international rugby. Fifteen east Europeans playing 15 south-west Africans for the pool A wooden spoon on Australia's closest point to the Antarctic Circle.

Zeffy Montgomery, a ten-year-old whose school produced a banner for the Namibia team, summed it all up. "I think I'd heard of rugby, but not Namibia," she said. Tasmania is not a rugby state and its 500,000 inhabitants cannot even support an Australian Football League team. Yet more than 15,000 people turned out for a match between two teams who collectively had conceded 458 points in the tournament before yesterday's match.

Residents born on even days of the month were supporting Namibia, while the "odds" threw their weight behind Romania. The idea, conceived by Janie Dickenson, the Mayor of Launceston, also stretched to high-street shops and was a hit with the locals. The mayor herself, however, bizarrely chose to visit her boyfriend in Singapore rather than attend her city's moment of glory. Tasmanians are the butt of Australian jokes as much as the Welsh and the Irish are to the English. But Tasmanians rather like being set apart from the rest. It allows them to keep their lush, beautiful piece of Australia to themselves.

Bernard Charreyre, Romania's coach, is thrown in the air as players celebrate their victory over Namibia.

OFF THE BALL | 203

Mind that cow

England 2010
England 27 Ireland 0
20 August 2010
Surrey Sports Park, Guildford
Pool B

PATRICK KIDD

The England women's rugby union team, who began their World Cup against Ireland in Guildford last night, have to let their coaches know each week of any physical exercise they do over and above the planned training routines. Sophie Hemming's forms always provide a giggle.

"She picked up a slight injury a few weeks ago on one of her sprint sessions," Gary Street, the England head coach, said of the prop, who is a West Country vet in her other life. "She was sprinting up and down a field in the dark and ran into a cow. I imagine the cow came off worst."

Then there is the weight work that she does by lifting bales of hay and the tackling practice she gets from trying to grab a pregnant sheep at lambing time. Ideal preparation for taking on New Zealand later in this tournament perhaps?

"Wrestling cows complements the rest of my training," Hemming, 30, said. "About half my work is with large animals." [...]

She is glad that women's rugby still allows a normal career. "It's fantastic I can do both, even if it leaves me exhausted when I come back from a night on call and have to hit the gym," Hemming said. "You need to be physical to be a vet. Calving can take two or three hours, by the end of which you are soaked through. That goes down on my form as extra training."

Sophie Hemming getting ready for England's first match of the 2010 tournament against Ireland.

Look back in sadness

New Zealand 2011

FROM MARK SOUSTER

This was the red zone yesterday, the heart of Christchurch that had been shattered by the devastating earthquake on February 22: 22/2 is this city's equivalent of 9/11 in New York, or 7/7 in London. This, though, was caused by the destructive force of nature rather than terrorists. It measured 6.3 on the Richter scale and followed earlier earthquakes on September 4 and Boxing Day.

It hit at 12.51pm. The clock on the station stopped at that moment. It has not been restarted. One hundred and eighty-two people died. Many more were injured. This week should have been the start of the World Cup party for the city that rightly rejoices in being the rugby capital of the country and that is home to the Crusaders, the team of Dan Carter, Richie McCaw and countless other All Blacks. England were due to be based here, so, too, Australia.

The AMI Stadium, better known as the famous old Lancaster Park, was to stage seven matches, including two quarter-finals. On Saturday, England were supposed to play their first game there against Argentina. Instead of a celebration, however, there is sadness, despair, but also now, six months on, hope and desire rising from the rubble.

"We want to tell the world that we are open for business, that we can come back from this and that the area still has many attractions," Tim Hunter, the chief executive of Christchurch & Canterbury Tourism, said. It was to Christchurch that Martin Johnson, the England team manager, flew yesterday with Lewis Moody, his captain, three other players and Graham Rowntree, the scrum coach, in a gesture of goodwill and solidarity.

Martin Johnson, England's team manager, surveys the earthquake damage at the AMI Stadium.

Typhoon hits World Cup

Japan 2019

FROM OWEN SLOT, RUGBY CORRESPONDENT

On the eve of this World Cup, the great Italy captain, Sergio Parisse, posted a picture on Twitter of himself and two team-mates, Alessandro Zanni and Leonardo Ghiraldini. They are all in their mid-thirties and all have more than 100 caps. The accompanying message, translated from the Italian, read: "Proud and happy to play this last World Cup together."

Yesterday, less than a month later, these sentiments crumbled when the news broke. Ghiraldini hadn't actually played a game here in Japan yet and was set for a last run-out against the All Blacks. When he was told that the game had been cancelled because of Super Typhoon Hagibis, he broke down in tears. This was no way to end a career. [...]

As we know, Typhoon Faxai last month caused three deaths and \$443 million (about £360 million) of damage. Hagibis is estimated to be two and a half times the size. While we do not fully comprehend what is about to hit us, we do not know to what extent we should curb our rage about what is lost to the World Cup. We will have a better understanding when it has blown through.

Nevertheless, the anger was loud and clear yesterday. Parisse asked publicly if World Rugby would ever dare eliminate the All Blacks, or another such leading nation, from its tournament. Who knows? We just know for sure it would rather not.

International Stadium, Yokohama and the surrounding areas were flooded due to Typhoon Hagibis.

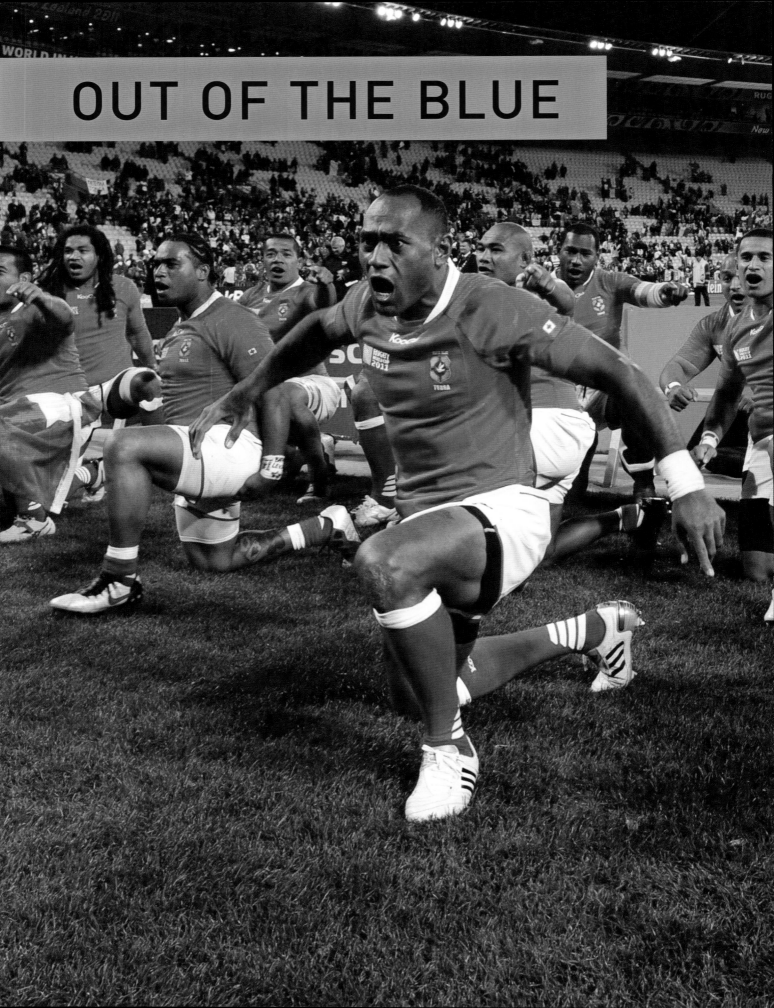

OUT OF THE BLUE

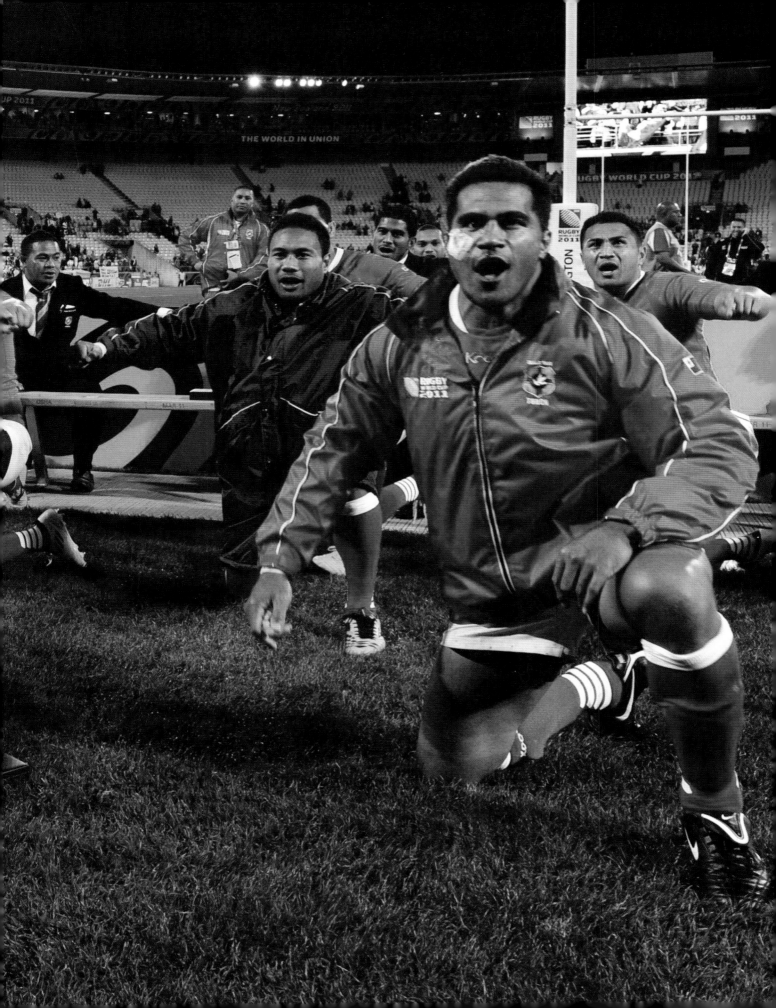

Backs to the wall

Britain, Ireland and France 1991

New Zealand 29
Canada 13

20 October 1991
Stadium Nord, Lille
Quarter-final

FROM DAVID HANDS, RUGBY CORRESPONDENT

Canada's maple leaf fell finally to the ground at the Stadium Nord here yesterday, but their performance in this World Cup leaves a lasting memory. Like the Western Samoans at Murrayfield on Saturday, they took a lap of honour around the rain-drenched stadium and 34,000 French, New Zealanders and a handful of Canadians paid them the tribute they deserved.

The reality of the last quarter-final was a match decided before the interval; the romance was Canada carrying the play to New Zealand deep into the final stages of a second half which they "won" 10-8, enhancing yet again the respect earned by a marvellously combative back row.

Canada's prop, Eddie Evans, gets the ball away watched by Al Charron, his flanker.

Over a point a minute

South Africa 1995

New Zealand 145

Japan 17

4 June 1995
Free State Stadium, Bloemfontein
Pool C

FROM JOHN HOPKINS, BLOEMFONTEIN

Astonishing is the only word for this performance by New Zealand here yesterday. Nobody could have dreamt there was going to be such disparity between these pool C teams when neither Wales nor Ireland could score more than 60 points each against Japan.

What was no less surprising was the appearance afterwards of the All Blacks management – Laurie Mains, coach, Colin Meads, the manager, and Brian Lochore, the campaign manager. They looked stony-faced, as though their team had lost instead of scoring 21 tries and breaking just about every possible record. Are they never satisfied – or were they, like many spectators, stunned at the clinical dissection they had just seen?

The All Blacks played sevens rugby, running in tries that began behind their own line. Marc Ellis seemed to be able to score at will – his six tries equalled the world record for an international match. New Zealand scored at the rate of one try every four minutes. [...]

Simon Culhane, who was making his debut for his country, set two records. The stand-off converted 20 of the 21 tries and then scored a try himself for a total of 45 points, thus edging past Gavin Hastings's 44 points compiled against the Ivory Coast. He had also beaten the world record points total for a man making his international debut, set by his countryman, Andrew Mehrtens, against Canada, before half-time.

Marc Ellis eludes Japan's Tsutomu Matsuda on his way to another try. Ellis made eight appearances for the All Blacks between 1993-5 and Culhane six between 1995-6.

Uruguay glee in Gala

Britain, Ireland and France 1999
Uruguay 27 Spain 15
2 October 1999
Netherdale, Galashiels | Pool A

BY ALASDAIR REID

A successful World Cup is a vessel of delight as much as glory. Uruguay's victory over Spain in Galashiels on Saturday afternoon may not have had the resonance that will result from some of the mightier collisions the tournament has in store.

There was an element of absurd exaggeration in Daniel Herrera, their estimable coach, with his post-match declaration that beating Spain was the equivalent of actually winning the World Cup but his glee was understandable when he reminded an Argentine journalist of the significance of the result. Uruguay's single victory was one more than South America's other representatives had managed over three tournaments.

Although Uruguay thoroughly deserved their win, they fashioned it in a style that would not unduly trouble Scotland and South Africa, their pool A opponents. Uruguay's victory owed much to the strength of a scrum, anchored by Pablo Lemoine, the Bristol tight-head prop, that brought them two tries. The first, after 23 minutes, fell to Diego Ormaechea, while the second was a penalty try, awarded when the Spain pack caved in.

Diego Ormaechea (centre), the 40-year-old vet, remains the oldest player to have appeared in the World Cup and he went on to coach his country in 2003.

Caucaunibuca steals show

Australia 2003
Scotland 22 Fiji 20
1 November 2003
Sydney Football Stadium, Sydney
Pool B

FROM JOHN HOPKINS

Scotland were unconvincing on Saturday. There were periods, particularly in the first half, when they looked tense and alarm bells rang out loudly in their ranks every time Rupeni Caucaunibuca got the ball.

Kenny Logan, who had the dubious pleasure of marking Caucaunibuca after Simon Danielli had been replaced just after half-time, spoke with reverence – and humour – of the size of Caucaunibuca's upper legs and the power they generate. "Never seen thighs like that before," Logan said, smiling. "They're awesome."

There have been a number of very fast runners in the pool stages of this competition but none can hold a candle to Caucaunibuca, who seems to take off at three-quarter speed. His two tries were accomplished with such ease that he would surely have been able to score a third and maybe a fourth after half-time if he had not been injured.

His second try, run in from 70 metres, looked as easy as a try scored in a sevens competition. Mac McCallion, the Fiji coach, felt that the turning point came when Greg Smith, the Fiji hooker, left the field in the 32nd minute. More likely, it was when Caucaunibuca was injured. "He has got more potential than any player I have ever been involved with," McCallion said.

Rupeni Caucaunibuca runs in his second try against Scotland.

Front-row union

France 2007
England 12 Australia 10
6 October 2007
Stade Vélodrome, Marseille
Quarter-final

FROM DAVID HANDS, RUGBY CORRESPONDENT

England, who have lurked in the shadows since winning the Webb Ellis Cup in Sydney four years ago, burst so unexpectedly into the sunshine of the semi-finals that it was hard to comprehend the degree to which this squad have improved in three weeks. They played a game that neither Australia nor the rest of us believed they could play, at the breakdown and out wide.

It all began with a set-piece solidarity they have not shown for nearly two years, and certainly not at this tournament. But the Herculean efforts of Andrew Sheridan and his colleagues in the scrum would have counted for nothing had not England won the collisions and displayed the confidence to challenge the Wallabies across the field. [...]

It was nourished throughout by the massive effort at the scrum. There were only three in the first half, all Australia's put-in, but each one painted a picture: the first was reset three times before Phil Vickery was penalised for taking his side down. The verdict clearly puzzled England but Vickery had only words of praise for Alain Rolland, the referee. "He has two teams who want to scrummage, whether it's legal or illegal, and it's the toss of a coin," Vickery said. "As the game wore on, Alain realised our pack were genuinely trying to scrummage and it went against Australia."

The second scrum wheeled and gave Australia a free kick, the third collapsed and Jonny Wilkinson's penalty attempt went wide from 26 metres. It was the second of three missed kicks by the fly half against two by Mortlock but by now, every time the scrum packed down, Australia knew a mountain of pain. Guy Shepherdson will not have encountered a more powerful man than Sheridan and, when he left, Al Baxter knew precisely what to expect because he had opposed Sheridan at Twickenham in 2005.

*England's Andrew Sheridan faces up to
Matt Dunning, Australia's prop.*

No average Joe

France 2007
France 9 England 14
13 October 2007
Stade de France, Paris
Semi-final

MARK SOUSTER

Individual moments of inspiration win matches and there is little doubt that Joe Worsley's last-ditch tap-tackle on Vincent Clerc kept England in the World Cup. Jonny Wilkinson's penalty and dropped goal may have proved decisive but it was Worsley's intuitive and instant appreciation of the danger England faced in the 68th minute that made the difference and prevented a near-certain try.

Without it, France, who led 9-8 at the time, would have been out of sight. As Bernard Laporte, their coach, rued yesterday: "If I kept one image, it would be the dropped goal from [Jonny] Wilkinson, which meant it was finished. The other image was the bootlace tackle on Vincent Clerc. If we scored, we were in the final."

Worsley had been on the field 15 minutes as a replacement for Lewis Moody and that he was comparatively fresh enabled him to track back more than 50 metres and bring down the France wing. "I saw about four or five of them lined up on the other side of the pitch so I just took a risk, cut behind the backline and got on my bike," Worsley said.

"I saw the kick coming and got there as quickly as I could. It was lucky I did because [Julien] Bonnaire did an amazing tap back to Clerc. I took a line, was slightly stumbling but just managed to dive and get a bit of his ankle."

Joe Worsley's bootlace tackle is enough to unbalance Vincent Clerc.

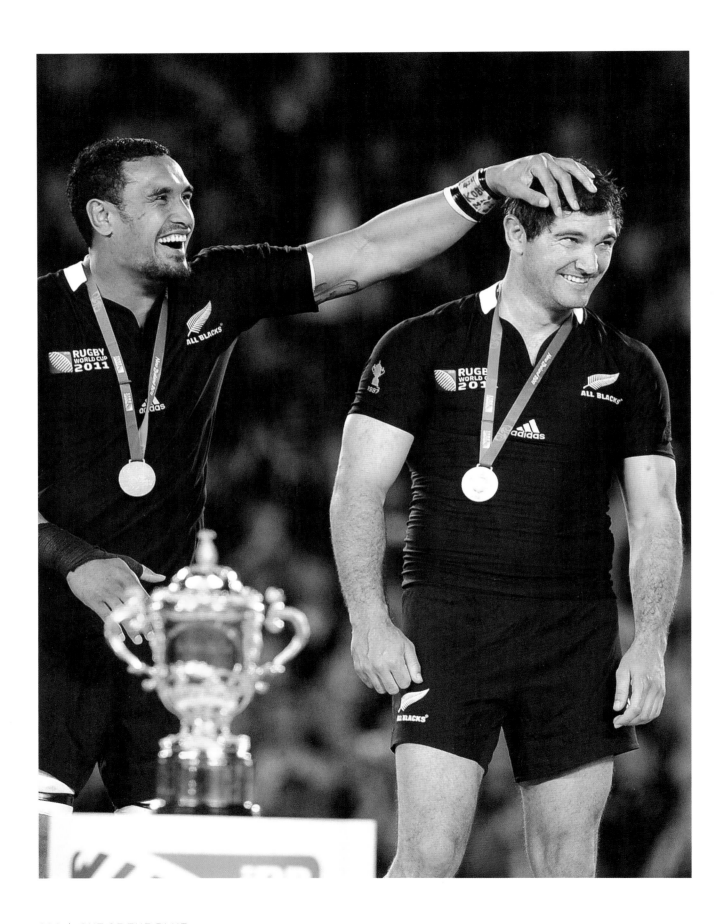

Donald fishes for gold

New Zealand 2011
New Zealand 8 France 7
23 October 2011
Eden Park, Auckland | Final

FROM TOM BELL

Stephen Donald was not angling for compliments after kicking the goal that won the World Cup, but he had every right to accept them with pleasure and a bemused shake of the head. The fly half, who joins Bath after the tournament, was on the banks of the Waikato River two weeks ago when he was asked to pack his fishing gear and head to the All Blacks' camp.

Little did he know how big a role he would have to play. Injuries to Dan Carter and Colin Slade had left the host nation casting around for No 10s, with Donald needed on the bench in case the jinx struck Aaron Cruden. As was proven in the 46th minute of the final, it was a good thing the message got through.

"My preparation probably hasn't been ideal," Donald said. "I was whitebaiting, caught a couple of kg and got a call from Mils [Muliaina, the full back]. Ted [Graham Henry, the All Blacks head coach] couldn't get hold of me and Mils told me to start answering my phone. I'd deleted Ted's number. When you go whitebaiting you pack a few beers with your gear, so I'm not as match-fit as I could have been."

A man who took his share of criticism when he was a squad regular suddenly had the naysayers' hopes in his hands when he took over the kicking duties from the misfiring Piri Weepu, in what could be his last act as an international because of the All Blacks' policy to select only from those based in New Zealand.

"Sometimes people have questioned my performances and I didn't want that to be what people thought of me," he said. "But it's potentially my last game for the All Blacks. At half-time Pow [Weepu] said: 'Do you want to take over?' I didn't line it up realising this was the World Cup, though. I haven't kicked a ball in about six weeks."

Jerome Kaino ruffles the hair of Stephen Donald,
New Zealand's match-winner.

Goromaru gives Japan inspiration

England 2015

South Africa 32 Japan 34

19 September 2015
Brighton Community Stadium,
Brighton | Pool B

BY MARK PALMER

Japan roared in unison with their army of magnificently excitable supporters, and simply willed South Africa out of the game. If you're going to wait 24 years to claim a scalp, you may as well make it a big one. Zimbabwe in 1991, South Africa in 2015. An inspirational performance from full back Ayumu Goromaru, whose 69th-minute score tied the scores at 29-29, will win the headlines, but it was a collective grit and technical class that won the game.

Japan's Ayumu Goromaru on the way to a 24-point haul against South Africa. Goromaru scored a try, kicked two conversions and five penalty goals for a match return of 24 points, keeping his side in contention whenever South Africa threatened to build a lead. On the day, of course, every Japanese player could claim the status of hero.

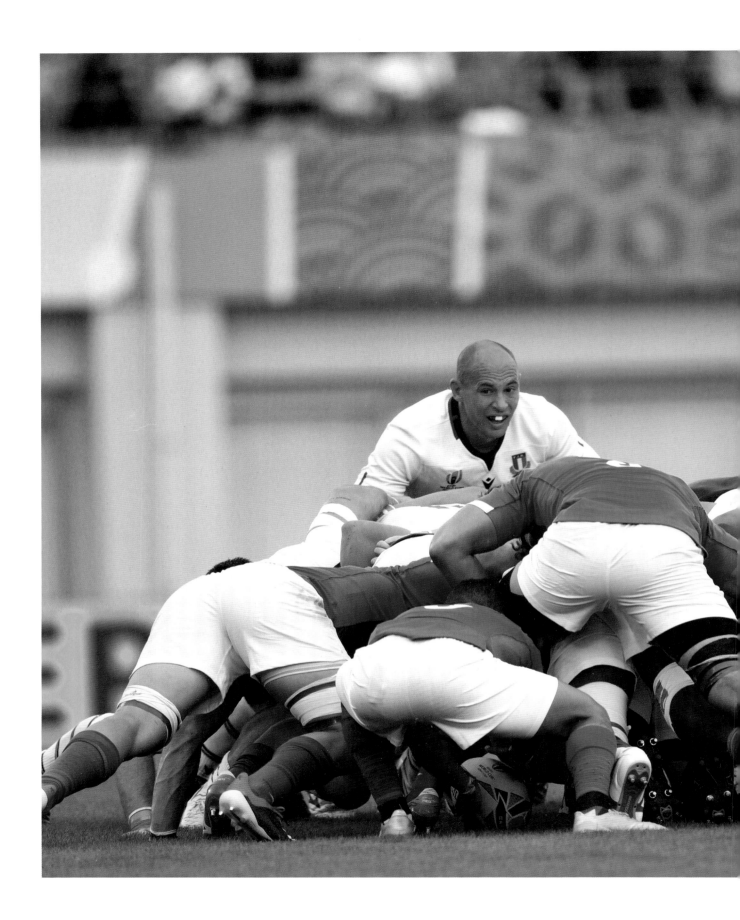

Parisse joins record holders

Japan 2019
Italy 47 Namibia 22
22 September 2019
Hanazono Stadium, Osaka
Pool B

Sergio Parisse started his fifth World Cup by guiding Italy to a comfortable win over Namibia yesterday, but he could not celebrate the milestone with a try. The 36-year-old No 8 was first denied the chance of scoring when his pack was awarded a penalty try, then when he lost the ball in a tackle close to the line and for a third time when he was called back by the referee, Nic Berry, after diving over from the base of a five-yard scrum.

From the very next movement he tried another pick-and-go, only to crash into Berry… "There was a lot of tension among the team – we have been preparing a long time for this game," said Parisse, who joined former team-mate Mauro Bergamasco and Samoa's Brian Lima as the only [male] players to feature in five Rugby World Cups.

Sergio Parisse eyes Namibia's forwards at the start of his fifth World Cup.

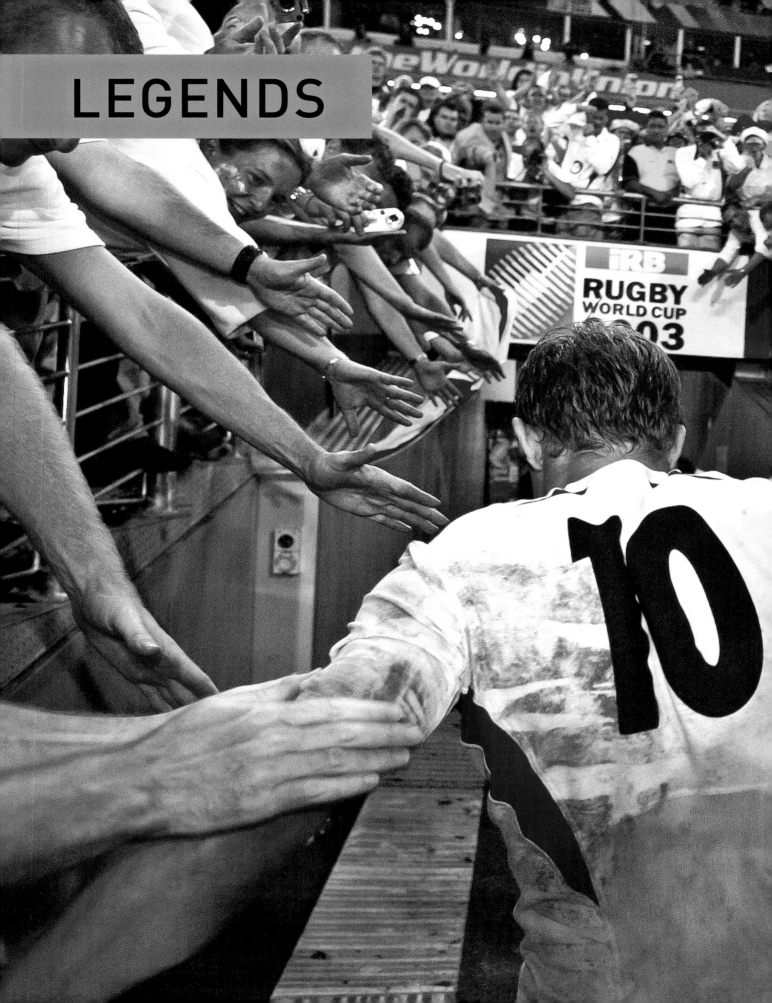

LEGENDS

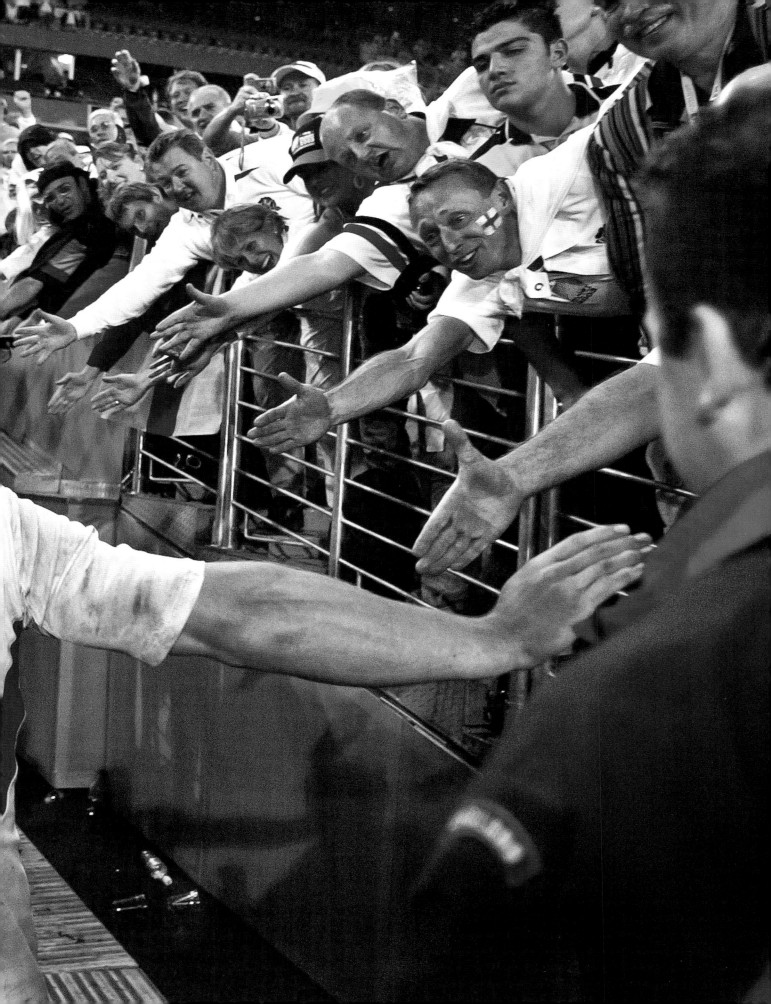

David Campese

Australia
World Cups: 1987, 1991, 1995

We knew all about David Campese when the first edition of the Rugby World Cup came around. He had been playing on Australia's wing for five years, he was possessed of a fabulous goose-step that few others in the world could match, he was quick – with his feet and his opinions – and capable of making costly errors (as he demonstrated against the British and Irish Lions two years later).

But there was an honesty to Campese's rugby that erupted best at the 1991 tournament. His all-round game, which allowed him to play full back as well as wing, developed because of the hard work he put into it. He made tries look easy and opponents appear ridiculous, and he scorned convention.

When New Zealand lined up for their pre-match haka in the 1991 semi-final, 14 Australians watched on. The fifteenth, Campese, was back in his own 22, juggling with the ball by himself, ignoring the display. "I stick to myself a lot of the time," he said. "In that situation it's very hard but, personally, watching the haka doesn't do anything for me. I appreciate that, in a team sport, everyone has to join together, because if a link is missing the whole thing doesn't work, but that's just the way I am."

In that game Campese, turning up as first receiver, scored one try and made another for Tim Horan with a no-look pass over his shoulder. In doing so he left his signature all over the whole tournament, even if, at Twickenham in the final a week later, Australia had to find another way to win. If South Africa, four years later, proved a step too far, few could complain. Campese did it his way.

DAVID HANDS

David Campese has the beating of Ireland's Philip Matthews during the 1991 quarter-final.

Patty Jervey

USA

World Cups: 1991, 1994, 1998,
2002, 2006

Where Patty Jervey led, others in the women's game would follow but the Georgia-born wing/centre became, in 2006, the first to play in five World Cup tournaments. Jervey was a member of the outstanding USA back division which won the inaugural World Cup in Cardiff in 1991 and was there when England gained revenge in the 1994 tournament final in Scotland.

It is easy to forget now that the USA featured in the first three finals of the women's tournament, losing to New Zealand in Amsterdam in 1998 but as the years passed, Jervey's enthusiasm for the game never dimmed. She remained a squad member for the 2002 tournament in Spain and wrapped up her international career in Canada in 2006, at the age of 42. Not that that

was the end – six years later, Jervey helped her club, Atlanta Harlequins, to become national champions and, at the age of 50, was still playing when Harlequins came fourth in the women's club championship.

She won forty international caps, scoring 38 tries and 178 points along the way, national records at the time and her appearances were not overtaken until 2013. A year later she became the first American to be inducted into World Rugby's Hall of Fame. "Being on the pitch and having the ball in my hands makes my soul sing," she said and she continues to inspire the next generation of American women.

DAVID HANDS

Patty Jervey fends off her Irish opponent, Jeannette Feighery, during the 2006 pool match in Edmonton.

John Eales

Australia
World Cups: 1991, 1995, 1999

Among his team mates John Eales was known as 'Nobody', as in 'Nobody's perfect'. There seemed little or nothing that he could not do: his basic job as a lock, to work in the set pieces, to hit rucks and mauls, but what about the rest? The reading of the game which helped him to a 55-cap tenure as Australia's captain, the tackling, the goal-kicking.

In an era when goals were kicked largely by the fly half or full back, Eales stood out as a match winner, even if his talents from the tee were not called upon in World Cups. His 173 points make him the highest scoring forward in internationals and he is one of a handful of players (21 of them) who have appeared in two winning World Cup sides.

When he played in 1991 Eales, 20, had only four caps to his name but the gangling 6ft 7in player partnering Rod McCall ('Sergeant Slaughter' to his mates) helped make a formidable second-row unit. His cover tackle on Rob Andrew in the final snuffed out a potential England try that might have swung a tight game.

He and McCall were still together in South Africa in 1995, when England beat the Wallabies in the quarter-finals, and by 1999, Eales was captain. His leadership skills were never required more than in the final against France when, in response to a series of gouging incidents, he told André Watson, the referee, that he would take his team off the field if the foul play did not stop. By that time the writing was, anyway, on the wall and Eales, a confirmed republican, was about to meet Queen Elizabeth II.

DAVID HANDS

John Eales on the rampage against France in the 1999 final.

Tim Horan

Australia
World Cups: 1991, 1995, 1999

The theory goes that World Cups are not won by inexperienced sides. Tell that to Australia who won in 1991 with a skinny kid (John Eales) in the second row and two 21-year-olds in the centre, Tim Horan and Jason Little. But these two had known each other since their early teens, they made their international debuts in the same year (1989) and were fellow Queenslanders.

Together they locked up the midfield and purveyed complementary skills: Horan, slightly squatter but more powerful, Little taller and a more graceful runner. Few, though, would have guessed at Horan's longevity when he suffered a career-threatening knee injury in the Super 10 final in 1994. That he made the World Cup squad a year later was a triumph for willpower and his medical advisers.

But 1999, the second of his World Cup triumphs, was his annus mirabilis. In his history of the World Cup, Gerald Davies wrote that Horan, in the nail-biting semi-final against South Africa, "was in a class of his own." This despite a virus that had kept him in bed throughout the day before: "He lasted," Davies wrote, "until the 74th minute, up to which time he gave a classical display of the centre three-quarter's art."

Horan himself said he was "in the zone." Rod Macqueen, his coach, spoke of his mental strength and the impact he had on other players. He remained in the zone in the final against France, joining the list of double World Cup winners and earning himself the award for player of the tournament.

DAVID HANDS

Tim Horan slips the tackle of Fabien Pelous in the 1999 final.

Anna Richards

New Zealand
World Cups: 1991, 1998, 2002, 2006, 2010

By the time a World Cup for women came along, Anna Richards was 26 and had been playing rugby since her student days at Canterbury University. There had been no schoolgirl rugby back in Timaru and she played netball at university before being dropped from the team and meeting a lecturer, Laurie O'Reilly, who suggested she might try her hand at rugby.

O'Reilly it was who moved heaven and earth to send a team from New Zealand to the first tournament. Richards, whose introduction had come as a wing, travelled as a scrum half in a squad all of whom had to find NZ$5,000 to make the trip, unsupported as it was by the NZRFU.

By the time the Black Ferns (the soubriquet they far preferred to the 'Gal Blacks' they were initially christened in the media) won the first of four successive tournaments, in 1998, Richards had switched to fly half.

That position allowed her to demonstrate the drive and aggression which was part and parcel of her game but also to bring out the best in a luminous back division.

Accustomed as she was to success with the Auckland Storm (unbeaten between 1994 and 2003 and where she now works as women players' development manager), she coaxed the national side to success despite the lack of quality domestic games which afflicted women players then and still do. That she was made a member of the NZ Order of Merit in 2005 and became the first woman to receive the Steinlager Salver in 2021 for the individual who has made a lasting contribution to New Zealand rugby says it all.

DAVID HANDS

Joy for Anna Richards as the Black Ferns make their fourth successive final.

Jonah Lomu

New Zealand
World Cups: 1995, 1999

Rugby's first global superstar. A sport which had not quite turned professional at the start of 1995 (by the end of the year it had), by and large eschewed the promotion of individuals. This was, the blazers said, a team sport, no individual bigger than the team. Man-of-the-match awards? Not on your life.

But Jonah Lomu was bigger than that, literally and metaphorically. At 6ft 4in and 19st, he played in the back row as a schoolboy but his pace told New Zealand's selectors he could be devastating on the wing and, in South Africa in 1995, he proved it. Ireland, against whom he scored two tries, felt the force first, another try came against Scotland in the quarter-finals then four against England in the semi-final.

But his colleagues, notably Josh Kronfeld, the flanker, knew that if they tracked Lomu, they could score tries too. Not until the final against South Africa was his naivety in defence shown but by then the world knew all about Lomu. The world then discovered that he was suffering from a kidney condition which required constant medication; in a curious way, it added to the lustre though it also contributed to the heart attack that killed him, aged forty.

Lomu arrived for the 1999 World Cup and scored eight tries before the All Blacks crashed out against France in the semi-finals. Thereafter his talents were seen only intermittently but his reputation and his humility made him an attractive proposition on guest shows and as an ambassador – which he was during the 2011 tournament in New Zealand. He shares, with Bryan Habana (South Africa) the all-time men's record of 15 World Cup tries.

DAVID HANDS

Jonah Lomu performs the Haka before New Zealand's 1999 World Cup semi-final match against France.

Joost van der Westhuizen

South Africa
World Cups: 1995, 1999, 2003

It was always the blue eyes you noticed most, blazing with an intensity which was perhaps at its height during the 1995 World Cup final in Johannesburg. Going into that tournament, Joost van der Westhuizen was by no means South Africa's first choice scrum half; the dependable Johan Roux having proved his qualities for Transvaal and the Springboks over the previous three years. By the conclusion, there was no question that van der Westhuizen's game-changing qualities had secured not only first place for his country but placed him among the best half backs in the world.

He won the first of his 89 caps against Argentina in 1993, secured a place in the affections of the new coach, Kitch Christie, against Scotland on tour in 1994 but there remained doubts about his self-discipline. Of his playing talent there was little doubt: at 6ft 2in, van der Westhuizen was tall for a scrum half but he also possessed a strength and athleticism that left others for dead. Nor was he short of courage: during the 1995 semi-final against France, played in atrocious conditions in Durban, he cracked a rib but told no-one so as to be sure of playing in the final against New Zealand. Not only did he play but he made potentially match-changing interventions, most notably tackling Jonah Lomu in full flight, while the quality of his passing ensured that Joel Stransky, his fly half and the eventual match winner, could pull the tactical strings.

Winning the World Cup at the first time of asking (South Africa did not play in 1987 or 1991), and before a rapturous crowd on home soil, was always going to be a hard act to follow, but by the time 1999 came round, van der Westhuizen was South Africa's captain. He led, as always, from the front and was one of the two Springbok try-scorers in the quarter-final win over England in Paris. But in a climactic semi-final against Australia at Twickenham, the goal-kickers held sway and South Africa had to be content with winning the third place play-off against their old rivals, New Zealand.

By 2003, van der Westhuizen was nearing the end of an international career which would leave him with both a record number of appearances for his country and a record number (38) of tries, both marks since surpassed. But this was not an outstanding Springbok squad, they had little form to speak of and it was no surprise when they lost to New Zealand in the quarter-finals. Van der Westhuizen came close to a try during that match in Melbourne and must have wondered whether, in his prime, he might have made it to the corner.

Rugby provided a stage for van der Westhuizen to achieve what he had always dreamed of as a child. Life after rugby proved more problematic and in 2011 he was diagnosed with motor neurone disease. His reaction was typical, creating as he did the J9 charity to raise awareness of the illness. He died in 2017, aged only 45.

DAVID HANDS

Joost van der Westhuizen passes the ball during the 1995 World Cup final win over New Zealand.

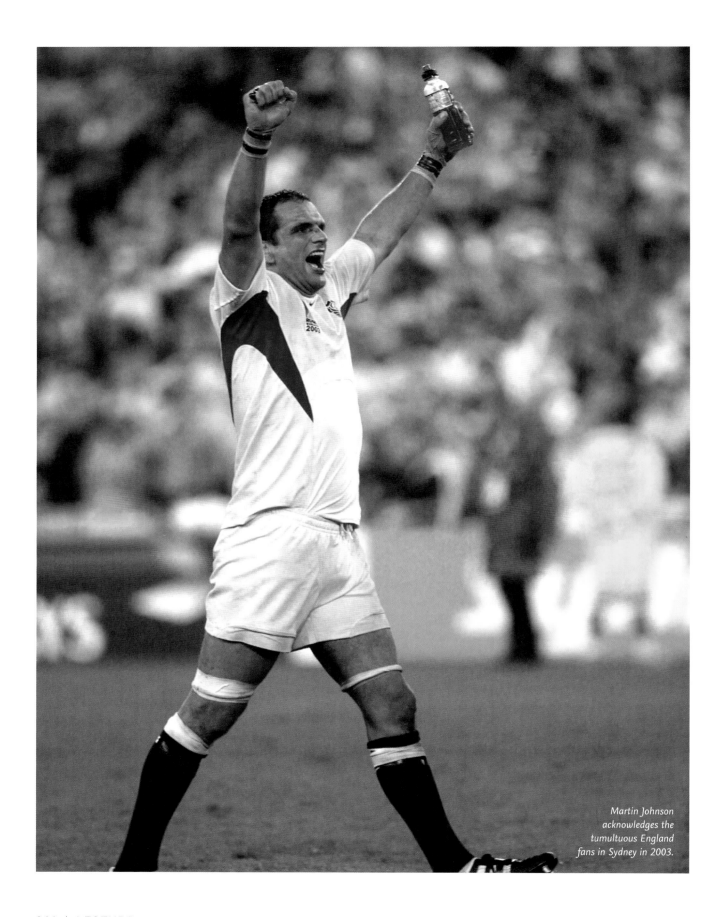

Martin Johnson acknowledges the tumultuous England fans in Sydney in 2003.

Martin Johnson

England
World Cups: 1995, 1999, 2003

FROM ALISON KERVIN, SYDNEY

He is a man of few words at his most eloquent and this [the 2003 World Cup final against Australia] was certainly not a time that called for eloquence. With the players on the pitch, the anthems sung and the World Cup final within minutes of starting, Martin Johnson pulled his team towards him, gripping players by their shoulders and pulling them closer into him while he looked up and breathed deeply.

His face looked tortured but determined as he dropped his gaze to stare into their eyes, moving round the group one by one. His face was beamed out on the huge screens at Telstra Stadium as he regarded his players, his stare aiming to tell them so much more than words could.

Then he spoke: "Let's go." He released his grip. That was it. The best rugby captain in the world, leader of the British Isles to their series victory in 1997. Now England to the World Cup in 2003 and "Let's go" is all he said.

"He doesn't need to say much," Jonny Wilkinson said after the game. "He just looks at you and you know. We all know what he expects of us and we all know he doesn't expect anything that he won't give himself. He's an awesome captain. You just want to win for him so much."

In one way or another, Martin Johnson was involved in five World Cups: three as a player, as ambassador and pundit in France in 2007, and as England manager in New Zealand in 2011. His aura, as the northern hemisphere's only World Cup-winning captain, remains so strong that he has been seen regularly since as a television analyst. From the outset of his international career, in 1993, Johnson dominated the game at the highest level.

England have had many good second-row forwards but none with the point of difference which made Johnson such a good leader. He could read the game like few other Englishmen, though he was not Clive Woodward's first choice as captain when Woodward became England coach in 1997, despite Johnson having led the British and Irish Lions to a series victory in South Africa that year. He took over from Lawrence Dallaglio as captain in a World Cup-qualifying game against Holland in 1998 and retained the role for the next five years, with intermissions only when caused by injury.

By 2003, England were the world's number-one team, they had beaten New Zealand and Australia on their own turf on a pre-World Cup tour, they were primed and ready. Johnson was then 33 and had already decided this would be his international swansong. Throughout his career, pragmatism had been a hallmark and he enforced it rigorously throughout the tournament in which he started every game save the pool game with Uruguay.

Even when the fates seemed to be conspiring against England in the final with Australia, Johnson stayed calm and his last drive paved the way for Matt Dawson, the scrum half, to return to his feet and deliver the pass for Jonny Wilkinson's winning drop goal. In his 82nd and last England appearance, it was some way to bow out.

DAVID HANDS

Jonny Wilkinson

England

World Cups: 1999, 2003, 2007, 2011

Given the number of injuries he sustained over an 18-year professional playing career, it seems the height of absurdity that Jonny Wilkinson made it to four World Cups. But timing was always one of his best characteristics, never more than in extra time in Sydney's Telstra Stadium when he kicked the drop goal which won England the 2003 tournament against Australia.

Wilkinson, a fly half, had been plucked out of relative obscurity by Clive Woodward, England's coach, to make his debut international appearance in 1998 as a replacement wing. He went into the 1999 tournament, still only 20, as first choice No 10 and scored 66 points in three matches but Woodward preferred the greater experience of Paul Grayson in the quarter-final against South Africa.

Jannie de Beer kicked England out of the tournament but by 2003, England were acknowledged as the best side in the world. Wilkinson was at the heart of it but hated the attendant publicity which led one reporter, at a press conference, to enquire of him whether he was a "basket case". Wilkinson's introspection was part of who he was but his goal-kicking (some Australian media asked if that was all England had) was rock solid.

It helped turn round an under-performing England in 2007, guiding the side to another final though not to victory over South Africa. Even that was beyond him in 2011, when England never achieved any momentum in New Zealand, but by then Wilkinson's place in the rugby firmament was as assured as his position as England's record points scorer, 1,179 in 91 appearances, and leading World Cup points scorer on 277.

DAVID HANDS

Jonny Wilkinson applauds fans at the end of England's victorious match against Australia in the 2003 World Cup final.

Fiao'o Fa'amausili

New Zealand
World Cups: 2002, 2006, 2010, 2014, 2017

The male game contains players who have appeared in five World Cups but none to match the achievements of the two New Zealanders, Anna Richards and Fiao'o Fa'amausili, who won four of them. Such a feat also requires a degree of longevity and Fa'amausili, the hooker born in the Samoan capital of Apia, was 36 when her side carried off the trophy in Belfast in 2017 and a year older when her international career closed.

A mere child, perhaps, alongside Richards who was 45 when her international playing career ended but the two played alongside each other in three tournaments, the first in 2002 when Fa'amausili won the first of her 57 caps. She stood out swiftly for the drive which inspired her team-mates and it was no surprise when she took over as captain in 2012.

The citation which accompanied her elevation to World Rugby's Hall of Fame in 2022 described her as "a massive driver of the level of professionalism and dedication that enabled the Black Ferns to dominate for much of her time in the black jersey." After her final appearance she was made an officer of the New Zealand Order of Merit.

Throughout her playing career, which encompassed 15 provincial titles with Auckland, Fa'amausili maintained her job as a police detective in the Auckland district of Manukau. Her standing in the game was such that, in 2021, she was elected president of the Auckland union, the first woman to hold that position.

DAVID HANDS

Fiao'o Fa'amausili throws the ball in during the 2017 Women's World Cup pool A match against Wales.

Richie McCaw

New Zealand
World Cups: 2003, 2007, 2011, 2015

"That last game," Richie McCaw said of the World Cup final win over Australia in 2015, "to have that as your lasting memory of your last time on the pitch is pretty satisfying." It was the culmination of 14 years at the international coal face, a period which earned the flanker 148 caps, in 110 of which he was New Zealand's captain.

Those figures, at the time, stood as world records, alongside the fact that, in 97 of the games in which he led the All Blacks, McCaw's side won. Two of those victories were World Cup finals, those of 2011 and 2015, and if any other player is able to emulate those statistics in the men's game, never mind surpass them, he will have done so the hard way.

Indeed, McCaw suffered during the 2011 pool games a reoccurrence of the foot injury sustained at the start of the year. There was doubt whether he would be able to play during the knockout phase and New Zealand brought in a replacement but McCaw came through. "I don't know how he did it," Graham Henry, his coach, admitted after the one-point win over France in the final.

McCaw's great skill, as player and leader, was in knowing just how far he could go to test the patience of referees. Opponents accused him of getting away with murder at the breakdown but that same could be said of every outstanding back-row forward. "In my opinion, he will go down not only as the greatest All Black of all time but the greatest captain we have ever had and possibly the greatest player to have ever played the game in the modern era," Steve Hansen, the 2015 coach, said.

DAVID HANDS

Richie McCaw raises the winner's trophy after New Zealand win the 2015 World Cup.

Index

1987 World Cup 13, 48, 50, 57, 159, 160

1991 Women's World Cup 14, 22, 235, 240

1991 World Cup 17, 52, 55, 56–59, 61, 119, 143, 144, 162, 195, 212, 232, 236, 239

1994 Women's World Cup 18, 235

1995 World Cup 21, 57, 59, 62, 64, 67, 121, 122, 125, 147, 148, 196, 199, 201, 215, 232, 236, 239, 243, 244, 247

1999 World Cup 28, 68, 70, 73, 126, 129, 130, 133, 165, 167, 168, 217, 236, 239, 243, 244, 247, 248

2003 World Cup 31, 74, 76, 79, 80, 116, 134, 136, 171, 192, 202, 219, 230, 244, 247, 248, 253

2007 World Cup 10, 32, 83, 84, 86, 150, 173, 174, 177, 220, 222, 248, 253

2011 World Cup 34, 88, 91, 152, 156, 179, 180, 206, 210, 225, 248, 253

2014 Women's World Cup 4, 37, 93, 94, 182, 250

2015 World Cup 39, 96, 99, 101, 103, 138, 155, 185, 187, 188, 226, 253

2017 Women's World Cup 40, 250

2019 World Cup 43, 105, 106, 109, 110, 140, 191, 209, 229

2021 World Cup 44, 46, 113, 115

Andrew, Rob 119, 121

Argentina 88, 103, 167, 173

Ashley-Cooper, Adam 103

Australia 17, 28, 31, 39, 55, 56–59, 61, 79, 80, 91, 103, 116, 121, 130, 136, 138, 155, 159, 160, 171, 179, 196, 220, 230, 232, 236, 239

Bachop, Stephen 70

Black Ferns 22–27, 40, 44, 113, 182, 240, 250

Blanco, Serge 50, 143, 159

Bobo, Sireli 86

Breckenridge, Tam 14

Bridge, George 105

Briggs, Niamh 182

Brito, Max 148

Brooke, Zinzan 122

Burns, Gill 18

Campese, David 50

Canada 4, 37, 93, 94, 115, 147, 188, 212

Carter, Dan 39, 138

Catt, Mike 31, 67

Caucaunibuca, Rupeni 219

Champ, Eric 159

Clerc, Vincent 152, 222

Cocksedge, Kendra 45

Cooper, Alice D 14

Cooper, Quade 171

Cross Green, Otley 195

Cueto, Mark 150

Culhane, Simon 215

Dalton, Andy 13

Dalton, James 147

Davies, Gareth 101

Dawson, Matt 31, 80

De Beer, Jannie 129

Dominici, Christophe 73, 177

Donald, Stephen 225

Dorrington, Sue 14

Dow, Abby 115

Dubroca, Daniel 143

Du Preez, Fourie 86

Dusautoir, Thierry 84

Eales, John 28, 236

Ellis, Marc 215

England 4, 14, 17, 18, 31, 32, 37, 40, 43, 44, 67, 80, 94, 101, 109, 110, 115, 119, 121, 122, 129, 134, 136, 143, 144, 150, 187, 205, 220, 222, 230, 247, 248

Erasmus, Rassie 43

Fa'amausili, Fiao'o 40, 250

Fiji 46, 86, 174, 191, 219

Foley, Bernard 155

Forsyth, Mary 14

France 13, 28, 34, 46, 50, 73, 84, 93, 133, 134, 143, 152, 159, 168, 173, 177, 180, 199, 210, 222, 225

Gaminara, Juan Manuel 191

Georgia 99

Gonzalez Amorosino, Lucas 88

Gorgodze, Mamuka 99

Goromaru, Ayumu 96, 226

Griffin, Deborah 14

Habana, Bryan 83

Hamilton, Gordon 55

Harvey, Magali 93

Hastings, Gavin 144

Hemming, Sophie 205

Herbert, Anthony 17

Herrera, Daniel 217

Hesketh, Karne 96, 185

Horan, Tim 52, 61, 239

Hunter, Sarah 40

Inagaki, Keita 106

Ireland 55, 57, 59, 62, 68, 156, 167, 179, 182, 205

Italy 48, 126, 195, 229

Ivory Coast 148

Japan 96, 106, 185, 209, 215, 226

Jervey, Patty 235

Johnson, Martin 31, 247

Jones, Robert 52

Joubert, Craig 155

Kay, Ben 31
Kearns, Phil 17
Kirk, David 13
Kirwan, John 48
Kolisi, Siya 43

Lamaison, Christophe 133, 168
Laporte, Bernard 177, 222
Larkham, Stephen 130
Lima, Brian 74
Lomu, Jonah 62, 67, 73, 243
Lynagh, Michael 17, 56–59, 61

Mandela, Nelson 21
Mapimpi, Makazole 110
Marsh, Amiria 24
Mbeki, Thabo 32
McCaw, Richie 34, 39, 253
McLean, Katy 37
Mehrtens, Andrew 62, 73, 125
Mortlock, Stirling 79
Namibia 192, 202, 229
New Zealand 13, 21, 22–27, 34, 39, 40,
 44, 48, 61, 62, 67, 73, 76, 79, 84,
 91, 105, 109, 113, 122, 125, 133,
 138, 168, 171, 177, 182, 201,
 212, 215, 225, 240, 243, 250, 253
Ngwenya, Takudzwa 83
Nonu, Ma'a 91

Ormaechea, Diego 217

Parisse, Sergio 209, 229
Pienaar, Francois 21
Poidevin, Simon 17

Queen Elizabeth II 28

Richards, Anna 22, 23, 25,
 240
Robinson, Jason 80
Rogers, Mat 80, 171
Romania 188, 192, 202

Samoa 70, 74, 140, 165
Scarratt, Emily 94
Scotland 88, 106, 119, 144, 155, 219
Sheridan, Andrew 220
South Africa 10, 21, 32, 43, 64, 83, 86,
 96, 105, 110, 125, 129, 130, 147,
 150, 185, 196, 199, 201, 226, 244
Spain 22, 217
Stransky, Joel 125

Tasmania 202
Thomas, Gareth 187
Thorburn, Paul 160

Tonga 99, 126, 148, 180, 210
Tuilagi, Manu 109
Tu'ipulotu, Sateki 126

Uruguay 74, 191, 217
USA 14, 18, 26, 68, 83, 195, 235

Vaega, To'o 52
Van der Westhuizen, Joost 244
Vlaicu, Florin 188

Wales 52, 70, 76, 101, 113, 152, 156,
 160, 162, 165, 174, 187
Warburton, Sam 152
Webb Ellis Cup 10, 13, 17, 28, 31, 32,
 34, 39, 43, 253
Western Samoa 52, 64, 162
White, Jake 32
Wilkinson, Jonny 31, 80, 134, 136, 222,
 230, 247, 248
Williams, Chester 64
Williams, Shane 76
Wood, Keith 68
Woodman, Portia 113
Worsley, Joe 222
Wyllie, Alex 167

Acknowledgements

My grateful thanks to Robin Ashton, for trusting me with the project, to Richard Whitehead for his invaluable guidance on the technical side and marrying words to pictures, and to my son, Robert Hands, for throwing my name into the melting pot in the first place and applying an eagle eye to the proof-reading. Harley Griffiths and Rachel Allegro at HarperCollins have been magnificent to work with and have brought their considerable design skills to the book. Steve Baker, Sue de Friend and Chris Ball at News UK archives have responded with admirable speed to my queries. Thanks to an old friend and colleague, Steve Jones, for supplying the foreword, to another old friend, Michael Lynagh, for his recollections, and a fellow panellist for World Rugby's hall of fame, Anna Richards, for also going back in time.

Photo credits

Front cover (jacket): Simon Bruty / Getty Images
Front cover (hard cover): REUTERS / Alamy Stock Photo
p.4: Jordan Mansfield / Stringer / Getty Images
p.10: Paolo Bona / Alamy Stock Photo
p.12: Ross Setford/AP/Shutterstock
p.15: Jeff Morgan 09 / Alamy Stock Photo
p.16: Getty Images
p.19: Colorsport/Shutterstock
p.20: Colorsport/Shutterstock
p.23: Marco Mega / Alamy Stock Photo
p.24: Jimmy Jeong / Stringer / Getty Images
p.25(t): Craig Prentis / Stringer / Getty Images
p.25(b): Craig Prentis / Stringer / Getty Images
p.27: David Rogers / Getty Images
p.29: Sportsfile / Getty Images
p.30: PA Images / Alamy Stock Photo
p.33: MARTIN BUREAU / Getty Images
p.35: PA Images / Alamy Stock Photo
p.36: Jordan Mansfield / Stringer / Getty Images
p.38: Andrew Fosker/Bpi/Shutterstock
p.41: PA Images / Alamy Stock Photo
p.42: Newscom / Alamy Stock Photo
p.45: PA Images / Alamy Stock Photo
p.49: PA Images / Alamy Stock Photo
p.51: GEORGES GOBET / Getty Images
p.53: Bob Thomas / Getty Images
p.54: Professional Sport / Getty Images
p.56: PA Images / Alamy Stock Photo
p.58: Colorsport/Shutterstock
p.60: Getty Images
p.63: Colorsport/Shutterstock
p.65: Shaun Botterill / Getty Images
p.66: David Rogers / Getty Images
p.69: Colorsport/Shutterstock
p.71: FRANCOIS GUILLOT / Getty Images
p.72: Mark Leech/Offside / Getty Images
p.75: REUTERS / Alamy Stock Photo
p.77: AFP / Getty Images
p.78: Colorsport/Shutterstock
p.81: Colorsport/Shutterstock
p.82: PATRICK VALASSERIS / Stringer / Getty Images
p.85: ABACA/Shutterstock
p.87: REUTERS / Alamy Stock Photo

p.89: REUTERS / Alamy Stock Photo
p.90: Shutterstock
p.92: Jean Catuffe / Getty Images
p.95: Alain Coudert/Sportsvisi/Sipa/Shutterstock
p.97: REUTERS / Alamy Stock Photo
p.98: James Marsh/BPI/Shutterstock
p.100: PA Images / Alamy Stock Photo
p.102: Huw Evans/Shutterstock
p.104: Shuji Kajiyama/AP/Shutterstock
p.107: Colorsport/Shutterstock
p.108: Eugene Hoshiko/AP/Shutterstock
p.111: REUTERS / Alamy Stock Photo
p.112: ANDREW CORNAGA/EPA-EFE/Shutterstock
p.114: Phil Walter / Getty Images
p.116: REUTERS / Alamy Stock Photo
p.118: Colorsport/Shutterstock
p.120: Uncredited/AP/Shutterstock
p.123: David Rogers / Getty Images
p.124: Colorsport/Shutterstock
p.127: OLIVIER MORIN / Getty Images
p.128: Colorsport/Shutterstock
p.131: Gary M. Prior / Getty Images
p.132: WILLIAM WEST / Getty Images
p.135: REUTERS / Alamy Stock Photo
p.137: Chris Barry/Shutterstock
p.139: Jed Leicester/BPI/Shutterstock
p.140: PA Images / Alamy Stock Photo
p.142: PA Images / Alamy Stock Photo
p.145: Russell Cheyne / Getty Images
p.146: Colorsport/Shutterstock
p.149: Colorsport/Shutterstock
p.151: Kieran Galvin/Shutterstock
p.153: Marc Aspland / The Times / News Licensing
p.154: REUTERS / Alamy Stock Photo
p.156: Tim Clayton – Corbis / Getty Images
p.158: Colorsport/Shutterstock
p.161: Colorsport/Shutterstock
p.163: Colorsport/Shutterstock
p.164: David Rogers / Getty Images
p.166: Mike Hewitt / Getty Images
p.169: Ross Kinnaird / Getty Images
p.170: PA Images / Alamy Stock Photo
p.172: DPPI Media / Alamy Stock Photo
p.175: Andrew Fosker/Shutterstock

p.176: Kieran Galvin/Shutterstock
p.178: Tim Clayton – Corbis / Getty Images
p.181: Paul Zammit Cutajar/Shutterstock
p.183: Sportsfile / Getty Images
p.185: Graham Hughes / The Times / News Licensing
p.186: Mark Pain / Alamy Stock Photo
p.189: Kieran Galvin/Shutterstock
p.190: REUTERS / Alamy Stock Photo
p.192: Hamish Blair / Getty Images
p.194: Simon Bruty / Getty Images
p.197: Mark Leech/Offside / Getty Images
p.198: Mark Leech/Offside / Getty Images
p.200: Getty Images
p.203: Julian Smith/EPA/Shutterstock
p.204: REUTERS / Alamy Stock Photo
p.207: REUTERS / Alamy Stock Photo
p.208: Aflo/Shutterstock
p.210: REUTERS / Alamy Stock Photo
p.213: Getty Images
p.214: Phil Cole / Getty Images
p.216: Alex Livesey / Getty Images
p.218: Colorsport/Shutterstock
p.221: David Rogers / Getty Images
p.223: Marc Aspland / The Times / News Licensing
p.224: Shutterstock
p.227: Patrick Khachfe/Jmp/Shutterstock
p.228: Aflo Co. Ltd. / Alamy Stock Photo
p.230: Tom Jenkins / Getty Images
p.233: Colorsport/Shutterstock
p.234: Harry How / Getty Images
p.237: REUTERS / Alamy Stock Photo
p.238: Allstar Picture Library Ltd / Alamy Stock Photo
p.241: Mike Hewitt / Getty Images
p.242: Colorsport/Shutterstock
p.245: Professional Sport / Getty Images
p.246: David Gibson/Fotosport/Shutterstock
p.249: David Gibson/Fotosport/Shutterstock
p.251: PA Images / Alamy Stock Photo
p.252: Marc Aspland / The Times / News Licensing
Back cover (jacket): Colorsport/Shutterstock
Back cover (hard cover): Aflo Co. Ltd. / Alamy Stock Photo

Photo captions

Front cover (jacket): New Zealand's Jonah Lomu evades the tackle of England's Rob Andrew during the 1995 World Cup semi-final in Australia.

Front cover (hard cover): A lineout at the 2021 World Cup final between England and New Zealand.

p.4–5: England celebrate at the final whistle as they win the Women's World Cup in 2014. The final was played against Canada at the Stade Jean Bouin on 17 August in Paris, France.

p.10–11: 2007 Percy Montgomery holds aloft the Webb Ellis Cup as South Africa celebrate their victory over England in the 2007 final in France.

p.46–47: France's Emeline Gros scores a try in a pool match against Fiji at the 2021 New Zealand Rugby World Cup.

p.116–117: George Gregan, Australia's long-serving scrum half, drops a vital goal in the 17-16 pool win over Ireland during the 2003 World Cup.

p.140–141: Ed Fidow of Samoa is handed a red card during the 2019 World Cup match against Scotland in Japan.

p.156-157: Sean O'Brien reflects ruefully after Ireland's defeat by Wales in their 2011 quarter-final in New Zealand.

p.192-193: Romanian fans show their colours for their pool A match against Namibia at the 2003 World Cup in Australia.

p.210-211: Tonga players perform the Sipi Tau after winning their pool A match against France in the 2011 World Cup.

p.230-231: Jonny Wilkinson leaves the pitch, and is met by overjoyed fans, after his extra time drop goal secured England's victory in the 2003 World Cup final against Australia.

Back cover (jacket): South Africa's Francois Pienaar receives the Webb Ellis Cup from President Nelson Mandela after their 1995 World Cup final victory against New Zealand.

Back cover (hard cover): Japan win a lineout in their pool B match against South Africa at the 2015 World Cup in England.

Writers and columnists featured

Writers: Elgan Alderman, Mark Baldwin, Stuart Barnes, Tom Bell, Rick Broadbent, Nick Cain, Gerald Davies, Jane Flanagan, Michael Hamlyn, John Hopkins, Matt Hughes, Steve James, Alison Kervin, Stephen Jones, Patrick Kidd, Gabby Logan, Alex Lowe, David Miller, Ashling O'Connor, Alasdair Reid, Peter O'Reilly, Mark Palmer, Daniel Schofield, Owen Slot, Mark Souster, Lewis Stuart

Columnists: Rob Andrew, Michael Lynagh, Anna Richards, Gareth Thomas, Jonny Wilkinson